In Afghanistan

ALSO BY THE AUTHOR
A Runner's Guide to Europe

IN AFGHANISTAN
An American Odyssey

Jere Van Dyk

Authors Choice Press
San Jose New York Lincoln Shanghai

In Afghanistan
An American Odyssey

Authors Choice Press
an imprint of iUniverse, Inc.

For information address:
iUniverse, Inc.
5220 S. 16th St., Suite 200
Lincoln, NE 68512
www.iuniverse.com

Originally published by Coward McCann (GP Putnam Sons)

Excerpt from *Seven Pillars of Wisdom* by T. E. Lawrence.
Copyright © 1926, 1935 by Doubleday & Company, Inc.
Reprinted by permission of the publisher.

The text of this book has been set in Janson.

ISBN: 0-595-21553-X

Printed in the United States of America

To Dad

Introduction

In late 1981 I traveled briefly through two parts of Afghanistan: in the mountains along the eastern border and in the desert in the south. The principal languages there are Pashto and Persian, of which I know only some words and phrases. I was in Afghanistan and on its borders for less than three months and visited only one city, Kandahar, briefly and secretly. I was always, in effect, a prisoner: I did not go anywhere alone; I always did what my guides said. Their orders and their desire were almost always to protect me. In this war, to the Afghans, all foreigners are possible Russians, and I was a foreigner—an American who saw with Western eyes traveling in an Eastern culture. I went a bit naively with my dreams. I remember once reading an old man's advice to his grandson: "Live your dreams, my son, and then write about them." This is the story of my journey and of why I went.

As I write this there are courageous European doctors, men and women, mostly French, working in makeshift hospitals in the Afghan mountains; many more have stayed for months and left; others will come to replace those now there. Other journalists, too, have gone there—some more than once,

among them Edward Giradet, Dave Kline, Aernout van Lynden; some are perhaps there now, and others will go. Although each one of us has his or her own story to tell, this story is in a way for everyone who has gone. Regardless of our politics and our reasons for going, the war in Afghanistan has deeply touched all of us.

I want especially to thank Mike Kaufman, Bob Semple, and Craig Whitney of the *New York Times* and Tony Austin and Ken Emerson of the *New York Times Magazine*. I could not have written this book without them. I also want to thank John Brockman and Katinka Matson, friends and agents, who first suggested that I write it; Rosanne Klass at Freedom House in New York, who has been generous with her advice and from whom I have learned much; and Louis Dupree, whose excellent source book, *Afghanistan*, I consulted often. My warm appreciation and thanks to my parents and to my brother and sister, Kody and M'Lyss, to Arthur Hill and Marie Lee, Aden Hayes, Bill and Melanie Norris, Steve McCurry, Lauren Stockbower, Jim Sheldon, Wayid Karim, other Afghan friends who prefer to remain anonymous, and especially to Ken Guest, and to Pat Janish at the Better Letter who transcribed and photocopied, sometimes until very late at night.

A final and sincere thanks to Tom Miller, my editor at Coward-McCann, whose talent, hard work, support, and patience have seen us through.

I have changed many of the names of the men I lived with and the names and locations of their villages. Their war continues. Some of these men saved my life; others would have, had they needed to. I will never forget them. While they will probably never read this, I wish them well. *Astalah mashai. Hodai Payman.*

Vancouver, Washington
January 1983

We were trapped.

We started running. Everywhere there was pandemonium and panic. Women, some in *chadri*, some no longer caring, ran toward us. Many carried babies; children, some carrying younger brothers and sisters, ran behind them. There were sheep, goats, and donkeys led by old men hobbling as fast as they could; bicycles and motor scooters went both ways. The dust was so high we covered our faces with our turbans. Old men, women, even children, shouted to us as we passed, *"Allah O Akbar."*

We ran for an hour, working our way through many small adobe villages. Finally we reached a site like the one we left: a series of vineyards in rows of four-feet-deep trenches, with two-story *kishmishkhanas* standing, like adobe barns on the American western plains, in the center. Low clay walls divided the fields. A five-foot-high wall separated the southern border of the fields from the desert. There were now other groups of guerrillas like ourselves. Ahmed spoke with the leader of one; a decision was made. We would stay here; they would take the next house.

Ahmed opened a brown picket gate, and the men walked slowly, rifles ready, across the field to the *kishmishkhana*. Inside,

it was empty, cool. We sat on the hard dirt floor, our backs to the wall, the cold made worse by our fear. The spy was led to the corner. He was blindfolded and his hands were bound. Mousa tied his feet with the part of his turban he had used to pull him along. He slouched down in the corner.

Ahmed directed ten men to come with him. They crouched in the low antechamber while he talked; then, single file, left. I went over to see. Ahmed pointed to the wall at the southern edge of the field, which they had been sent to defend.

Now they came. The Russian helicopters appeared above us and began to turn—giant gray hawks, circling, circling, circling. When they came directly overhead, their roar made it impossible to talk. Ahmed sat on his haunches in a doorway, rifle hidden under his blanket, chewing on a piece of straw, watching, wondering when and from where the attack would come.

The pilots—Russians, I guess—were hunting for us, and when they saw us, they would either attack or radio to the infantry and the artillery somewhere out there.

When the arc of the helicopters took them away, it was silent.

I slumped against the wall and began to write in my journal. It was 9:00 A.M., November 26, Thanksgiving Day, 1981. The room was, strangely, like a small chapel. There was even a small cross over the entrance. It was not meant of course to be a religious symbol; only another opening, a window for light. There were now eighteen of us, nineteen counting the spy in the corner. Ten more were at the southern wall outside. These men around me—for they were no longer boys, joking teenagers like they were last night before the bombardment began—rewrapped their turbans tighter. They must not come loose when the battle begins. I realized now, that was what was going to happen: There was going to be a battle. Still, the full emotional impact did not register. A boy-man next to me—he was no more than sixteen—was shivering, his lips trembling as he watched me write. He rewrapped his turban again, then cocked his rifle

for the hundredth time. Nerves. Nerves. I looked around. There was not a man who wasn't scared. Some smiled, talked quietly; most were silent, mouthing prayers. Alishan brought out a small Koran, read from it, kissed it, touched it to his forehead. Mousa counted out his bullets—he had maybe thirty—and gave ten to a friend. It was to be seventeen Lee–Enfields, one Chinese sub-machine gun, maybe five grenades, two anti-tank rockets against the helicopters, the infantry, and who knows what else.

You can't cut it any closer than this, Jere. My God, my God. Afghanistan. Why?

It seemed so long ago, but it was only nine years since that late afternoon in a small café on the Boulevard St. Germain with Jaap in May 1973. The sun was shining. A gentle breeze blew our pantslegs and open shirts, and the leaves in the trees above us were in full bloom, and their fragrance was the sweetest perfume in Paris.

We had just picked up our grades at Science Po (Institute of Political Studies, University of Paris), where we had labored for the past year. It was wonderful. Our names were on the list. We had passed. The week before I had won the 1,500 meters in the French University Championships, certainly not to be compared with the NCAA meet at home, but it was fun. And there was Michelle. She was from the south of France, with long brown hair that she brushed back over the top of her head and a soft lilting way of speaking that was so captivating. Her cousin had introduced us; he was a classmate, a Corsican, a political activist whose family ran casinos on the Riviera. She could play Chopin beautifully on the piano and knew German and was studying Arabic, though her English was awful. Her goal was to make films, of course—passionate, political, beautiful films, mirrors of herself. I learned with her what love is; and as Jaap and I sat in the sun around the small, round, marble tabletop drinking wine and feeling the breeze and watching the Left Bank world walk by, we knew what it is to be young in Paris in the spring,

carefree and happy and with the whole world in front of you. How we shared our deepest thoughts as good friends can, on love and adventure, what we'd do when we grew up. Jaap secretly wanted to become a painter—his work was good—but he would return to Amsterdam and study law. I would go to Scandinavia and compete on the European track circuit and then I was going East. I did know how far, but Afghanistan was for some reason foremost in my mind. It seemed the wildest, most faraway place on earth.

I had dreamt of going there on my first trip East. In 1968, after college, I left America and traveled through Europe and discovered Paris still in its May Day revolutionary fervor. I hitched across North Africa and through Algeria looking for Eldridge Cleaver in Algiers and found the Sahara Desert, the Mediterranean, a military dictatorship, and Ben Bella in jail. I went to Istanbul and to the Pudding Shop, which years later became the rendevous point for the young man in *Midnight Express*. Then, it was known among residents for its rice pudding coated with nutmeg and the goat's milk that made your hair stand on end. Among travelers in the '60s, it was the last stop in Europe, an underground caravansary on the great route East: part '60s North Beach/Telegraph Avenue coffee house, part rue St. Jacques café, without the posters, alcohol, music. There were wood tables and chairs and benches; in the back a small glass-encased cooler for the puddings and yogurt; behind that, a wood counter where coffee and tea were brewed; on the right-hand wall when you walked in, a bulletin board with messages and mail with addresses such as "Steve Isbell, Pudding Shop, Istanbul, Turkey"; in the air there was the smell of hashish and sweat and clothes not washed in weeks and the sound of a guitar and someone singing in French, Italian, or accented English. There were Turks with dark eyes, mustaches, and a week's ugly growth and small groups of Europeans, Americans, Australians, or a Japanese sitting alone; and they stared out from deep, hollow sockets that looked right at you, saw you, and did not even know you were there.

There were community journals too: grimy spiral note-books or pieces of paper stuck between wide strips of leather where all the wanderers, adventurers, draft dodgers, drug runners and addicts, small-time wheeler-dealers—misfits who, because they were white, got away with more in the East—and seekers of Nirvana could write a tale. These were the logbooks of the new Eastern traveler—as if we were the first to go out there—and a guide for those on the way. I remember reading them for the first time and wondering just how true those stories were: the blood-seller's tales of putting your arm through the hole in the wall and never seeing the needle that went in, the Chicken Street scene in Kabul, the Khyber Pass at night, the freak colony in Goa; sordid accounts scrawled in more than one language of Turkish prisons, bandits, bad needles, Afghan border guards.

From the window of the Pudding Shop, the Blue Mosque was visible 200 yards away, but it seemed more distant and forbidding against the cold, gray, winter sky, its six minarets reaching like fingers up through the snow to God. When the muezzin's call to prayer penetrated our world, it always quieted me and sent shivers down my spine.

At Erzurum, the last major city before Iran, I decided to return to the U.S. to go into the army. The draft notice had long been there. I did not want to fight in Vietnam, but I now saw America differently. It had given me much. I had an obligation, a responsibility. I returned, but I knew I would be back. With Jaap five years later, I knew it was time.

September, four months later, Kody, my younger brother, and I sat in the dirt in a decrepit junkyard in Mashhad, Iran. Two days before, while we were driving at night near a point which would become famous as Desert One six years later in the aborted hostage rescue, a white horse had bolted from the side of the road, jumped, and landed on the hood of our car. I swerved too late. The car was destroyed in front—the engine was in the back—and the horse was dead, and a crowd had appeared out of nowhere. One man had a rifle which he waved frantically in the

air. We had killed his most valuable possession. This was Per-
sia—only Tehran with its skyscrapers was Iran—the land of the
Koran—an eye for an eye. The Trans-Asian highway on which
we traveled was the hippy trail, a two-lane macadam road which
ran from Istanbul to India, perhaps all the way to Vietnam. No
one knew for sure. Everything on the road was rumors anyway.

The owner of the junkyard took one look at us and at the
car; he knew we could not leave the country unless the VW was
in the same condition as when it entered and charged us a for-
tune. We paid the thief $800 and, with $50 in our pockets, drove
from the junkyard to the border station and, an hour before
sundown, across a bumpy dirt road into Afghanistan.

A solitary guard stood in the blazing sun next to the single
wooden pole which ran across the road, a barricade against the
outside world. His brown round face and dull eyes were without
expression, his thick, baggy, wool uniform too large, his boots
untied, his single-shot rifle with a long shining bayonet firmly
beside him. He surveyed us, our newly reconstructed vehicle,
and, against his better wishes, raised the pole and let us pass. We
drove to the back of a single-story, cinder-block building which
had not been touched, it seemed, in fifty years. A man sat be-
hind an old wooden table. On it were a glass of tea, a stack of
dirty papers, a rubber stamp, and his head. Flies hovered above.
We cleared our throats. He looked up, bored, disgusted that we
should bother him. He took our passports, thumbed through
them quickly, upside down, found the pictures, looked at us
closely, handed them back.

"Passports," he said and nodded his head towards the build-
ing fifty yards away. "This is customs. You must go to passport
control first."

We trekked across the dusty compound and met another
man with epaulets on his shoulders, half a glass of sugar in his
tea, and his head resting on his arms on a wooden table. We
presented our passports.

"Brothers?" he said, thumbing through our passports.

"Good. We must be certain you do not carry forbidden items into Afghanistan: drugs, guns, tape recorders, cameras. You must go to customs."

"But, he said come here first."

"He was wrong. Do as I say. Go."

We walked back across to the first building where a VW van belonging to a group of Dutch and an Opel sedan belonging to a young German couple were being ransacked by customs agents. Door panels and floorboards came off, their packs were spread out on the ground.

The officer in charge looked up. "Yes?"

"The other man told us we must first get clearance from you before we can have our passports stamped."

"He is wrong. You must have stamp before we check your car. He knows that. Tell him I told you."

"We did."

"I can do nothing without stamp. Go."

"Wait a minute." But he was on his way out to supervise the ransacking.

Halfway over to the passport office, the officer in charge pulled his head inside and slammed the door. We banged and banged, and finally he answered.

"Closed. What do you want?"

"We were just here. You said go to the customs man first. We did and he said come to you."

"He is wrong. He lies."

"Fine, but how do we get into your country?"

"I don't know. Today is too late. Come back tomorrow."

We tried customs once again.

"The passport man said you were mistaken. First you must clear us, then we go to him."

"He lies."

"He said the same about you." We then realized the sun was about to set. The border would close, and the men would bow in prayer on the ground southwest toward Mecca, and we would

sleep here tonight. We had been running back and forth for an hour.

"This is crazy," I said to the man.

The customs man smiled. "This is Afghanistan."

We sat on the floor in a room with the Germans and Dutch and shared rice and tea an old man brought and fell asleep to the pungent odor of hashish, the sounds of voices talking quietly and wind blowing across the wasteland that stretched forever around us.

The next day customs did not touch the car, and we drove to Herat. The main street was filled with small shops which sold sheepskin coats and carpets and trinkets for the buses which came from London and for the young hashish eaters going East and West. Standing in line at a bank, I saw an old man in a ragged blanket and brown leather sandals with a wad of Afghan notes two inches thick and an envelope with the words "Manufacturers Hanover Trust, New York" printed on the front.

We slept in a clean adobe hotel where we lowered our heads to enter. Behind us a clay brick fort overlooked the city. A dirt alley ran between the fort and the hotel, and in one corner of the alley was a thick black pipe with a faucet attached where mothers and children gathered to get water with aluminum pails and earthen jugs. The kids never splashed the water, and they laughed and mugged when you took their picture and fumbled with their language, like kids everywhere with not a care in the world. But they never stuck out their hands—unlike children in Cairo or Tangiers or Istanbul, who murmured "Baksheesh, baksheesh" with looks that tore my heart, as their parents had told them to do. They were poor, and to them we were rich, but they would never beg. They might charge you far too much in a bazaar, but they would never beg. Never. Now the children do not laugh. They have seen their older brothers and fathers return wounded or dead on rope litters, and they have had to run to hide with their mothers when the helicopters came roaring over-

head dropping the bombs that crumbled their homes and killed their animals and scorched the ground where the crops grew. Those laughing kids by the water pipe in Herat. The boys are teenagers now who fight and die; the girls are married and have children and live in refugee camps while their husbands fight in the mountains or run guns across the border or collaborate with the Communists or, having seen too much of the poverty around them and hoping for something better, become Communists.

We drove southeast on the two-lane cement highway, built by the Soviet Union, to Kandahar, the gentle oasis founded by Alexander the Great in the desert.

The air was warm and soft, and we slept outside on the grass behind a house that was the next way station for travelers to the East. We ate watermelons and oranges and raisins and delicious apple tarts that you could buy from a small bakery that had a screen door that did not keep the flies out. But we were in a rush to reach Kabul, the capital. With our money almost gone, I had found a phone in Mashhad and telephoned a friend in New York asking him to send money to any bank that he could in Kabul. We drove the other half of the single paved road that ran across Afghanistan, now of asphalt, more finely engineered and smoother and built by the United States to complement the Soviet version to which it was connected at Kandahar.

The deeper we drove into Afghanistan, the more I began to sense something magnetic and timeless about this silent land. Far off the road were pitched the black tents of the nomads. Camels and sheep grazed nearby. There were no telephone or electric wires. The sky was wide and bright blue and clean. For a while, the road followed a series of large holes, wells dug by Alexander's army as it made its way across Asia. I thought that kings and armies could come and go, but this ancient, eroded, windswept land would outlast them all. A coup in Kabul meant nothing out here, nor did travelers from the West or men landing on

the moon. Man, here, was like the poet's snow which lit upon the desert's dusty face and was but an hour or two, then gone.

Kabul had soldiers in the streets and open sewer ditches; chocolate ice cream, yogurt, apple pies, hamburgers, and hashish for sale on Chicken Street; in the bazaar, Levi's jeans, Indian merchants, fortune-tellers, a money market where you sat on a carpet and changed any currency in the world; businessmen with marble houses and fountains in the garden, taxi drivers who took hashish in payment, an American Embassy official who rode a Harley-Davidson around town with a Colt .45 strapped to his waist; a restaurant in a tent where a pilaf dinner cost twenty-five cents and hot fresh bread a penny; police patrols who rode horseback through the city at night with dogs at their sides and rifles on their backs.

The days passed. The money never came. We moved to the top floor of the Atlantic Hotel with Peter, a German who lived on apple pies and hashish and read Vonnegut and who, a year before, had married, for six months, a tribal chief's daughter in Ghana; two Turkish drug runners with shaved heads who had just been released from prison and were waiting for visas and money from their embassy to leave; and a Japanese who had arrived six months ago on his way West.

I sold a pair of jeans for $15 to a German tourist. It was fun. Afghanistan was an adventure, the Wild West in Asia, a land, we used to say, roaring into the Middle Ages. From the top floor of the Atlantic we moved to the roof. We bought peanuts, raisins, fruit and, with a jar of Skippy creamy peanut butter we had found standing alone in a store in Tehran, we had bread. But then Kody's skin turned yellow; his strength weakened. We needed money to send him home. We would have to sell the car. But we couldn't. No longer could one drive a car across Asia, sell it for twice what it cost in Europe, and fly back as travelers had done for years. On July 17, 1973, former prime minister Sardar Mohammed Daud Khan overthrew his cousin and brother-in-law, King Mohammed Zahir, while the monarch was in Rome

for medical treatment. Feudal Afghanistan became a republic, and things would no longer be the same. We would try Pakistan. At the border we found that Kody's visa, written in Pashto and acquired in Istanbul, was good for only a week. We had been in Afghanistan a month. So, after I finally convinced my mother to permit my nineteen-year-old brother to take a year off from school to go across Asia, here he was with a case of jaundice, waving good-bye at the border station, going to jail. I took the car through the Khyber Pass to Peshawar, Pakistan. Afghanistan and Pakistan controlled the pass only during the day, and that control ended ten yards beyond each side of the two-lane macadam road. At sundown the Pathans, great-grandchildren of those who slaughtered the British upon their retreat from Kabul in 1842, take over. Those barren, craggy hills are theirs. Two days later I sold the car in that no-man's-land for $300 to an American traveler—with the help of an Australian outlaw who ran Scotch between London and Delhi and a blond American schoolteacher who would take me to the Koochis—got Kody out of the prison yard, and put him on a bus full of Australians going West.

Anna lived in a whitewashed walled compound in Kabul with a servant and a guard and roamed through the bazaars and countryside with a wonderful wide American smile. She would take me to meet a tribe of Koochis whose caravan had come down from the Soviet Union and would be at camp for a few weeks before continuing south through the Khyber Pass to warm winter grazing lands in Pakistan.

She drove her '68 Chevy station wagon east from Kabul on the road to Jalalabad, then turned and headed north on a dirt track until we reached a maze of black tents. A hundred yards away she stopped the car. The Koochi dogs—ugly, dangerous creatures—growled, their fangs showing, their saliva dropping. A man emerged from a tent and recognized her. The dogs backed off; the hair on their backs lay down. A woman sat on the

ground flattening dough on a hot black iron plate. Embers glowed beneath. She looked up at us, smiled at Anna before letting her eyes fall. Her nose was pierced on one side. Her long black hair was braided, and her wrists were covered with bracelets. She wore a long black and red cotton dress richly embroidered in purple on the front; a black shawl that fell down across her back was over her head. She was not veiled. A small group of children crowded around, somber until we smiled, and then they laughed and pushed forward. We sat on quilted blankets. Kahmir, who had bid us come, sat on my left. His thin dark face was clean-shaven. He did not have a mustache. Sedentary Afghans, even nominal Moslems, wore at least a mustache. The Prophet Mohammed had one. Kahmir spoke quietly to his wife, who had been breastfeeding. She put the baby down and brought out glasses for tea. Kahmir poured. We were eight: Kahmir, his wife, the baby, a tow-haired boy about five, his sister about eight, the striking young woman making bread, Anna, and me. The dirt floor was swept clean. The teakettle was aluminum. At the rear of the tent, blankets and quilts were stacked neatly on top of one another. Long wooden stakes held their home up.

I was mesmerized by the soft, graceful manner of the women. I thought that they should be as hard and tough as the life they led. Kahmir's wife, like the young woman I called Roxane, after Alexander's wife, was not veiled and looked directly at us. They moved like cats in their long red and black and purple dresses and bare feet; Roxane's movements as she made bread were feminine and supple. Through sign language and minimal Pashto we explained that I wanted to travel with them. Kahmir spoke quietly with his wife.

It was November. They didn't know when they would leave, though it would be soon. I asked when soon was, a ridiculous question. Kahmir wore a watch, but it was a status symbol, not a guide. He could not read it, nor would it have mattered if he could. Time does not matter in Afghanistan. One does not fight against it. There is enough. We drank more tea. The sun

moved across the sky. Roxane went to fetch water. Kahmir's wife went to another tent with the baby. The little girl kept the embers glowing. The boy had gone off at his father's bidding to help watch a small flock of sheep. Kahmir did not seem to want to know where I had come from. He did not seem curious. We were there. That was sufficient. That of itself was acceptance. Out in the sun, dogs slept. Low voices came from a nearby tent. A few camels wandered from scrub brush to scrub brush, arrogant creatures they looked. Anna's '68 blue and white Chevy sat a hundred feet away, like us, an intruder from the twentieth century.

A week later I took an Aeroflot flight from Kabul to Tashkent in the Soviet Union. As the plane's propellers droned high over the Hindu Kush, the stewardess passed out hard candy and cups of hot tea. I thought of Kahmir and his wife and Roxane who had come across these massive barren peaks weeks before. There is a poem: "For lust of knowing what is not to be known, we make the golden journey to Samarkand."

There was a group of hearty, chain-smoking Russians on board. My hair was by now long, and I wore a wolf-skin coat that I purchased in the bazaar in Kabul for twelve dollars. We talked about Russia and America and music and sports. When I told them that I had been to the Soviet Union before as a track athlete, they called for champagne. But there was none. They said they were engineers. The golden road north to Samarkand was history. The Chinese had sealed off their border with Afghanistan in the Wakhan corridor. There was now a paved highway from Tashkent to Samarkand down to Kabul and from Kabul all the way south to Kandahar. An airplane took only hours but made much noise, and only the tops of mountains were seen; one did not taste the water from the streams or feel the hot sun and the wind or smell the smoke of camel-dung fires, and one could not stand quietly and feel the silence and the gentle presence of a man like Kahmir and his family or sense

someone as alluring as Roxane out in the center of ancient, dry, and magnetic Afghanistan.

Tashkent came into view, and we saw the smokestacks of prosperity and, on the ground, felt the industrialization of Soviet Asia. And the muezzin did not call the faithful to prayer.

Moscow was cold, and there was snow in the streets, and at night a man caught a girl's eye, watching her return the look for a fleeting second and then walk on. In Asia a girl never looked. She did of course, but he never saw her.

I flew to Paris, and then I returned to the States. I worked in the Senate for Henry Jackson, returning to Paris when I could to see Michelle. I continued to run track, wrote a book on running in Europe with a friend, Aden Hayes, worked as a commentator on public television in New York, traveled to the Middle East and up the Nile.

In early 1979 I began to talk with the Chinese about my lifelong desire to mount an expedition to retrace by camel caravan the Silk Road and route of Marco Polo across China.

In August Senator Jackson went to China and presented a copy of my proposal to senior officials in the Foreign Ministry.

Christmas, 1979, I sat in my parents' kitchen in Vancouver, Washington, and watched the televised pictures of Soviet troops in Kabul; and I thought of Kahmir and Roxane and the Atlantic Hotel and Kandahar and the hot, dry, windswept plains of Afghanistan. Right then I knew I would return. I had mixed emotions about the Russians' presence: Maybe Communism would help that feudal land; but then everywhere I had seen Communism in practice it had meant totalitarianism. For the moment I was selfish. I would try to make the Olympic team, run one more time on the European circuit, and push the Silk Road/Marco Polo expedition. I had enough money to live on.

* * *

One may ask, why China? Two reasons: adventure and family. My father had been stationed there in the Marine Corps, and an aunt and uncle had lived there fourteen years. My uncle was operations manager for the China National Aviation Corporation, the first man to fly over the Himalayas, the first man shot down by the Japanese in the Sino-Japanese War. His pilot's license was signed by Orville Wright. His stories of Clare Boothe Luce, Ernest Hemingway, General Chennault, and General and Mme. Chiang Kai-shek kept me entertained for hours.

But the expedition moved slowly. The Chinese were reticent about letting foreigners travel through the western reaches of their country; few, if any, Westerners had been there in decades. There were Soviet troops on their northern border; probably missile and underground atomic testing sites, also. It may be one of the last recently unexplored regions of the world. But was I CIA?

In September, a year later, I would receive tentative permission to travel as far west as Urumchi, but no farther. My goal, however, was to reach the ancient mythical stone tower at the edge of what is now Afghanistan. But by then, Afghanistan itself was more important.

The U.S. Olympic Committee boycotted the Moscow Olympics because of the Soviet invasion of Afghanistan. As it turned out, I did not qualify for the U.S. Trials. I ran the European circuit, and, in September, I ran my last race of that season, a mile at Crystal Palace in London. A Spaniard jumped the gun, and we were called back. We jogged around like skittish horses, nervous before the race. Again we were called to the start. We toed the line, and Steve Ovett, the world record holder, raised his fist and shouted, "All right, men. Let's go!" It was great theater and a nice psych job, but it was also a call to battle, and I knew then that it was time for me to go. He had fire in his eyes, and I didn't.

My athletic days were over, the time which had given me purpose and made my spine tingle. I would now need something else.

I stayed in London for a few days with David Green, a friend I knew from Washington. While at his house, I read Mary Renault's book, *The Nature of Alexander*, about Alexander the Great. There was a quote by Alexander in the preface which struck me: "It is a wonderful thing to live with courage and to die leaving an everlasting flame." I certainly did not want to die, and men are not gods, but I wondered about courage. How much did I have?

I did know that I needed fire, something to make the juices flow. Because for an American boy who plays sports, once those intense formative years are over, the rest of life is not the same. When again will he feel the thrill as he did when he carried the ball across the line and 100,000 people roared? Much more than that, the pursuit of money or power or fame does not seem to mean as much to a man—to most men, anyway—as what he has gained from spending the better part of his youth in athletics, trying again and again and again, pushing himself to his limits, asserting himself beyond his doubts, and in his own solitary way, succeeding. Friends from these days, like soldiers together in combat, are special for the rest of his life.

I needed something with which to convince the Chinese that I was someone of substance, and I needed to break from my athletic past. I needed a new goal. Who was I to the Chinese but yet another struggling writer/adventurer from the West trying to use China? I had hoped that having friends in Washington, an athletic background, and family ties in China would make a difference. It didn't.

I remember a story my father told me when I was ten.

It was a cold and misty November afternoon. He was in a small village north of the Great Wall on the southern edge of inner Mongolia. All of a sudden, women grabbed their children

and ran inside; shutters closed; the street was deserted. Then, through the mist, from off the Gobi Desert, came a Mongol camel caravan. The men had thick black beards and wore heavy fur coats and wide fur hats. They carried rifles and wore bandoliers across their chests like Mexican riders with Pancho Villa. The Bactrian camels had long, thick brown hair, and the air stood white when it blew from their nostrils.

"They were," he said, "the fiercest-looking men I have ever seen in my life."

I began to read about Genghis Khan, Tamerlane, and as boys do, became fascinated by the mystery, the adventure, the glamour of Asia. The cruelty, the hard, hard existence, the death upon death were things that never entered my mind. They never do for a boy. They never do until he really knows them. But boys and men will always dream. For is there not a part of every boy that does not dream of racing on a camel like Lawrence in Arabia with his sword glistening in the sun, his men behind him on the wide open desert? Or, of being King Arthur or D'Artagnan or sitting in the saddle on a high plateau at sundown in the West? These are dreams with which young boys are always afflicted.

But there were other reasons, too. I wanted to face what I thought was the ultimate test of courage. I wanted an accomplishment. I knew, as I believe all men know, that I had to see what I was made of. There comes a point in a man's life when he has got to be able finally to look any man straight in the eye and say, "I have done what I had to do in life," or forever be an unhappy man.

I was curious about the Afghans, these proud, courageous men who fought against overwhelming odds for what they saw as their freedom and who believed, without hesitation, in God.

So what did it all come down to? I wanted to go, yes. I was curious; I wanted to test myself; I wanted to convince the Chinese—and myself—that I was someone of substance. I was searching for an ideal; I wanted to live my dreams. Friends had

got their Olympic medals; I hadn't. I wanted an accomplishment.

The more I thought and learned about it, the more I wanted to go. Those strong, proud people I remembered were holding out against the Red Army. They had a commitment to freedom, a purpose. Their world was black and white. I had to try to do something.

It all seemed to fit together. Afghanistan.

I read an article on the Op-Ed page of the *New York Times* by Rosanne Klass, director of the Afghanistan Information Center at Freedom House in New York, and I went to see her. At first she was cautious. I made an appointment to see her again, and as we talked, I was impressed by how much she knew about Afghanistan. A week later she gave me some contacts. One was Mahmoud, a tribal chief and military commander in eastern Afghanistan. His ankles had been destroyed by helicopter machine-gun fire, and he was finally brought to Washington for medical treatment and to plead with the U.S. Government for help for Afghanistan. I drove to the house outside of Washington, where he was staying with a former colonel in the Afghan Air Force who was once in the Ministry of Defense in Afghanistan. Mahmoud was about five-ten with rich black hair and strong brown eyes, and he looked at me for a long time before he said anything. Finally he seemed to make a decision that he could speak. He told me that he had lain in a cave for a month, his legs wrapped in leaves and chicken skin, before he could be taken to Pakistan on horseback for treatment. That was one year ago. His legs were still not healed. We talked for two days, and as I got to know him, I knew that my decision to go was right.

He told me stories of his tribe fighting with only old rifles against a modern mechanized army for "our freedom." *Freedom*, a word that my generation did not really know: we had never gone without it; we never had to fight for it; we had so much of

it, we did not know what it meant. After North Africa, the
Middle East, Asia, the years in Europe, I developed a fondness
for America—an immigrant's idealism—that cannot come from
living here. Freedom we took for granted; the Afghans couldn't.
More importantly, Mahmoud said, they had God, which gave
them their strength. They would suffer but would ultimately
win. They had inner freedom.

In much of Western Europe and America, God is no longer
a force in men's lives. I had all my life wrestled with the concept
of God. I had been raised in a family where God and the Bible
were pre-eminent. I believed in God as a child; I wondered, I
questioned, I doubted as an adult. Here was a man who spoke
fervently of his cause, who could laugh about living in a cave for
a month with chicken skin and leaves to dress his wounds, who
was not afraid to say he believed in God. He did not seem afraid
of anything. His world was right and ordered. I envied him. His
passion reminded me of that which I once had, in 1968: the
Chicago Convention, Robert Kennedy's death, student uprisings
in Paris, the Soviet invasion of Czechoslovakia; in 1970, '72, '73
in Paris: the hours spent in cafés talking, arguing, laughing,
dreaming of revolution, of adventure, of art and literature, great
deeds we would accomplish, of my hero at that time, André
Malraux. Paris very late at night. I remember going with a class-
mate to see the East Berlin Opera Company perform
Beethoven's *Fidelio*. "The Prisoners' Chorus," the rising, haunt-
ing, melodic cry for freedom, sent shudders down our spines;
and we, as youth, were committed to making the world right.
This passion. Where had it gone?

I visited the Chinese embassy in Washington and said that I
was going to Afghanistan. Would it help the Silk Road expedi-
tion? It would not hurt, but neither would it help, I was told. It
didn't matter. I did not ask about Chinese involvement in the
war. The official I had talked with for many hours over the past

few months walked me to the door. He could not commit himself, of course, but he did. He smiled, shook my hand. "Good luck," he said.

I talked to friends, to everyone I knew who might be able to give me advice. With a friend from my days in the Senate, Arthur Hill, who had his own news service now, I began to contact newspapers and magazines in a search for a way to pay for the trip.

A friend in the Joint Chiefs of Staff's Office in the Pentagon told me about the chemical and biological warfare reports he had read.

"Don't be stupid," he said. "There's a war going on over there. Do you know what war is?"

"No, not really, but . . ."

"I do," he said. "Don't go."

Another friend called me "crazy brave." "Like Gordon Liddy," he said.

I talked with more refugees and with Jim Sheldon, an Australian-American photographer who had been there and made his name by going.

"There were many times, mate, when I thought I was a dead man. A man came after me with a knife on my way out. The group I was traveling with was attacked by another tribe. I lay under a bush while a helicopter hovered over me. I had to pay two men fifty American dollars to take me directly over the mountains where there was no trail, because I had been told in a village that two spies from Kabul were after me."

I spoke with friends and officers in the State Department. I would be on my own. The United States government could do nothing if I were captured. I must not take my passport in. They could not encourage me to go or brief me or prevent me from going. They could only offer advice.

There was one man I had yet to see, my former boss, Senator Henry M. Jackson of Washington State. I had worked for him from 1974 through 1977. I grew up in Washington State,

and he was my senator. As a student and as a G.I., I had opposed Jackson because he was, to me, a Vietnam hawk. But then I worked for him in domestic affairs. He was a decent man. You can tell much about the character of a public figure by how he treats his family and those around him. Jackson had helped me. On the trip to China, he had presented my expedition proposal to senior officials of the Foreign Ministry, thus circumventing much of the largest and oldest bureaucracy in the world. I went to Dr. Dorothy Fosdick, his trusted foreign policy assistant, and told her my plans. Together we went to see Scoop. I told him where I stood with the Chinese and my plans to go to Afghanistan and, briefly, why I felt I had to go. I watched him carefully as I talked. He was almost seventy yet looked ten years younger. He listened to me carefully. I saw something in his eyes, a split-second flash that told me deep down what he really thought.

"I don't think you should do it. I worry about these reports of chemical warfare. Pursue the Chinese project. Don't go to Afghanistan."

It was as if I had been hit and had all the wind knocked out of me. Jackson walked me to the door.

"I'm like your father, Jere," he said. "Come back anytime. I'll be here."

I walked down the massive hall of the old Senate Office Building and remembered that split-second look in his eyes. It was more like a twinkle. I stopped to see Julie Cancio, one of his longtime assistants.

"He told you not to go, didn't he?" she said. "I knew he would. He's just being protective. You'll go. You've got this wild streak in you somehow. You've got to get it out of your system."

There is a scene in Peter Brook's film, *Meetings with Remarkable Men*, the story of the early life of G. I. Gurdjieff. Young Gurdjieff and his friend, the Russian prince, Yuri Lubovedsky, sit before a wise man somewhere in the wilds of Asia, perhaps Afghanistan:

"Why have you come?" the old man asked.

"We are seeking truth, father, and we have come to you for guidance," the prince said.

The old man replied, in disgust, "You can't find truth. You know what it is; you always do. Deep down you know. Instinctively."

I knew. Julie was right.

I returned to Arthur Hill's office. There was a call from Jim Hougland at the *Washington Post*. He had received my letter. Could I see him? I went immediately. We talked for half an hour, and I liked him immensely. He wanted to help, but I had never worked on a newspaper; he didn't think the paper could give me any money. Nevertheless, I should talk to other people at the paper.

In the meantime, I talked to the foreign editors of other newspapers and to magazine editors, and their response was always the same: no experience, no money. Let's wait until you return.

Finally, I wrote the *New York Times*. Why hesitate anymore about anything? I called repeatedly. Finally, I got through to Robert Semple, the foreign editor. Yes, he had received my letter and would see me.

I called the *Post* back and I finally got in to see Dick Harwood, the deputy managing editor. Harwood said little. He had a deep tan and wore two elephant bracelets on his left wrist. He had just been to Angola with the guerrilla leader Jonas Savimbi and had written a series of dispatches for the paper.

"Have you ever been in combat?"

"No."

He nodded, it seemed, knowingly. "Don't take a weapon. If it gets really hot, there'll be one lying around."

He gave me copies of his dispatches and with them an impression of toughness and no nonsense. He said he could not give me any money. He gave me advice. I was glad to have it. Absolutely, I could see him when I got back. But the Afghanistan story was already getting old, although no one had interviewed captured Russians yet. A Dutch journalist, Aernout van

Lynden, spent three months there. His stories had appeared in the *Post*. Van Lynden was just now, months later, recovering from pneumonia and acute amoebic dysentery.

I went to see Karen DeYoung, the foreign editor. "Why do you want to go out there?" she wondered out loud to me. She was polite, yet distant, skeptical. I explained some of my reasons.

"How do I know you don't work for the CIA?" DeYoung asked.

It was a legitimate question. But I was taken aback. I did not work for the CIA, but the fear would persist in people's eyes. Journalism would be the right cover to make contact and convince the guerrillas to take someone in; perhaps that was what she thought. I didn't know. I was naive, and she was an experienced journalist. I had read many of her stories.

As I was about to leave, she gave me her card and wrote a series of telex numbers on it. No money, no guarantee; but if I went, when I got out, I could send her my stories from Pakistan, and she would read them. It was a chance, the only one I had.

I returned to New York and had dinner with a young woman I was becoming more and more attached to. That night she told me a dream she had had.

"I was going with some friends to a party. You were supposed to go with me but said you would meet me there. I got to the party; I saw someone dancing and playing a violin on the roof. It was you. I called out hard but you didn't notice me. I kept shouting, and then you fell. We ran over, but it was too late. You're going to die in Afghanistan. Aren't you?"

"This," I thought, "is getting ridiculous."

The next morning I walked to the third floor of the *New York Times* on West 43rd Street. I met Semple and Craig Whitney, then the assistant foreign editor. Semple shook my hand and smiled. "You look awful."

"Yeah. My girl friend told me last night she dreamed I would die in Afghanistan."

"You better get a new girl friend."

"I know."

"Some sleep, too."

"Right."

Semple and Whitney were concerned that I had never worked for a paper. But they did not focus on that. They were interested in my background, my character. We talked a long time. I felt they were probing for a way to justify giving me a chance—and taking one.

They said they would think things over. I went back the next day and the next. No one else had come through yet. It was the *Times*, or I went alone with my fingers crossed that Arthur could come up with something while I was there.

Semple and I sat on the couch at the reception desk after the third day of talks.

"I meet a lot of charlatans in this business. How do I know that everything you've told me about yourself is true?"

"You mean, do I work for the CIA?"

"Right."

"Regardless of everything we've talked about, ultimately it comes down to one thing, doesn't it? Trust. You can call Jackson or any name I have given you. You can check on me. But that really doesn't matter. We've talked a lot about sports. Albert Camus once said in response to a question, 'As for ethics, all I know about them, I know from sports.' I've run track for twenty years. It has directed my life."

He looked at me. "I'm glad you said that. I'll let you know tomorrow."

I left, and I knew they were going to give me a chance.

The next day at three o'clock, I walked into the third floor newsroom and could feel the tension of approaching deadlines. Craig Whitney took me into a small office in the back and closed the door.

"Here is a check for $500 and a letter stating that the *Times* has first rights of refusal for any stories that you would submit from South Asia. It does not mention Afghanistan." As for the

$500, it was not much, but it was a symbol of trust.

"You can take this money and have the best night of your life in New York," Craig said, "or you can use it to help pay for your flight to Pakistan. And when you get there and look over the border into Afghanistan and decide not to go, that's all right. It's your money.

"Let me know what you decide, and if you go, I'll give you the number where you can reach Mike Kaufman, our man in New Delhi.

"And one more thing. I must tell you, Jere, that this is not without some risk involved."

We shook hands. He seemed to want to talk more, to give me some advice, to have me ask it. I told him I would return the money if I didn't go. He said to forget it, the money was mine. But it was not the money. He had appealed to my sense of honor. He had said, without saying it, that the *Times* was going to take a chance on me. That's all I needed.

I was going, regardless. But now I had a chance—a professional chance—to tell the world what I saw.

I deposited the check and called my father that night. I had told him my tentative plans before, and he had promised not to tell my mother. He was quiet. I explained everything. I would fly to Paris Friday night, spend two days there, then fly to Pakistan. I did not know that my mother was listening on the other line. He hadn't told her. I knew how she felt, but she only said quietly, "I'll pray for you, Jere."

I could see my father, in his late sixties now, standing at the kitchen counter in his work clothes, phone in hand, looking out over the Columbia River, his fine thin features, light gray hair, warm blue eyes; and I thought of the story so long ago about the Mongol camel caravan.

"I will pray for you. Your mother and I both will. If I were twenty years younger, I'd go with you."

My eyes welled up. I had a lump so big in my throat I

couldn't talk. He sensed it. He knew me. I was as emotional as he was. So he said, "You look like those guys, anyway." We all laughed. I said I'd send them a card.

My friend Aden Hayes and I went to see the English film, *Chariots of Fire.* I cried through much of it, partly from the tension of the trip, partly because of Eric Liddel. I had run the same race, the 440. Our religious heritage was identical. But where I had questioned, he had accepted and believed, and he had had the courage to stand up for what he believed in against the awesome weight of the British Empire. There it was again. Courage.

Back at my apartment, I wrote a letter to Senator Jackson. I do not remember my exact words. The letter was short. I said something that was as corny as it was true: "There comes a time, finally, when a man has got to do what he has got to do, even if it is against the advice of everyone. . . ." I ripped the paper out of the typewriter and felt a tremendous sense of exhilaration, of freedom.

The plane left in two hours. I was at an absolute emotional peak. I was absolutely certain of my convictions. I was doing the right thing, and nothing in the world would stop me.

I flew Air France standby, as flights were booked for a week. Better go out in style, I figured. The plane was jammed, the chicken rubbery.

Jean-Richard Finot, a close friend from my days of running track in Paris, met me at the airport.

We had breakfast in a café at the Trocadéro. I had once lived nearby. That night over dinner, I explained to him and his wife, Martine, the reasons for my trip. They were quiet for a while, but then we ate and laughed and talked about old times, and nothing more was said.

The next day I went to the *Times* office in Paris. There was a message from Craig Whitney authorizing me to call New York. I called. He gave me Mike Kaufman's number at the Holiday Inn in Islamabad, Pakistan, and wished me good luck.

But the Holiday Inn? I was going off to Afghanistan, and my first stop in Asia would be the Holiday Inn? Oh, well . . . I called. Finally, I got through. Mike, notoriously bad with names, called me Eric, and said he'd book a room.

Minutes later, word came on the wire that Anwar Sadat had been shot. I left the *Times* office and walked over to NBC on the Champs-Élysées. The office was in a state of pandemonium. They were trying to charter a plane to Egypt.

I had thought on the flight to Paris that, as there was no guarantee with the *Times*, if I could sell a few minutes of footage, it would definitely pay for the trip. American Express and MasterCard would pay until then.

At the NBC office, I met Martin Fletcher, an Englishman, who happened to be an old friend of Kaufman's from Africa. "Great fellow," he said. "Give him my best. So you want a camera to go to Afghanistan, do you? Plan to write, take stills and video? I would say that's quite impossible. But so what?" He grinned openly. He was terrific.

We talked on the phone with Tom Wolzein, producer for *NBC Magazine* in New York. The next morning I would be given a camera and a car to the airport.

Near the Arc de Triomphe, I found the office of the Association for Information and Documentation on Afghanistan, which was also—for the public—a wholesale carpet dealer's office. The door was unmarked. I had been given directions.

I knocked and a young Frenchwoman with a bandanna in her hair opened the door slightly. I introduced myself.

"I am sorry. We must be careful. Not so long ago, a bomb was placed by the door."

Inside were rolls of Oriental prayer rugs stacked against the wall, metal desks, many piles of paper, typewriters, telephones, bottles of Coca-Cola and Vichy water, the smell of Gauloises cigarettes.

"Hi. Mike Barry. Welcome. Good to see you. Sit down. What can I get you? What do you want to know?"—in rapid-fire

staccato talk. An intense smiling young man with a high fore-
head and bright quick eyes, he stuck out his hand.

Barry had been a member of SDS at Princeton, and all his
life he had been fascinated with Afghanistan. He was American,
raised in Paris. His father was a journalist. He had married a
Frenchwoman and was now living here. He wanted to tell me as
much about the war as he could, and we had only a few hours.
He knew Afghanistan; he was getting his Ph.D. in Asian Stud-
ies. He was fluent in Pashto, Farsi, Urdu, and French. He had
written a lengthy piece on Soviet atrocities in Afghanistan for
Jean-Paul Sartre's and Simone de Beauvoir's monthly journal *Les
Temps Modernes*.

"One would think the left in France, in Europe, would
support the Soviet invasion: Afghanistan is a feudal nation;
Communism would bring roads, doctors, schools, take the bur-
den from women's backs. The American left is divided."

"First of all, you cannot compare the French left to the
American left. What is left in America is moderate in France.

"The French are fascinated by Afghans—strong, proud,
free, with their turbans, their wild magnetic country—they're
romantic figures to them. And they admire the Afghans because
they have stood and fought against the Russians. In Europe—in
Germany, Holland, Scandinavia, Italy—though the Communist
Party there attacked me for my piece in *Les Temps Modernes*—
Afghanistan is a powerful political issue. For Americans, Af-
ghanistan might as well be another planet. Europeans know
where Afghanistan is. They know what it is to be invaded.
Europe is political—films, art, literature, café talk. They live it
and breathe it."

"What about Afghanistan?"

"The *mujahidin* cannot defeat the Red Army. The Russians
can wait it out. This is no Vietnam. The Vietnamese had weap-
ons supplied by the Russians and the Chinese. The Afghans
have nothing. Reagan does nothing for them. Russia hopes the
resistance will wear itself out and that Pakistan will eventually

destabilize itself. And they know, too, the West will eventually forget Afghanistan, as they forgot Hungary, Czechoslovakia.

"On the other hand, the Russians have problems. They cannot get the Afghans to work for them. The Afghan resistance has been most efficient in destroying potential collaborators; the Russians cannot control the country through local sympathizers. In Afghanistan, collaborate and you die. In the end, bribery cannot work.

"The Russians will have to kill everyone. Genocide. Listen, Stalin pacified Soviet Central Asia—their autonomous republics of Turkmenistan, Uzbekistan, Tajikistan, Kirghizia, Kazakhstan—brutally. Millions were killed. Will they do this in Afghanistan? I'm afraid they will. Go and see for yourself. Then come back and tell me what you think."

If Barry's thoughts seem brutal, even simplistic, it is because I have compressed them.

Hamayaum Shah Assefy, former Afghan diplomat, now a "carpet dealer," was the man in charge, but he was not anxious to talk. The radio had just announced that Anwar Sadat was, in fact, dead.

"This is a very sad day for Afghanistan. Sadat was our friend, one of the few we have in the world. He gave us guns. Now he is dead. I am very sad."

Assefy was an urbane, sophisticated, world-weary man. His eyes were sad. His French was excellent. We drank café au lait in a *tabac* across the street. The table at which we sat had a glass top, and the ashes from his Gitanes Filtres scattered lightly on it. Behind him, two teenagers were deeply engrossed in a pinball game. Laborers in blue work shirts stood at the bar, polishing off espresso coffees with Calvados chasers. Hard rock blared from the jukebox. Assefy wore a double-breasted blue Yves St. Laurent blazer, tan pants, burgundy shoes, an Eastern man who looked very much at home in a Parisian café.

"I wish I could go with you," Assefy said.

"Come off it. You like this life. If you wanted to carry a rifle in the Hindu Kush, you would be there."

"Perhaps. Yes, I am at home here, but my heart, my soul, are in Afghanistan. We must all do what we can. I can do more for our cause here than I can with a gun. There are Afghans everywhere now—in Germany, France, America. But do you think, deep down in their hearts, they like it? No, of course not," he answered his own question.

"Afghans, the true Afghans, the heroes in our poetry, are strong men, fighters who are poets, warriors who are weak beside a beautiful woman. I am only here to serve the true Afghan. He may not exist; you may not meet anyone like that, but he exists in our dreams, and so he exists. With God on our side, we will win, or we will die standing straight."

Two hours later, I caught an Air France flight to Karachi. Again, standby. One more good meal before Asia.

The massive jet roared down the runway, lifted, broke through the clouds and thundered east. The pilot's confident voice mentioned in passing the cities, once weeks, even months of travel apart, over which we flew—Strasbourg, Munich, Belgrade, Sophia, Istanbul, Baghdad. Night came, and he was silent as we passed over Persia. The flight would end in Ho Chi Minh City, on the other side of the world. We ate cold salmon in lemon and green pepper, braised beef Bordelaise, mixed vegetables in butter, Paloise salad, cheese, pastry, Brazilian coffee; and Asia—vast, silent, hungry Asia—passed below.

Steve McCurry, the young photographer who won the Robert Capa Gold Medal Award (given by the Overseas Press Club) for his pictures from Afghanistan, was in India when the Soviets invaded Afghanistan in 1979. He took a jar of instant coffee along when he went in. It gave him a quick buzz, he said, mock energy, and the Afghans did not drink it, so he had it all to himself. I had a package of bouillon cubes which I bought in Paris. We had dried milk packets with our coffee on the flight,

and the stewardess gave me two dozen. Other passengers gave me theirs.

"Going on a trek in Asia, young man?" an elderly lady with a poodle in her purse asked me.

As night fell, I sank back into my seat and thought about what lay ahead. I remembered the poem:

> We travel not for trafficking alone,
> By hotter winds our fiery hearts are fanned,
> For lust of knowing what should not be known,
> We make the golden journey to Samarkand.

It was fitting, then.

I reread the first chapter of T. E. Lawrence's *Seven Pillars of Wisdom*.

> . . . we lived anyhow with one another in the naked desert, under the indifferent heaven. By day the hot sun fermented us . . . at night, we were stained by dew and shamed . . . by the innumerable silence of stars. We were a self-centered army without parade or gesture, devoted to freedom, the second of man's creeds.
>
> We had no shut places to be alone in . . . man in all things lived candidly with man.
>
> I was . . . unable to think their thoughts or subscribe to their beliefs. . . .
>
> If I could not assume their character, I could at least conceal my own and pass among them without evident friction, neither a discord nor a critic. Since I was their fellow, I will not be their apologist or advocate. Today, in my old garments, I could play the bystander, obedient to the sensibilities of our theater . . . but it is more honest to record . . . these ideas and actions . . . naturally.
>
> Of course, our words and pleasures were as suddenly sweeping as our troubles.

39

And this, carefully:

> Pray God that men reading this story will not, for love of the glamour of strangeness, go out to prostrate themselves and their talents in serving another race.
>
> A man who gives himself to be a possession of aliens leads a Yahoo life, having bartered his soul to a brute master. He is not of them. He may stand against them, persuade himself of a mission, batter and twist them into something which they, of their own accord, would not have been. Then he is exploiting his own environment to press them out of theirs.
>
> In any case, the effort for these years to live in the dress of Arabs, and to imitate their mental foundation, quitted me of my English self and let me look at the West and its conventions with new eyes.
>
> . . . Easily was a man made an infidel, but hardly might he be converted to another faith. I had dropped one form and not taken on the other . . . with the resultant feeling of intense loneliness in life . . . and a contempt, not for other men, but for all that they do. Such detachment came at times to a man exhausted by prolonged physical effort and isolation. His body plodded on mechanically, while his responsible mind left him, and from without looked down critically on him, wondering what that futile lumber did and why. Sometimes these selves would converse in the void; and then madness was very near, as I believe it would be near the man who could see things through the veils at once of two customs, two educations, two environments.

We arrived in Karachi shortly after midnight, descending from the 747 into the hot, sultry, grimy world of Asia. White,

heavy, well-dressed Westerners were suddenly uncertain now that they were no longer in the West. We walked to a waiting bus that was without windows and looked forty years old. Slim dark men stood about watching us.

The arrival hall was a small room with two black conveyer belts, a dozen shopping carts, and a hundred tired, sweating people fighting for the attention of three customs agents. On a wall was a blackboard with a list, in English, of what the traveler could and could not bring in and what to declare. The list was long. This was Pakistan, a new Moslem state carved from the British *raj* and set on its own in 1947. It was an experiment to create a pure Islamic state in the twentieth century. It has also been America's ally from the time of Eisenhower and John Foster Dulles. You were allowed only one camera; I had three.

"French, Italian, Arab?"

"American."

The customs agent wore white trousers and a white shirt with epaulets; and he had a nicely trimmed gray mustache, dark hair combed straight back, was slim, about fifty. He smiled.

"Anything to declare?"

"Three cameras."

"Why have you come to Pakistan?"

"I have a tourist visa."

He chalked my bags and waved me through. If Congress does not give these people the money they want and the F-16s to keep India at bay, it will not be so easy next time. But two American businessmen told me how customs insisted on taking apart, screw by screw, the most sophisticated high technology equipment, for which they had just received permission from the Commerce Department to sell abroad. They dismantled the most delicate mechanism right there, they said, on the floor.

I spent the rest of the night in an orange plastic chair in the domestic departure hall.

All flights north to Islamabad were booked for the next three days. Today began the three-day festival of Id-ul-Adha,

the Islamic holiday commemorating Abraham's devotion to God and to his son. I would have to try standby. What's new? I was two for two; go while you're hot. At six the next morning a crowd of dark, anxious faces pushed towards the counter. I waved my letter. The clerk heard me, saw my face. A white man in the Third World. It is the unfair privilege of being white, American, therefore rich, powerful, somehow better. A half-hour later I was on a flight to Islamabad and the Holiday Inn. Well, as Kaufman had said on the phone, it was the best place in town, and it had a telex machine.

British Prime Minister Margaret Thatcher was in Islamabad, having stopped off on her return voyage from a Commonwealth meeting in Melbourne to see President Mohammed Zia ul-Haq and to lend, by her presence at the Khyber Pass, Britain's support for the Afghans. The airport is in Rawalpindi, twenty miles away. Islamabad, like Bonn, Brasilia, and Washington, was created to be the seat of government.

Mrs. Thatcher's solid white British Airways plane stood gleaming in the sun on the tarmac. Soldiers with narrow faces and black berets, blue sweaters with epaulets, creased trousers, web belts, and clipped mustaches stood in groups or, at the direction of ribboned officers in khaki, moved potted plants, the red carpet, and the crowd back. The officers sported walking sticks, a tradition of their former conquerers. I rode to the hotel in the Holiday Inn's green and yellow van, thus avoiding the fifty taxi drivers who had descended on me, grabbing my bags, hoping for a fare. An Englishman with a rich mane of white hair and a blue pinstripe suit rode in the front.

"You must be in the foreign service, up from Karachi to see your leader."

Only an American would open up a conversation with a personal question.

"No, I'm a lawyer. Practice in Karachi. Got an invitation to dine with her Ladyship and the president."

The countryside rolled by. Adobe houses, water buffalo, dark slender people in pajama-clothes.

"I always liked this part of the country. It's like it was 2,000 years ago."

"How long have you lived here?"

"Thirty-five years. Came right after partition. Seemed like a good place for a young lawyer to start out. I've done quite well. Actually, I represent a few of your companies, in addition to some British ones, Bank of America, IBM, Pan Am."

"Do you ever go back to England?"

"Oh, yes, my wife and I go home every year. We've got a cottage in Devonshire."

"Home?"

"England is always home."

Islamabad has concrete government buildings, empty fields, unfinished structures. The streets are paved, clean, and run at right angles. There is little noise, little poverty, no soul. An Asian city is only beginning to grow around it.

Water shot up and fell gracefully in the fountain outside the hotel. The doorman, in painted slippers, a white turban, a black and gold vest, a figure from the colonial past, opened the modern glass door. Slight, anxious, polite young men stood behind the counter. Muzak poured softly through the foyer, the coffee shop, the empty disco, the carpet shops, the newsstand, the airline ticket office—a Western hotel manned by Asians to re-mind Westerners of home. The swimming pool, with clear tur-quoise water, was surrounded by white metal lounge chairs; tea was served in heavy silver teapots; biscuits, on fine china. Busi-nessmen from Europe, like small bleached whales, lay in the sun, discussing quietly their pending contracts. A woman in her late forties with short red-blond hair, long silver earrings, large Dior sunglasses, and a small blue bikini drank a gin and tonic while reading *Urdu Made Easy*.

I took a nap, went for a run, left a message for Kaufman,

then went for a swim. A white moon reflected on the water. The air was brisk, clear, and I kept imagining Afghanistan to the west.

Kaufman was tired. He had just returned by helicopter from Peshawar, where he had witnessed the prime minister of England addressing a sea of male Afghans.

"Can you imagine what those ragheads thought? 'What has happened to mighty Britain? They once tried to conquer us, and they easily controlled this measly country we're stuck in. No wonder England's a mess. Ruled by a woman. And these are the people who say they are going to help us?'

"The crazy photographers really wanted Thatcher to point a rifle up the Khyber Pass, like Brzezinski, but she wouldn't do it."

He had a deadline to meet and so worked at his Olivetti, two fingers and fast, while I read a newspaper.

We went downstairs to eat in an open-air restaurant. He introduced me to the other journalists who were there: Trevor Fishlock of the London *Times* and Mark Tully of the BBC—"the Walter Cronkite of Asia."

Tully was born in India and speaks most languages out here. Everyone in India knows him. "Ah, Mark Tully, the famous Mark Tully," Kaufman mimicked a South Asian pronouncing his name. "Everyone listens to the BBC out here. They believe it more than they believe their own governments and the press. It is gospel, absolutely the most powerful medium in Asia."

Mike and I hit it off immediately and talked as if we'd known one another for years. We came from different backgrounds, had led different lives, but we were together out here; we both wanted someone to talk to. He was open, no pretenses. What impressed me most was his desire to help. Here I was, given a shot by the *New York Times*, the newspaper for which he had worked for over twenty years, an institution he clearly loved and respected, to cover a war on his beat.

"You know, every morning I get up and ask myself, 'Well,

which of my 800,000,000 subjects and which of their concerns should I write about today?'" He gave me that mischievious grin of his. His territory ran from Burma to Iran. We talked for hours that night about his background and mine, about athletics, New York, and why I had come.

The next day, Friday, the Islamic day of rest, Mike rented a car, and we drove up to Murree, the old summer seat of the British colonial government. The air smelled of pine; small wood houses and shops overlooked a deep valley; north was Kashmir, the Karakoram Mountains, China; east, India, Pakistan's arch-enemy; west, Afghanistan. As we walked up from the Murree hotel to a restaurant, I asked Mike why he had not gone into Afghanistan. He replied, "I've been in. I interviewed Hafizullah Amin [former prime minister, now dead], and after that they would no longer issue me a visa. I want to go in, but I do not want, and am probably incapable of, the walking and climbing and starving. There is no way I can propel my scarred and overweight body over those mountains." At lunch he began to talk about what it was like to be a foreign correspondent. He'd been the *Times'* man in Africa for four years and its man in South Asia, based in New Delhi, for the past two. In Africa he had covered wars in Angola, Rhodesia, Zaire, Ethiopia, Somalia, and, in South Africa, had covered the riots at Soweto. In the U.S., he had covered the Attica prison uprising. "I'm the *Times* riot correspondent," he said, smiling. "They sent me to England once to cover one.

"Actually, my job consists of lounging around swimming pools at overpriced hotels waiting to interview a head of state."

That night we went with a group of journalists traveling with Margaret Thatcher to the American Club, a makeshift restaurant/bar/movie house/pool room in the ambassador's old residence. It was the only place to go now, since the embassy had burned down.

We had an American dinner: pan-fried chicken, mashed potatoes, green beans, white bread, cherry pie and ice cream for

dessert. We drank California red wine. Another bottle of red was ordered from the Pakistani waiter, and the stories began. They talked about the British journalist who went in with the Tanzanian troops when they "liberated" Kampala. The Brit was the first to grab the mace, symbolic staff of the tribal chief, from Idi Amin's house, and he sold it on the spot to a German for $10,000 U.S. "Journalism as a disguise for buccaneering I call it," said Mike. They talked about the British film company composed of former SAS commandos who advertised they would go anywhere at any time under any conditions to get footage for television. They would parachute in or arrive underwater, whatever it took. Mercenaries of another sort.

A few of the correspondents knew one another from Zaire, when the French Foreign Legion was disptached to stop the slaughter of Europeans in copper-rich Kinshasha Province. Mike recalled an incident.

"We were at a landing strip, ready to leave. There were maybe a dozen Legionnaires and a hundred of Mobutu's soldiers, trigger-happy, looking for plunder. They glared at us, our cameras, watches, white skin. Two soldiers said something to this eighteen-year-old blond Slavic-looking Legionnaire corporal. The two blacks were armed—Kalashnikovs, extra clips in their belts. The Legionnaire, unarmed, walked over to them, back straight as a board, and, standing a foot away, dared them to repeat what they had said to his face. They didn't move. The Slav turned around and walked a hundred yards to the plane with his back to these two who'd kill you for the watch you wore. He was fearless. And Mobutu's men knew it. And they respected him for that. You could see the sweat on their faces. They wanted to kill him so badly they could taste it. And they stood there."

Another bottle was ordered, and the journalists' stories got worse. It is better not to use real names. Mike was quiet. The others drank. The fun of comparing tales with your friends who knew, who had been there, who held, like you, the whole world

in contempt because of the horrors they had witnessed, who wrote and filmed for the world back home that really didn't care—well, sometimes it was better to wash it down with wine.

Linda Ronstadt sang for the Marines and the Australian secretaries going through Heinekens at the bar in the other room.

By the fourth bottle, all the barriers came down. Brian and Bob had been together for five years, traveling the world, filming news. They, like other British and French crews, went where Americans never dared to go. Their footage was what Americans generally saw on TV. The Americans, they said, were more anxious to have their faces on the screens than they were to get the news.

"Mobutu wasn't so bad," Brian said. "After all, he tried not to kill too many people."

Bob broke in. "Sure, he was better than Amin, and Giscard d'Estaing's friend Bokassa in the Central African Republic. He wasn't a cannibal."

"We were in Liberia shortly after the coup," Brian said. "The young cocky colonels had arranged for the day's executions to be held on the beach with the roaring ocean in the background, the sand, the sun at the right angle for the cameras. The crew was there, setting up to film the event, but Bob forgot a lens and had to return quickly to the hotel. A young army major came over.

"'Are you ready?'

"'Ready?' Bob asked. 'No. No, we're not. Why?'

"Then we realized what was going on. The colonels had set up the whole bloody execution for us, for television, so they could show the world how tough they were; and then they'd probably ask us for a copy of the tape."

"What did you do?"

"Shot it, shot them shooting people, shot them with our camera, while men killed men in cold blood for being on the wrong side."

I remembered seeing a photograph in the newspapers of men tied to barrels on a sandy beach, the ocean in the background.

"Those men might be alive today, had we not been there. I'll never do it again," Bob said. "Never. Never. Never."

I thought about the movie camera NBC in Paris had given me.

"You're a liar, Bob," Brian said. "You'd do it again. It's like an Antonioni movie. Remember the one with Jack Nicholson? *The Passenger*. We become amoral. We have a job. We cover the bloody news, risk our necks to get it, and most of the time it seems no one cares. We get used by the dictators we cover and by the fat producers with bracelets and gold chains back home."

"That is wrong. Remember Bangladesh? You were a hero that day, Brian. A hero! You were bloody noble. That's been since Liberia."

I asked what had happened and Bob explained.

"It was after the coup. There was a firing squad. Yeah, another one. It was hot and dusty, and there must have been 500 people standing around, waiting for the execution. A man—a young guy about thirty—was led to a wooden post. His hands were tied behind him. His shirt was open at the chest. He was real good-looking. He had black hair, and his eyes had a tremendously defiant look. He refused a blindfold. It was like a movie, but it was real. I watched him, mesmerized, wondering, like anyone, how I would act if I were there, if I'd have his guts. We were filming the whole thing. And then this kid, this little boy— he was about ten—broke through the crowd and ran in front of the firing squad, across the open ground, and wrapped his arms around this man's legs. It was his father. I put the mike down, and Bob put down the camera. We didn't say anything; we just looked at one another and turned and walked away. I cried, and I'm not ashamed to say it.

"That execution was set up for us. And do you know what they did? They shot that man while his little boy's arms were

wrapped around his legs. And an American photographer, I won't say who, took a picture of that guy and his son. And he won a Pulitzer Prize for it."

We moved into the bar. Credence Clearwater, Linda Ronstadt, Emmylou Harris. Popcorn and peanuts. Cigarette and cigar smoke hung in the air like polluted fog. Small Pakistanis brought up bottles of beer for the Marines, the English and Aussie oil rig workers, and the Portuguese and English girls looking for husbands and passports to America.

The subject of guns came up. Mike said he had never used or carried one. As usual, he was witty.

"I figure my gun is my mouth. I scream 'Journalist, journalist,' wave my hands in the air, and start talking. Real fast. You learn how to talk fast growing up in New York."

I knew Mike was telling me something, and I remembered what Dick Harwood had said. "Don't take a weapon. If it gets really hot, there'll be one lying around."

Brian, not drunk but filled with enough wine to lower his guard, took me aside.

"We've talked a lot of bravado tonight. Let me tell you, you're a young enough guy. You're going to Afghanistan, going to make your name. Don't be foolish. Don't try to be a hero. Just keep your head down. You're going in for yourself. That's all that really counts. Forget about everyone at home; they don't really care. They'll use you, spit you out, forget you. You're cannon fodder to them. So you've got to do it for yourself, don't you?"

He looked at his friends.

"But that's why we all do it. We want to be a part of history or at least touch it. There's not a man here who doesn't care; if we become amoral, then we're finished. But remember, be careful. I wish I could go in with you."

Mike and I walked back to the hotel. The cold air was refreshing, and there was only a faint smell of Asia: that combi-

nation of defecation, garbage, spices, and smoke. There was no traffic. Embassy guards wrapped in blankets huddled by small open fires, the Lee–Enfield rifles with bayonets fixed always beside them.

"Do you consider yourself cynical?" I asked.

Mike walked on silently for a second.

"I guess I don't think I've ever met a prime minister or a president who doesn't have feet of clay. And I've met a lot. We are all weak. Human. That's a better word. That's all. I remember going down to Washington and seeing Jack Kennedy on the Senate floor. He was a strikingly handsome young man, a terrific speaker, poised, leading a debate on civil rights. He was like a god, a knight on a white horse, and I was a believer."

He stopped talking for a second.

"You know, I loved Africa. Much more than I like Asia. I had the whole continent, except the north. I went everywhere. Africa's alive; there's dancing and music and vitality. You see women on the streets. Not like here, where they hide them behind veils. Moslem societies are boring. What kind of world is it, anyway, without women around, just to flirt with? But back to cynicism. Maybe I've seen a little too much. Maybe I've been out here too long. But when you see babies clubbed to death and missionaries, women, raped, massacred, like I have in Rhodesia, because they were white . . . and the corruption . . ." His voice broke and trailed off. "Yeah, I guess I'm cynical."

"I don't believe you," I said. "I remember an article you wrote in the *Times* Sunday magazine on Mother Teresa after she won the Nobel Peace Prize. You wrote that you went to Calcutta skeptical that this woman was for real, and then I remember at the end you called her a saint."

He smiled. "You're right. She was immune to hype. She talked to the highest and to the lowest in the same, simple, caring way. If there's such a thing as a saint, she is one. She gave you hope."

We walked on without talking; words would spoil it.

The next morning at breakfast we went over problems of communication and logistics. It would be up to me to contact him and the secondary contacts we had established. A call came for Mike from Brian. Would I take a camera into Afghanistan for the BBC? Mike said I had already gone. Another call came for him, this from President Zia's press secretary. The president was not yet ready to talk. Another day, so to speak, by the pool. We shook hands, and I left to catch the daily train from Rawalpindi to Peshawar.

My taxi, with its horn clearing the path, dropped me off at the Rawalpindi station. I felt, in my illusions, like young Churchill; only I carried my bags. Finally, then, this was Asia: begging hands, flies, a thousand staring eyes. I bought a first class ticket and sat on my briefcase in the sun, swatting flies, reading the Koran, drinking tea. An official in a white cotton uniform carrying a clipboard said, "Yes, the train does arrive. Perhaps sometime soon. *Insh'Allah* [God willing]." The soul of Islam, the fatalism of Asia.

The pale yellow coal-burning train arrived two hours late. Three cars long, one for each class. Third class meant broken-down wood-slat seats, chicken crates, people, many people. Second class had fewer chickens. I opted for luxury, knowing what the following weeks would bring. The seats were vinyl and cushioned. There was room to breathe, though coal dust covered us. The train lurched through the red clay countryside. The soil was red, the air dusty red, the sun red. Red clay brick villages passed by. At night, the train pulled into Peshawar, the last city of the old British *raj*. Peshawar, which means "frontier town"— it is the capital of Pakistan's North–West Frontier Province— was once a walled city with sixteen gates. Traveling merchants called *powindahs* brought their caravans here every autumn from Bukhara, Kabul, and Samarkand. It was the last stop before Afghanistan. I grabbed my bags, asked directions, and found my way to Dean's.

* * *

Dean's Hotel, a former British Army barracks, is a single-story whitewashed motel with a lawn and an eight-foot wall to keep Asia out. The expensive rooms had air conditioners; those in the back did not. There was an overhead fan instead and a black, 1940s phone, which I later learned was always monitored. There was a Thermos of purified water. Outside were a hundred eyes of the hotel help, men, I had been told, who cleaned rooms for one meager salary and reported guests' activities to the police for another. The dining room and the small lobby were dark and musty, and the brass was kept polished by men in frayed white cotton uniforms. I lay on the cot and went over my plans. I must keep a low profile. I was in Peshawar to write stories about the refugees. I would not mention the *Times* unless I had to. Rumor was if a journalist got caught going into Afghanistan, the Pakistanis would throw him in jail for a few days, maybe throw him out of the country. Worse were the rumors of Khalik agents, spies for the new Afghan government, who were infiltrating the *mujahidin* headquarters and the refugee camps and buying off people with money from Moscow. Men had disappeared.

The next morning I set out to find Munchi, whom Jim Sheldon said I could trust as my driver, counselor, guide, money changer, eyes and ears, a poor but faithful friend. Munchi and his car and all that he knew had cost Jim twenty-five dollars a day, plus gas.

A young man pulled up beside me as soon as I walked out beyond the wall. He drove a three-wheeled covered rickshaw with motorcycle handles and a lawn-mower engine. Peshawar was filled with them, sputtering and roaring from dawn until dusk, darting and dashing and leaving a putrid trail of gray carbon monoxide behind.

"Good morning, sir. Taxi, sir? Hashish? Opium? Heroin? Young girl? Young boy, sir?"

I left a note for Munchi at the two addresses Jim had given me. That night he quietly knocked on my door. He had walnut-

colored skin, black hair combed over to the side, a thick black mustache, a thin frame, and two metal front teeth. He was thirty-five, he said, but the lines in his forehead were deep, and his neck was drawn like a chicken's.

"You are a friend of Mr. Jim's? Mr. Jim good man. You are my friend."

He had a soft voice and a quiet manner, but I felt a sense of conspiracy about him, and he did not always look me in the eye.

"Do not say important things on telephone, Mr. Jere. My brother is operator. Spies listen. Look for microphones. They put certain people"—he smiled—"in special rooms. Do not talk to hotel people. Do not tell anyone what you do. Some men good, some men bad. I have friends here; I have friends everywhere. I will help you. When you are ready to go to other side, no one will know."

"Other side?"

"Afghanistan." He nodded his head left.

I walked him to his light blue Datsun sedan. The air was warm and soft, and now that the breeze had blown away the suffocating odor of carbon monoxide, one could breathe the rich smell of eucalyptus, rhododendrons, and a hundred other plants of Pakistan. A cat crept across the asphalt path, and the tall gaunt Pathan guard watched Munchi drive away.

Before going to sleep, I took a shower. It was early October, and the weather was still warm. An Englishman was taking a shower in his room at Dean's once, when he noticed a cobra wrapped around the spout at the top. He calmly turned off the water, got out of the tub, picked up his pistol, shot the snake through the head, and returned to finish his shower. Not having a gun, I checked closely beforehand.

The pre-recorded call to prayer and the rooster's crow woke me before sunrise. Munchi came by exactly at eight, and we drove to the office of the commissioner for refugees. I had made an appointment to see him the day before. Munchi knew the way

and, with an unnerving confidence, honked his way through morning rush hour traffic—the brightly painted buses with passengers jammed in and hanging out the back door like flies clustered around an open wound; the three-wheeled rickshaws darting about recklessly; donkey-driven carts; the crowds of pedestrians, some savvy but too many mindlessly walking as if Allah, in His divine grace, would protect them from getting hit. Munchi swerved through it all like a good halfback.

He waited by the car. I walked through an open courtyard past a group of old men sitting on their haunches with glasses of milk-tea in their hands into the dark cool office. A fan turned above us. Tea was poured. I sat on a hard bench below a picture on the wall of Mohammed Ali Jinnah, founder and father of Pakistan, charts plotting the money and goods supplied to refugees, photographs of field hockey teams, quotations in Arabic from the Koran, a photograph of the Great Mosque in Mecca. A hundred years ago Sir Richard Burton became the first infidel to secretly visit Mecca and survive; today, anyone can see it in a photograph. The commissioner was a tall friendly man with a good handshake and an excellent command of English, who, I had the distinct impression, had learned to deal with Western bureaucrats, journalists, and other busybodies quite easily over the past two years. With him was a man about forty, with wire-rimmed glasses and a cardigan sweater over his pajama-clothes, reading a Karachi newspaper. He, I was told, would be my escort; he would assure that I saw what I was supposed to.

Our first stop was an unfinished four-story cement-block apartment house. A fat smiling guard with a walrus mustache, three-day growth, and food stains on his dark blue shirt stood at the door. He had a piece of pastry in one hand, a glass of milk-tea in the other. Next to him a sour-looking skinny teenager stood at attention with a rifle, gleaming bayonet attached, at his side.

On the top floor was the office of Ahmed Zeb Khan, protocol officer, in his early thirties, an engineer by training, at home in English. He wore Western pants and an open-necked

shirt and dealt with visitors to the refugee camp. They had been coming since the war began, missionaries full of good works from the West. We had tea. I was shown charts, a slide show, and we had more tea. I wasn't interested in the charts, although I pretended to carry out the charade. Khan was proud of his work, even excited. The sullen watchdog in the cardigan sweater even sensed his enthusiasm.

"Why do you help these people?" I asked.

"Because it is our duty. It is in the spirit of Islam. The Afghans are our brothers. They are Moslems like us."

"You do this just to help someone else?"

"Yes. Do you believe in God?"

"I'm not sure."

"You see, in the Koran God tells us we must help our brothers, and it gives me pleasure to know I do. That is why the Saudi Arabians and our other brothers give so much money. The Afghans are better off here than they are back in Afghanistan. It is the purpose of every Moslem to do God's will. It is a burden on us to help the Afghans, of course, but we welcome it."

"It is wonderful . . . very noble. It is very encouraging to hear, but sometimes it is hard to believe."

The watchdog broke in. "The West is so bloody self-righteous."

Bloody?

"You think we Moslems all have swords in our hands and knives in our teeth. Look, inside our border we have the highest number of refugees in the world—over two million. Compare their reception here to that of the Vietnamese in the U.S.A."

"You cannot so easily compare the Vietnamese boat people to Afghans."

"No? You Americans are hypocrites. You have a Statue of Liberty. You are the richest country in the world, so you think you can tell us how to live—with your murders, your divorces. Your president says he wants to defeat Communism, but he does

nothing for the Afghans. You are rich, but really it seems that you are a very poor people."

"You don't like Americans, do you?"

"America, the land of refrigerators, is the hope of the world"—he laughed—"or so we used to believe. It is no longer an example to us."

We returned to Munchi's car, and Khan gave him the name of a refugee camp. Munchi knew it; perhaps it was part of the tour. We headed for it, back to Peshawar, dodging cars, people, our horn leading the way.

Khan said, "O.K., we talk about the camps. Each family receives a monthly allotment of tea, wheat, sugar, sunflower oil, dried skim milk. No fruits or vegetables, they are too expensive, even for many Pakistanis. Each person is issued one set of clothes and one pair of shoes annually. They can grow their own vegetables, like onions, tomatoes, squash. The Afghans are in charge of all 220 camps. Public and private matters are settled in their own tradition, mostly by *jirga*." (*Jirga*, which has been compared in its functioning to Athenian democracy, is the ancient Afghan system of governing where male leaders sit as equals in a circle and settle all important public and private affairs.)

The camp was on the other side of Peshawar, on the way to the Khyber Pass; and my stomach, not yet accustomed to the joys of Pakistani cuisine, was rebelling violently. The problem, no doubt, was my being another effete American, which the watchdog would certainly be happy to agree with. I prayed for the car to arrive and for strength.

A Frenchwoman I know, whose work takes her through some of the wildest spots on earth, once gave me her thoughts on this. "Americans, unlike Europeans, cannot cope abroad because of your Food and Drug Administration. The FDA," she claimed, "takes all the bacteria out of food. Everything in America is clean, packaged, sterile, bland. No wonder your cheese is no good and your stomachs so weak." I thought of this woman now, and breakfast.

The camp lay on a barren tract of land near the road. Heat
shimmered above the ground. There were gray clay brick houses
and army field tents. An irrigation ditch flowed between the
road and the camp. A milk cow sat on her legs under one of the
few shady trees. Three women in long red dresses, their heads
covered by long black scarves, knelt beside a well.

"Our purpose is to give the Afghans a sanctuary and to
make their lives better." Khan was talking. "We teach them
plumbing—which is unknown in Afghanistan, it seems—auto
mechanics, carpet weaving, carpentry, and cabinet making.
They get medical care. We have set up a water system. All
children can go to school."

It was not at all like pictures of refugee camps that one saw
in Southeast Asia. There was plenty of room. The children
looked healthy. The medical tents were clean and empty. A
dozen or so little girls with silky black hair and bright smiling
eyes, so cute you wanted to hug them, sat on straw mats under
an open tent listening to their instructor, paper and pens in their
hands, tin pots for drinking water nearby; an equal number of
boys with shaved heads sat next to them. A water truck drove
by. The camp store had piles of onions and cucumbers for sale.
A man rode by on a bicycle. A thirteen-year-old girl sat in the
shade with her newborn baby. There were few women evident
and fewer men. It was clean, and there were no smells.

"Are all camps like this, so clean, ordered, and without
people?"

"Yes. You cannot see the women. The men are in town.
They take the money we give them—each family gets 500
rupees [$50] a month—and start businesses. They are good at
business."

"No problems?"

"Yes, there are some difficulties. This is not their home and,
well, Afghans are very independent, stubborn people. They
won't listen to anyone, except maybe another Afghan."

I finally found a bathroom, an open piece of ground be-

tween two high mounds of gravel. For an Afghan, they say, all the world is an outhouse. I could practice being an Afghan, for once inside, I would always have to look and act like one. Non–Moslem males always stand up when nature calls; Moslems crouch. When Burton, in 1848, was in Arabia on his way to Mecca, he once, thinking no one was watching, remained standing. A man saw him; and Burton, knowing what this meant, walked over and slit the man's throat. Had his disguise been exposed, he would have been killed immediately. It was not that way now, but there were many things to learn before I could pass myself off as an Afghan.

Now, I had to locate each resistance leader's headquarters in Peshawar and find a man I liked and trusted and convince him to have his men take me inside.

I went to see Doug Archard, the American Consul in Peshawar, an articulate, soft-spoken, blond-haired man with a solid iron handshake. We talked over cups of tea—both of us wondering about the other—and he gave me a list of the *mujahidin* groups.

He had a duty to perform: "I must advise you, officially, not to go to Afghanistan. The American government cannot help you once you cross the border, and the Pakistanis will throw you in jail if they catch you going in. You are completely on your own. Don't take a passport or anything that will identify you as an American." I liked him and his wife, Mary, and I found I liked them even more when I saw their three adopted Pakistani children with bright smiles and pure American accents.

My list contained eight names attached to eight political parties scattered throughout the city. Some of the names were familiar; others I had never heard of. I assumed there were more. I asked about the flow of arms.

"Stay away. The Paks are sensitive about this. If you go snooping around, you'll be on the next plane back to New York."

* * *

First on the list was the Hizb-i-Islami (Islamic Party) of Gul Badeen Hekmatyier. I had heard it was the most powerful group, the richest, and possibly corrupt. I had not met or seen pictures of any of the political leaders. I knew only what I had been told or the little I could find to read about them. I wanted to find a strong, clear-eyed, yet humble man, a young poet-warrior dedicated to freeing his people. Munchi drove me to the Hizb-i-Islami headquarters. It was time for the evening prayers, and Brother Gul Badeen would not see anyone. A man would call me that night. A few hours later the phone rang. The caller announced in excellent English that Brother Gul Badeen would see me at four the following afternoon.

A thunderstorm swept through Peshawar early in the afternoon and knocked power out in the Zaryab Colony section where Gul Badeen had his headquarters. The ground outside the sandstone building had turned to mud. A teenager with dull eyes, a week's growth, a black turban, and an AK-47 stood outside the metal door. He took me into a dark, dank room. A table with a single candle on it stood against a wall. For a minute there was no one else. Then a man in his late twenties entered through a curtained doorway followed by three other men. He introduced himself in good English as Mangal Hussain, cultural secretary for the Hizb-i-Islami Afghanistan. He had jet black hair, a big smile, very white uneven teeth, and eyes that, at a reception on Capitol Hill, would have immediately looked past me for a more important guest. The guy was a hustler, the type who could hold his own anywhere for five minutes.

Hussain, one heard, had guaranteed visiting television crews "plenty of action, lots of fireworks, in the afternoon when the lighting was just right." There was, of course, a price attached. One heard that many crews saw plenty of action and never left Pakistan.

But today he would not be the translator "because you are an American, and I speak only Oxford English." A man who

59

spoke American would translate for me. Hussain was such a phony and tried so hard that I couldn't help but like him. He knew that I saw him for what he was, and so in a crazy way we got along. They led me into another dark room with wood chairs spaced around a low table; a brown metal cabinet stood in the corner. The walls were bare. Gul Badeen Hekmatyier was said to be the wealthiest, most powerful, and most vicious of the political leaders; an engineer by training, he is said to have murdered a man in Kabul before fleeing to Pakistan, to have a Swiss bank account, the backing of Qaddafi and of Khomeini. He is rumored to be a member of the Akhwany, the Moslem Brotherhood, the Islamic fundamentalist organization whose headquarters are probably in Baghdad. Its members despise the West, and want the world to be as Islamic as Arabia during the time of the Prophet. They probably killed Sadat.

Gul Badeen, followed by five men, entered the room. We rose while he sat. He wore clean white tailored pajama-like clothes. He was thin, under six feet, with a narrow face made longer by a dark beard and a round gray karakul cap; he had cold, cold dark eyes that did not smile—ever. I did not like what I saw, and the feeling was mutual. On his left, a short, stocky, sweating man with a shaved head and a skullcap and papers in his hand placed a fancy pocket tape recorder on the table. Another man, at Gul Badeen's bidding, left and returned with bottles of Orange Crush and Coca-Cola for everyone except the leader, who went without. Mohammed would never have touched the stuff. I sat on Gul Badeen's right, Hussain next to me. Our only light was from a lantern whose flame brought out the shadows of the lines of the faces of the men, each of whom had a long black beard and calm clear eyes—the eyes of a zealot.

Gul Badeen, bored and aloof, wanted to get on with the interview. I began by asking about the state of the war and in particular how his men were doing.

"We are defeating the infidels. We are stronger than ever before. We shall win because of our faith."

He went on, describing the success of his men against the Communists, the atrocities committed by the Russian invader, the number of refugees, the number of Afghans killed.

"We must fight alone because you, the Western mass media, are more afraid of Islam than you are of Communism."

I felt I was listening to a tape recorder. His eyes bore in on me, this representative of all that he hated. If I were to get to know this man, I would have to talk about his faith. It was what interested me most about him.

"But how can God help you defeat the Red Army?"

"There is no possibility for anyone to resist without complete faith in Islam. We shall win because we have God."

"How?"

"Because with God we are not afraid. The West is afraid. We are fighting *jihad* [holy war] and we cannot lose. Our strength is our faith."

I had heard that his men had attacked other Afghans. "Are you fighting a war on two fronts: one against the invader from the north and one against those who do not want a pure Islamic state in Afghanistan?"

"Yes. We are fighting the Communists, and we fight all vestiges of colonialism in our country. We will stop only when a pure Islamic state is established."

"Like Saudi Arabia?"

"No. It is too corrupt. It is a family-run country. Not a pure Islamic state such as we, by the grace of almighty God, shall create. We shall drive the Russians out, and the West, mind you, must not come in."

I looked over at Hussain, who flashed his slick smile at me, his gleaming teeth like the wolf's in *Little Red Riding Hood*.

"Wouldn't it be better to put differences aside for the moment and, like Mao and Chiang Kai-shek, who united to fight the Japanese, unite to drive out the Communists, then settle your own battles for the sake of Afghanistan?"

"Mao was weak, and Chiang Kai-shek was corrupt. Neither man had God. We shall win because we do."

The light from the lantern flickered. The men around me were enraptured by their leader. The sonorous call of the muezzin came from the mosque that was attached to their head-quarters. Brother Gul Badeen had been fasting all day, and— would I excuse him?—they must now go to prayers. We had talked for two hours, and Gul Badeen had not hesitated in his answers once; he had not taken a drink, nor for a split second had he shown a sign of uncertainty or vulnerability or interest in learning anything about me. He never once smiled or showed any emotion; he was frightening—and stronger than me.

The next morning Munchi drove down another bumpy dusty road, dodging children, a cart, a bicycle rider, a water buffalo on our way to see Professor Burhanuddin Rabanni.

Two dozen Tajiks from Badakhshan Province sat on carpets and straw mats outside while their commander talked with Rabanni. They were immediately friendly and looked more Western than Asian; except for their clothes, they could have passed unnoticed on most American city streets. The Tajiks had wildly curly hair and beards and crinkly eyes that danced when they laughed. They, it is said, were the first in Afghanistan. Now, dispersed by their Pathan conquerors, they, like the Hazaras, were a subject race. They asked me to go with them on a journey that would take six weeks, over the Hindu Kush to their home along the Russian border. The commander promised to take me into the Wakhan corridor, the finger of land in Af-ghanistan separating the Soviet Union from Pakistan. The cor-ridor, according to these Tajiks and confirming what I had been told in the West, had been annexed completely by the Soviets. The Kirghiz had been driven out. (These people, so beautifully photographed by Roland and Sabrina Michaud in *Caravans to Tartary* when they traveled with them by camel caravan which, perhaps, plied the ancient Silk Road—maybe Marco Polo had once traveled with them—were then in Pakistani refugee camps. They had somehow heard Alaska was like their ancient home-

land in the Pamirs and had wanted to go live there. In August 1982, they and their animals—yaks, sheep, camels—were transported by plane to Turkey.)

Rabanni was as arrogant as Gul Badeen, the man he broke away from. But where Gul Badeen was dark and intense, Rabanni was soft-spoken and had a weak handshake. He wore a gray karakul cap and a full black beard that was six inches long. His head was shaved. He never smiled. Maybe he too had seen too many journalists.

"Russia," he said, "is the first enemy; the West is the second. The West talks, but it is afraid to act. We as a people and as leaders here in Peshawar are united; we have a common flag, a common emblem. Our prospects are bright. We shall win eventually, but it will be a long hard war."

The Tajik commander who was with him seemed bored with Rabanni's talk. He was here to get weapons and money and then return to his home in Badakhshan. Had he heard or seen evidence of chemical or biological warfare? I had been told in Washington that was where there was evidence of it. He said no.

Rabanni was bored too, bored with mouthing his speech to yet another journalist. They come and they go and the war goes on. And too, I am from America. There is a crude poster plastered on the cement block wall outside of his compound. It reads:

> In point of us conquerist America and blood thirsty USSR are both enemy of the great revolution of Iran and Afghanistan. And the intrigues that America design against the revolution of Iran, criminal Russian confirmed it. And the flood of blood that circulate by the executioner Russia is in Afghanistan is confirmed with America. Rabanni.

I felt no rapport with Rabanni. I did not dislike him as I did Gul Badeen, and perhaps posters like that were for the consump-

tion of his rabid anti–Western Islamic followers or to assure that money would continue to flow from Khomeini. I asked him about this, but he would not answer. I was looking for a leader, someone to inspire, and it clearly wasn't him, though I would have liked to travel across the Hindu Kush with my laughing Tajik friends.

The next day, we drove to the compound of Syed Ahmed Gailini, the leader most respected in the West because he is not, so it is said, anti–Western. He knows English and how to talk like a social democrat. Gul Badeen supposedly knew English also, but that fox would not use it even though he twice corrected the translator. Gailini is a Moslem, but pro–Western.

It was morning. I could see him in the afternoon, before prayers. There was a war going on; the country had been invaded by nearly 100,000 Russian soldiers, and the political leaders held office hours. Nine to five, an hour or two off for lunch.

The guards lifted their rifles and let me pass. Munchi, as usual, waited outside. I entered a spacious room with a rug, couch, easy chairs, screen doors at the end which opened onto a porch and a green lawn with flowers and shrubs along the wall. A boy brought a tray with tea and pieces of candy to suck while I drank: tea Afghan-style.

A handsome, clean-shaven man with rich black hair and a thin, aquiline nose began to talk. For twenty minutes I spoke with this man before I realized he was not Gailini. He was the heavy-set man in dark clothes and sunglasses who sat across the room and said nothing. I could not see his eyes. He asked me, in excellent English, if I had read certain statements given before the U.S. Senate Foreign Relations Committee. He said if I wanted, I could go in with some of his men the next morning. I should talk with his cultural secretary. Then he excused himself and went outside to pray on the lawn. Gailini was more a man who would write pamphlets than a leader of men.

The next morning, more curious than ready, I went to where Gailini's "cultural secretary" had directed me; a man said it would cost $350 to pay for my trip. Mad at what I thought was a bribe, I walked away, climbed in Munchi's car, and rode out Takhal Bala Road, on the route to the Khyber Pass, to the office of Yunus Khalis. We turned off on a narrow road. A boy of about ten led three black, glossy water buffalo, each with a rope through its nose, across our path.

Two teenagers with ready smiles and rifles stood at the iron gate. In the dirt courtyard, a dozen men sat on straw mats under a cloth canopy supported by wood poles. On the ground floor of the house were three rooms with tables, chairs, typewriters, a copying machine, paper, pamphlets, glasses for tea, dust on everything. I was led up wooden stairs and into a small room, maybe ten feet square. Three broken-down couches, forty years old, filled with men and boys, lined three walls. A place was made for me.

Yunus Khalis sat in a worn green-cushioned chair behind an old wood desk against the back wall. He had a full gray beard, a white turban pushed back on his bald head. He looked at least seventy and he sat erect, his thick hairy wrists resting on the desk, his legs wide apart, his baggy pants pulled up showing big calves, old shoes, no laces, no socks. A leather bandolier with two rows of bullets attached to a holstered pistol ran across his chest. He was holding court. I liked him immediately.

An old man with a ragged American army coat draped over his shoulders listened to Khalis's verdict, stood up, shook his leader's hands, bowed his head, and left. Two young men in their early twenties explained why they were here. Khalis wrote something on a piece of paper. They took it gratefully and left. For two hours men came and went. No one acknowledged my presence. Finally, the man next to me turned and asked in broken English what I wanted. I told him that I wanted to go to Afghanistan. I sat there for another hour. The same process

continued as old men, grizzled and humble, and young beardless boys, bright-eyed and anxious, came, entered the room, sat on the broken-down couches, and waited their turns.

Then Khalis turned and looked straight at me, his eyes never wavering. He was making a decision about me, a man who spoke no language he knew, who came from another world, whose culture was totally alien to his own. I doubted that he would think much of it, anyway. His mind made up, I assumed, he stopped staring at me. Nothing more was said that morning. An hour later I left, and Munchi drove me back to Dean's.

"Where do you want to go next, Mr. Jere?"

"Nowhere." My mind was set. I wanted to go in with Khalis's men. And now I would wait.

Two days later I sat in a chair on the lawn at Dean's, reading. A waiter in a starched white cotton tunic with gold buttons brought a late lunch on a tray, a club sandwich with french fries and a pot of tea. The lawn had been freshly mowed that morning, reminding me of Saturday afternoons when I was a kid. From beyond the wall I could hear the din of motorbikes, rickshaws, shouts, buses, trucks. Birds picked at the ground. The sun was still warm. The flowers and eucalyptus trees and grass cut out the smell of pollution. It was a good feeling: I no longer felt the need to rush. Asia was beginning to sink in.

I looked up and saw three men standing over me. One was Shir Naabi, a stocky twenty-two-year-old twice-wounded commander who led guerrilla operations for Yunus Khalis in and around Kabul, the Afghan capital. Naabi's brother, Amuhla, had questioned me the other day. They stared at me for a minute. They, too, were searching for what character lay behind my eyes. Had their leader made the right decision? Could this man take it? Was he worth the effort they would go to for him?

Naabi, with curly black hair and unwavering dark eyes, had dealt with foreign journalists before, and though he knew little of the West, he sensed that publicity might help. I knew he had

been fighting for three years and wondered what good journalists did. The war went on, and there was still no help from the West. He was trying to learn English. He asked questions about the West, questions of curiosity, not envy. His life was in Afghanistan. His resolution, toughness, and intelligence were what made him a leader of men two and three times his age.

The other two I had not seen before. One, who did not say anything, was tall, slim, with dark-rimmed glasses, a black turban, black vest, black pants, and sunken cheeks. A man who introduced himself as Mohammed Hakkim did most of the talking. He was clean-shaven, unlike most *mujahidin* to whom a beard was symbol of their struggle. He wore a white skull cap, a thick green V-neck sweater over his baggy clothes, and was in his late twenties. He leaned forward, elbows resting on his knees.

I could go in with them. Did I have the proper clothes? I would need to pass for an Afghan to get by the Pakistani military checkpoints on the way to the border. My beard and hair and eyes were brown like many Afghans. With Munchi I had purchased the necessary clothes: two sets of baggy Afghan trousers with a rope belt which drew around the waist, two shirts which came over the front and back of one's pants, a high-collared vest with two deep pockets on the inside and four on the outside, a black turban with thin silver threads, brown sandals with rubber-tire soles, and a dark brown wool blanket with red, gold, and green stripes on the borders which would be a wrap to wear, a rug on which to pray, and a blanket to sleep with at night. The *kalee* (the shirt and pants) made to order cost $25, the *patkai* (turban) $12, the vest $5, the *pattu* (blanket) about $7, the *chupplee* (sandals) about $7.

Hakkim and Naabi said I must be ready to go at 8:30 the next morning. A man would come to pick me up. I must tell no one. Naabi asked if the police had talked to me. "No, not officially," though I assumed the constant queries from the men at the desk, the restaurant waiters, and other men represented the

police. Was I being followed? I didn't think so, though I wasn't sure. They looked at one another.

"We will deal with this," Hakkim said. I had no way of knowing what he meant. Their business was done. The sun was setting. It was time for them to go. They got up, and each shook my hand, and I watched them walk across the lawn and out the driveway, their native clothes and turbans a striking contrast to the clipped lawn and gardens at Dean's.

I walked back to my room, turned on the fan, and lay on the cot watching the fan slowly build up momentum. Soon it was in full swing, creating its own force. I could turn it off, or I could let it run. I could turn back now, check out of this room and return to New York, or I could go ahead. Tomorrow it would be too late; I couldn't turn off the fan.

I could feel the adrenaline beginning to flow, not like it used to the night before a big race or an important event or task; those were the tests for which I could more or less prepare myself. They were known. I had no idea what lay ahead, and there was no way to prepare. I was fit: I had been sick a few times, but that was to be expected. I did exercises: push-ups, sit-ups, and, with a pack on my back and in my army boots purchased on Canal Street in New York I did step-ups onto large rocks on walks through Peshawar late at night. I had run ten miles the day before I left New York and I had felt fine. In a Peshawar pharmacy I had bought what medicine I would need from a list given me in Paris by doctors with Médecine Sans Frontières, the French medical crews who worked secretly in Afghanistan, Central America, Africa, Southeast Asia—wherever they might be needed. I already had aspirin, tetracycline, pain pills, ointment and bandages meant for cuts or wounds, water purification tablets, vitamin pills, eye ointment, poloris for gum and mouth infections, and a Swiss army knife. I had, in the past, never given much credence to vitamins, feeling that, even in athletics, good food was more important. But on a trip up the Nile, I had

experimented and learned that vitamins did make a difference. I had been traveling three months and my resistance was down. One day I would take a multivitamin with the gruel I was eating, another day not. I found that I felt much better when I took the pill.

I also had an old Pentax camera, a small, fully electric Canon that I could quickly take a picture with and then hide in my jacket, and the movie camera from NBC. I had my old army fatigue jacket to wear over the vest but under the blanket, a cheap digital watch, the powdered milk, pens and paper, bouillon cubes, a thermometer, a Chinese pencil flashlight, a map of Afghanistan, writings from the Koran and on guerrilla warfare. I packed these into a green canvas daypack, my vest and fatigue jacket pockets. Instead of leaving the rest of my gear with the embassy, I would give it to Munchi when he came by later that night to keep for me.

John Fullerton came by, and with Munchi driving, we went off to a restaurant in the old bazaar for a send-off dinner. Fullerton was a successful journalist who got bored with life in London and came out to Peshawar two years ago. No man knew more about the war in Afghanistan. Politically, he was conservative, an intelligent, savvy, blond-haired, blue-eyed Englishman who longed in his heart for the nineteenth century. His wife was in England but would return in a month. We talked for two hours about the war, politics, books, and love. We understood one another. There was no need to talk much about it. We both knew that a man may want to reach to the stars, "to write his will across the sky," as Lawrence had put it, but he does so at a price. He must have love, companionship, and, maybe, he must have God; otherwise, what is the good of it? "For what doth it profit a man. . . ?"

We carried on until the owner, who sat in the corner and could stay awake no longer, kicked us out. Back at Dean's I fell fast asleep.

*　　*　　*

At 8:30 in the morning Hakkim quietly opened the door and entered my room. I turned and saw him standing there and knew immediately that from now on my privacy was gone. He was nervous, unlike yesterday. He looked me over carefully: my pants, shirt, vest, sandals, blanket, my pack, the turban which I couldn't wind around my head. We would deal with that later. He took the pair of khaki pants and cotton shirt I had in my hands and motioned for me to follow him. We walked down the asphalt driveway which led to the gate. A dozen staff members watched us.

"We must go quickly," he said. "These people are all spies."

A black four-door Toyota, with its engine running, sat near the exit gate. He told me to get in the front. The driver, his turban crushed against the car roof, his huge torso bent over the wheel, grinned and extended his hand.

"*Ah-salaam aleikum* [Peace be to you]."

Hakkim got in the back. Another man sat next to him. We drove to the old bazaar and onto a bridge. It was rush hour, and there were horse-drawn carts, motorized rickshaws, swirls of dust, donkeys, and people, people, people. The car stopped. Hakkim got out and told me to get in the back. He shook my hand and, with the other fellow, disappeared into the crowd. Three men emerged and climbed in: one in the front, two in the back on either side of me. We drove off through the crowd. No one said a word. I was now, I realized, a prisoner. We were on our way to Afghanistan. We swerved and honked and headed southwest on a paved road which ran past rice fields, irrigation ditches, water buffalo, stacks of deep-red mud bricks drying in the sun, children watching small flocks of sheep. We were—it seemed—headed towards Miram Shah, a town on the Afghan border, an area where the laws of a tribe are the laws of the land.

A half hour later, we reached Darra, a loud, single-street, Eastern Dodge City, and every second building was a gun shop,

and every man over sixteen carried a rifle, and dark green kilo slabs of hashish selling for fifty dollars each were stacked neatly next to boxes of ammunition, pencil guns, pistols, any kind of rifle. We turned off into a dead-end dirt alley and, leaving our sandals at the door, entered Ahmed's Gun and Ammunition Shop. We sat on the wood floor, I in the back, in the corner. The entrance opened onto the street. Gunfire sounded through the streets. A man has the right to try it out before he buys.

"Chin chai, tor chai?" Green tea, black tea, which did I want? I ordered green tea. A man shouted at a boy who soon returned with two hand-sized aluminum tea pots and cups without handles which said "Made in China" on the bottom. I had been told by the driver to not say a word.

I sat cross-legged, holding the cup with both hands. The hot tea was cooling off. The men talked. Then one of them went with the shopkeeper, returning some minutes later with a gunnysack of banana-shaped rifle clips and another of .303 caliber bullets. With a key that hung from a chain around his neck, the man who had sat on my right in the car bent down, unlocked his vinyl attaché case, pulled out a three-inch thick wad of Pakistani rupees, and counted out half for the shopkeeper. Business over, we finished our tea, embraced our host—who gave me a quick knowing look—and left. We drove for a few miles. When he was certain no cars were following, the driver pulled over to the side, and we exchanged turbans. Mine was too new, he indicated, and might arouse suspicion. He rewrapped it for me.

We drove southwest through a land that became increasingly desolate; the ground was brown and crumbled in one's hand. There were fewer trees and fewer people. The paved road, though uneven, had power lines, and we dodged to avoid the garishly painted buses and trucks with people hanging out the windows, the back doors, crammed on top. The road wound around and up until we approached Kohat, a name which my friends had made me repeat over and over again. We drove beneath a high stone arch; on our right was an adobe fort which

looked like a small Crusader castle. The Pakistani police stopped
the car, asked for papers. The driver got out. The police looked
closely at each of us; they went through the trunk, again looked
at the papers, waved us on. We rode for eight hours. We stopped
to share a bunch of grapes beside the road; we stopped again to
pray, another time to eat. The roadside diner was adobe, no
windows; lunch was potatoes and meat cooked in hot, spicy,
greasy gravy. I ate with the driver, outside.

"Mister, we must be careful of spies. Do not talk, and keep
your face down."

About every hour we passed a military checkpoint while I
sat in the back, in the middle, trying to look mean and Afghan. I
kept remembering my father's words—"Well, you look like
those guys anyway."

Before we reached the next single strand of cable that
stretched across the road, I had to repeat over and over the name
of the next town in case the police asked me directly where I was
going. If they asked me what time it was, I would say the next
town; if they asked me my name, I would say the next town.
They were military police in berets and blue sweaters with
chevrons on the sleeves and pistols on their sides. At the check-
points, white painted stones led to their station or to their fort,
which sat alone, out here in the middle of nowhere. The police
looked us over carefully, but we always passed, and I breathed
deeply each time the cable dropped. My companions loved it, at
first smiling, eventually bursting into uproarious laughter.

And so, we got to know one another. Abdullah, the driver,
was soft-spoken; his blue eyes watched me closely through the
rearview mirror. He knew some English and directed the flow of
conversation. What was my name? Was I Moslem? Was I mar-
ried? Where did I come from? What was I doing here? He had
three daughters and had once been a major in the Afghan air
force. He smiled, a handsome man, and talked about his daugh-
ters and said he did not want to fight because of them. He
extended his arms and mimicked the sound of a rifle, watching to

see how I would react. Akmatcha sat on my left, an Afghan Falstaff, with big wrists, big belly, big beard, warm crinkly eyes. He couldn't get over my digital watch and wanted to show his friends in Miram Shah. (I gave it to him, and he returned it the next morning at dawn.) Patrola, gaunt, with black horn-rimmed glasses and the key to the money around his neck, sat on my right. He said little. Molov sat up front. He was twenty-one, and his chest was wrapped in bandages; his left arm hung in a sling. Abdullah explained that Molov was an antiaircraft gunner returning again after getting patched up for the third time in a Peshawar hospital. There were lines on his face. He looked much older than twenty-one.

They would teach me words of Pashto, and they would look at me for what seemed like minutes trying to figure out what I was made of.

We arrived at Miram Shah at sundown. Military police directed cars and camels pulling flatbed carts. We drove past a Pakistani military fort, the highest building on the plain, while a bugler sounded retreat. We continued along a dirt track which turned and turned again between ten-foot-high mud walls. Finally we stopped, and Abdullah knocked on a wood plank door; a young man peeked out and, recognizing Abdullah, let us into a courtyard of broken bottles, tin cans, flies, pigeons, moulding bread, and stacks of wooden crates. It was a secret ammunition depot and would be my home, and prison, for two days. My three companions shook my hand and left, and the three teen-agers who guarded this garbage dump took over.

The small room had cement walls and a dirt floor covered with straw; bedrolls were stacked against the wall. A single wood beam ran across the ceiling. A magazine photo of a Swiss Alpine village hung on the wall. There were no windows. A single light bulb hung from the rafters. There was no running water. Kalashnikovs, Lee–Enfields, Indian self-loading rifles stood in the corner. There was dirt and dust and a thin layer of sand over everything. For dinner they cooked rice and small bits

of gristly meat in a black pot over a Bunsen burner. We dipped pieces of bread into the community pot, each taking from our side of the bowl, though they kept pushing the best portions of meat towards me. For dessert we shared a bunch of green grapes.

We listened to the nightly BBC news in Pashto and in English. The announcer reported rumors of serious fighting in Kandahar, Afghanistan's second largest city. After the news, I had to listen to a thirty-minute cassette tape recording of a battle between a group of *mujahidin* and a Soviet helicopter gunship. At eight o'clock I lay on the hard dirt floor, swatting flies and mosquitos and listening to the wind. My guards were asleep. This was the first time in weeks that I had had a moment for reflection. Up until then it had all been dreams and talk and preparations for departure; now I was up against reality. Why, in truth, had I come here? What awaited me across the border? I could still turn back. But I knew I wouldn't.

Before dawn the three young men were up, sitting on their legs, thick dirty hands open, touching the ground with their foreheads, rocking back, quietly mouthing their morning prayer. A black pot of water was outside; I washed as they had done before prayers. Then we boiled what was left for tea and ate yesterday's bread, which they kept wrapped in a small brown wool mat. We ate slowly, breaking off small bits of bread, and drank many cups of tea. It passed the time. There was nothing to do. Time and the need to do something, of course, were Western notions. I wanted to get going, but they would not let me leave the compound. So we played school; I taught them a word in English, and they taught me its Pashto equivalent.

Sulah Khan, who did most of the talking, said he had been a student in Kabul. Too pushy, he put me off. Jahan Gul, who was a farmer, and Janat Gul were quieter. Jahan left on a bicycle and returned with a small cake that we ate with green tea in the afternoon sun. With a knife blade six inches long, he cut the cake into six pieces: one each for them, three for me. They insisted.

I found crates with English-language markings and, among the rifles, an M-1, the American rifle used in World War II. Where did these crates come from? They did not know, and they watched me carefully when I inspected the compound.

The next day, late in the afternoon, someone knocked on the door. Sulah hid me in the back, and Janat took down the wood bolt. It was time for me to go, quickly. I grabbed my bag, threw on my blanket, and Sulah wrapped my turban. I hadn't yet mastered the art of wrapping twenty yards of cloth around my head properly and leaving the right amount hanging free.

A man I shall call Gul Shah stood at the door. He shook my hand, looked me over, took the pack from my hand, and began to walk. I followed him. He was tall, with sallow cheeks, a thick mustache, crossed bandoliers, and a rifle. He led me to a small red Toyota pickup parked at the corner. I got in. A boy about twelve, whose legs barely touched the floor and whose eyes barely saw over the dashboard, sat in the driver's seat. Gul Shah, to my surprise, climbed in the other side, and the kid took off with the skill of a stock-car driver across a rocky wasteland, up dry riverbeds, flat out down dirt tracks, then up a hill, finally to a cluster of adobe houses on a plateau. No electric wires here, no more flies, only the dry rushing wind.

Gul Shah got out and motioned for me to follow. The kid drove away. I was led to an empty house which sat on the plateau's edge, motioned to rest on a rope litter, and left alone. After sunset, a group of children materialized behind a lantern, staring at me. I smiled and, shyly, they smiled back.

At dinner under the stars, Gul Shah, the twelve-year-old driver, an old man, and two other men had a grand time watching me roll rice into a ball, dip it in grease, and smear it into my mouth. When we had finished, a girl about ten came and picked up the community pan and put it on her head and took it to the women. The old man pointed to his ear and said in sign language that he was deaf. Was I a doctor? I said no but, wanting to please and pay for my dinner, asked what was wrong. I tried to act like

I knew what I was doing. I gave him two aspirin, and he was happy. I did not know the significance of that gesture, but the word would be passed—the foreigner was a doctor and could treat fever, polio, gout, and battle wounds. The men motioned to me. It was time for evening prayers. No, I nodded, I was not a Moslem. They accepted this and bowed, kneeling southwest towards Mecca, palms upturned, foreheads touching the ground. Their voices were low as they repeated each part of the litany.

"*Allah O Akbar* [God is most great]

Allah O Akbar

Allah O Akbar

Ashahadu anna la ilala illa-llah [I testify that there is no God but Allah]

Ashahadu anna la ilala illa-llah

Ashahadu anna la ilala illa-llah

Ashahadu anna Mohammed rasulu-llah [I testify that Moham-med is the messenger of God]

Ashahadu anna Mohammed rasulu-llah

Ashahadu anna Mohammed rasulu-llah

Hayya 'lla 's-sala [Come to prayer]

Hayya 'lla 's-sala

Hayya 'lla 's-sala

Hayya 'ala 'l-falah [Come to prosperity]

Hayya 'ala 'l-falah

Hayya 'ala 'l-falah."

Then, Gul Shah and one of the men picked up their rifles and led me down the mountain, west, to the border. We walked for an hour. A spotlight played over the mountain, then came down, close, too close, to our heads. We stopped. Gul Shah pointed to a small building maybe 200 yards away.

"Pakistani police," he said.

We waited, walked on; the light came again. Gul Shah motioned for me to take off my boots and wear my sandals. I was making too much noise. I changed and we went on. After a

hundred yards, we knelt down again. It was quiet, but they would not move. Gul Shah took off his sandals and motioned me to do the same; for the next hour, we walked barefoot along a dry, rocky riverbed.

There was no way of knowing when we crossed the border—no markings, no border posts—but it must have been some time around midnight. I saw and heard nothing else, and eventually we put our sandals back on. At about two A.M. we came to a four-man army tent that was bright in the dark, for the clouds had now blown away, and the moon appeared. Gul Shah called out. A voice responded. We crawled in. There were ten men inside. My guides whispered their message, shook my hand, and left. It was cold, but we had the heat from each other's bodies. I forgot about my cut-up feet and fell asleep.

It was still dark when the man on my left, whom I will call Kassim, poked my ribs and said in English, "We go." We walked for an hour. The sun rose over the mountains behind us. A lone, turbaned figure watched us from a hillside. Sheep grazed nearby. There was frost on the ground and desert scrub. We climbed slowly, walking west through a wide gully. Afghanistan became greener and more vivid, with clumps of trees and a wide, wide blue sky, and the perfect quiet, and air that was so fresh and brisk. Afghanistan! My spine tingled like a boy's. I felt the sensation of adventure. Two men with camels came towards us. Kassim watched them carefully, greeted them; they passed. I looked at Kassim—at the rifle that he had oiled before we left slung over his frail shoulder, his ragged clothes, the gray beard, the quick looks ahead and behind. He loved smuggling me into the country; his ancestors had perhaps been smugglers for centuries. He thought he heard a noise, and we moved off to the side behind a rock and waited. He broke off two plant stems and began braiding a rope. His hands were quick and nimble for such an old man, I thought. As if reading my mind, he pulled out a small plastic sack and handed me a red card. It was an identification from a construction company in Abu Dhabi,

where he had apparently worked as a laborer. The card said he was born in 1947, which would make him thirty-four. I looked at the deep lines in his face, at his old, old hands. He looked at least seventy.

By noon we reached our destination, a mud and rock house which sat alone under a giant cedar tree on a small hill. The owner brought water and insisted I lie on the bed he had prepared for me. He fed us with glass after glass of green tea half-filled with sugar. The first glass almost knocked me over, but the third, with no more sugar added, was just right. After the tea he gave me half-scrambled eggs in water with sugar sprinkled on top and bread. While we sat in a circle in the shade, catching a small breeze, I saw women gathering wood on the opposite hillside.

My host tapped his heart and shook his head, asked me what he should do. I took his pulse, gave him two aspirin, and suggested, for starters, he quit drinking tea with three giant spoonfuls of sugar in it.

An hour later, two young men came down the mountain behind us, walked in, looked me over scornfully, and waved a piece of paper with the Yunus Khalis Hizb-i-Islami emblem on it—a different emblem from Gul Badeen's Hizb-i-Islami, which Khalis, disgusted with Gul Badeen, had broken with—and a message in Persian script. Was I the man? Kassim nodded. My new escorts were about twenty-five, arrogant, and trying to act tough. They were armed with Kalashnikovs and crossed bandoliers; they wore black turbans, white pajama-clothes, a week's growth. Our host gave them a bowl of milk and bread, which they slurped down quickly.

One of them walked over to my pack and spilled its contents on the bed, laughing. Kassim saw the cameras, the Swiss army knife, and held out his hand. Our host pointed to my blanket and rubbed his thumb and forefinger together. I went into the wrong pocket and brought out a hundred-rupee note—about ten dollars—which was too much. Kassim grabbed it and the tension lifted.

My new escorts were in a rush. One led, one followed, and we pushed hard up the mountain. Three hours later, their point made, we slowed down, and before sundown we reached the village where we would spend the night. The village was on a ridge overlooking a dry riverbed. A stream trickled over rocks at one side of where, at one time, a large river had rushed through. There were maybe a dozen single-story adobe houses, chickens, goats, children. There was no sign of war.

We entered a dark cool room with adobe walls, a dirt floor, and rough-cut log beams and sat on straw mats. A man brought tea and joined us. There were two rope-mattress beds, a lantern, and a portable radio. The men talked and stared at me. Later a young boy brought in a pot of cold water and a bowl and we washed. There was no soap. Dinner was warm bean curd and, for me, eggs half scrambled in oil. We ate with pieces of warm gritty bread. After the meal, a pot of water was passed around and we took turns drinking from the spout. I would have to drink it, but I couldn't get sick and be a burden on them. I couldn't show weakness. My guides had tried to test me all afternoon, pushing hard, then stopping, pointing their rifles ahead, going "Boom, boom!", watching me, laughing stupidly. Was I afraid? Afghans not afraid. Moslems not afraid.

I had not prayed with them.

After dinner they produced small tins of chewing tobacco laced, I later learned, with lime, which they chewed and spat in the corner or into a small aluminum spittoon which sat in the center. I slouched against the wall, writing in my notebook. One of the guerrillas finally addressed me. He sat cross-legged with his rifle in his lap and his back against the wall. Now he too rubbed his thumb and forefinger together. This had to stop. I said no, shaking my head. He stared at me, his eyes even more sinister in the flickering lantern light, but he did nothing. The next morning he left before dawn.

Rahim, who had eaten with us the night before but had slept elsewhere, a tall, unsmiling man with small eyes, motioned for me to come with him. Prayers were over. He carried his rifle

on his shoulder like a garden rake, and before the sun rose, we were quick-marching across the plain of Khost. It was a wild, windy, beautiful plateau that stretched for miles. Tufts of brown grass blew around us, and a jagged row of snowcapped peaks, half-hidden in mist, lay far ahead. The city of Khost, a helicopter base with a brigade of Soviet troops to protect it, was three miles east.

By early afternoon we stopped at a *chaikhana*, a tea house, that had dark gray adobe walls and a canvas top, and tea and bread dipped in mutton gravy was served. Rahim pressed me to eat and to leave quickly. I only wanted tea. When I poured in the powdered milk, the tea turned white and totally fascinated the other men at this roadside inn. Rahim motioned for me to pay. I gave a boy five rupees, and got three Afghanis in change. It cost forty-three cents.

Rahim was making it clear he did not like me or his assignment; we had pushed hard because he did not like to be in the open with helicopters so near. We headed up the mountain, the sun now beating mercilessly overhead. Twice Rahim had to ask directions, once at the *chaikhana* and now again from a man who passed us. A bad sign. My feet were hurting; the cuts from the midnight stroll along the riverbed had not healed, and Rahim, like a gazelle, kept bounding up the mountain. Finally I hollered at him to slow down; he stopped, turned, and slowly brought the rifle off his shoulder. He stood there for a second facing me, the rifle in his hand. Then he shifted it to his other shoulder and walked on as fast as before.

There is a code in the hills and deserts of Afghanistan that is called *Pushtunwali*, as hard and uncompromising as the people themselves, and it is a stronger force in their lives than the Koran. One of its commandments is to protect your guest, even if he is your enemy. I did not like this man, but there was no need to fear him.

Our path narrowed to a goat trail. The wind cooled and blew through the scrawny cedar trees. The ground was dry,

rocky. There were no animals, no birds in the air. A man came towards us, a rifle over one shoulder and a teakettle in his hand. His wife, who looked fourteen, trudged down the mountain behind him with a six-foot wood-frame cot balanced on her head. We greeted each other as we passed. "*Ah-salaam aleikum.*" "*Astalah mashai* [May you never be weary]."

I watched them go. What was I doing here? I thought. I don't like this man, and he doesn't like me. That man's wife, a teenaged girl, was treated no better than a pack animal. I looked at the desolate land around us. I was tired, my feet hurt, the sun beat down. Maybe a Communist government is what these people need; maybe that girl could go to school and not into slavery. Maybe men with the soul of Rahim wouldn't have rifles. My mind whirled from too much sun, no water, no food; the pack was heavy.

Two helicopters flew high above us, northwest, in the direction we were traveling. We stopped to watch their awesome gray bodies, bright in the sun.

We reached the summit and heard the dull thud of a bomb. For the first time, there was an expression on Rahim's face. On the northern, downward side, we came to a thread of water seeping out of the mountain, forming a small pool. Rahim bent over, put his mouth to the water, and drank for only a second; his knees did not touch the ground. I used my hand and must have gulped a quart, and it was cool and as sweet as honey.

By nightfall we reached the village where we were to have stayed the night. But the two helicopters had come an hour before, and two houses lay in rubble. A man in his twenties was brought to me. A machine gun bullet had torn through his stomach, and his right calf was shredded by shrapnel. Rahim had said that I was a doctor. The word had been passed on.

I bandaged the man's wounds with his turban, and a camel was made ready to transport him back to Pakistan. When we lifted him on the camel's back, he grabbed my hand; his eyes burned with pain and were scared, but he did not say a word. I

gave him some pain killers. He offered me a cigarette. I don't smoke, but I took it. He had a four-day trip ahead of him, and the route over which we had just come was marked with white flags fluttering from the top of long poles—the graves of those who had died on the way.

We couldn't stay in the village.

I went to get my pack, and Rahim took it from me. He insisted on carrying it. For the first time, he smiled.

We walked fast, I no longer behind him. The terrain was flat, and the villagers had given us tea and bread. I thought of the young man on the camel and the fear in the eyes of the villagers. The twentieth century had come roaring down from the skies, pressed buttons, brought fire, and disappeared again, mechanically, heartlessly, a quick dip before heading back to the base and a shot of iced vodka. On the ground, there were quiet cries, glazed eyes, piles of clay where there had once been homes.

We met a man who told us there was a road an hour's walk ahead and that there would be a truck traveling west on it. We could catch it if we hurried. *"Astalah mashai,"* he said.

We made it. The truck had one headlight and a clutch that was almost gone, and it looked a hundred years old. It was a Russian flatbed truck with corrugated aluminum siding, and of the fifteen men in the back, I was the only one without a rifle. It was a taxi. We drove for two hours, stopping periodically where there was nothing. Men would climb down, disappear into the night, and we drove on. There were eighteen charred tanks and armored personnel carriers lying on the side of the road or in gaping holes in the middle of it—traps set by the *mujahidin*. The destruction had occurred months ago; green and gray had turned to brown-red rust. The carcasses had been scraped clean; as in a ghetto, only the hulks remained.

Finally the truck pulled up before a series of dark shapes beside the road; there was a house with a light shining in the window. We climbed the wooden stairs. Behind the glass win-

dows, dull lights flickered. Inside there were maybe forty armed men with thick black beards sitting on the floor, blankets wrapped around them. They watched us enter. The room was warm. The pungent odor of hashish and burning cedar filled the room. In the center was an iron potbelly stove, called a *bokhari*, from which a six-inch pipe led to the ceiling. Kindling went in the bottom part; the fire heated the water in the next compartment up to which a faucet was attached. It made hot water for tea and provided heat.

We could wash in a small stream that ran by the road, and I, the Westerner, could brush my teeth. Thus refreshed, we had dinner—bread, tea, no sugar—and fell asleep with the others on the floor.

At dawn, while Rahim prayed, I washed at the stream. A series of bombed-out, abandoned adobe shelters were next to the wood house. Small groups of men huddled around low-burning campfires; a dozen camels sat on their legs chewing their cuds. Burlap sacks of what was probably grain lay on the ground around them. I noticed a small stack of RPGs (the Soviet anti-tank, free-flight missile launchers), AK-47s (Soviet Kalashnikov assault rifles), and mortars. I started to take a picture but heard a shout, and another, and rifles cocking. We cleared things up, and our departure was delayed while I took their group portrait. Afghans, it seems, are the vainest people alive. They always want their pictures taken. But it is an easy form of payment.

Late afternoon we arrived at Suran Markez, the small, secret winter supply headquarters for Yunus Khalis's men in Paktia Province. Rahim and I approached the camp, finally as friends, walking along a swift-running irrigation channel and on a path lined on both sides with poplar trees, as on small roads in the French countryside. The village sat on two sides of mountains, and in the valley below ran a small stream. There were children playing, chickens, adobe houses, donkeys, women evident, and five antiaircraft guns on the mountaintops surrounding

it. Rahim would spend the night, then return to his village. Another man would take me from here.

We joined a group of twenty men around the *bokhari* in a community house to drink green tea and chew on lumps of hard brown sugar the size of giant marbles. I ate a dozen balls and drank as many cups of tea. For dinner we had *khroot*, a mixture of sour milk, bread, and oil, which we scooped out with morsels of bread from community bowls. There were three bowls: two for nineteen people, one for me. The foreign guest was given the best and would begin first. We sat cross-legged or on our calves while eating, careful that the soles of our feet did not face another—a sign of disrespect. We ate with our right hands. A round flat loaf of bread, called *marlee*, was placed in front of each man on a canvas tarp which served as our tablecloth. After dinner, which lasted as long as it took for a man to fill his stomach, young boys took our bowls away and rolled up the tarp with the bread inside. It would be breakfast tomorrow. The men stared politely at me and when I smiled, smiled back. But they left me alone. A man brought out a sleeping bag with a tag which said 'Made in Georgia, USA' (This would be the only evidence I saw of identifiable American involvement in Afghanistan). They would sleep under their blankets on the dirt floor.

But before going to sleep they listened to the BBC Pashto broadcast. Every night thus far I listened to the BBC. It has broadcast in Persian in Afghanistan since 1940, though in Pashto only recently. And of course there is the BBC World Service in English. The Voice of America broadcasts only in Persian, though Pashto is the principal language of the guerrillas with whom I was traveling, and does not seem to count for much, perhaps because it is difficult to pick up—jammed?—and the BBC comes in clearly. It has relay stations on Cyprus and on the island of Masirah off the coast of Oman. Because it programs direct to Afghanistan in medium and short wave, it gives the impression of a local broadcast.

IN AFGHANISTAN

The BBC announcer talked about events in far-off places: Poland, Washington, Cairo, London, New Delhi. I heard the name Babrak Karmal, the leader of Afghanistan, and derisive laughter all around. I fiddled with the radio. Russians speaking American English in barely noticeable accents came through clearly; there was Tchaikovsky from Radio Moscow, folk music on Radio Tashkent from Soviet Central Asia; from Radio Kabul, strident, haunting, Afghan music. A Radio Moscow commentator said, in American English, there were Zionist, Chinese, and American spies and soldiers in Afghanistan. The Soviet Union had come at the request of the Afghan government to drive them out. (These *mujahidin* have, thus, deduced that the Americans, Chinese, and Zionists, therefore, must be on their side.)

The next morning Mahmoud Shah, a mullah who seemed in charge, told me this would be my home for the next three days. He had black eyes, a raven-black beard, a stark white turban. That morning he taught a group of young boys with shaved heads and bright eyes the alphabet, repeating each letter until they got it right. They sat cross-legged in the room where we had slept, holding the small flat boards with letters and numbers on them, fidgeting and wondering when they could stop. Mahmoud is the boss. He is the only one who can read, write, and interpret the Koran. He told me he is the teacher for boys in all the villages in these mountains. Girls do not go to school.

He took me to a bunker dug into the mountain; nearby were a round, five-foot-deep hole where the village bakers throw dough against hot walls to bake bread and an old man with no teeth and a blue sport coat who worked on a mounted 12.7 mm single-barrel Soviet antiaircraft gun. The long black perforated barrel shone in the sun. The bunker held a desk with a typewriter, a mimeograph machine, four rope web litters, and, in the back, boxes of army socks, boots, ammunition, mines, and mortars; enough ammunition to last maybe an hour in a full battle, no more.

I spent the afternoon on the hillside, reading, taking notes, soaking my feet in the sun. Across the gully a group of men were building a clay brick house. Closer by, a boy about eight took two white mules, empty goat skins on their backs, down to the stream to get water. The bakers continued their work. A woman swept her front yard with a branch of leaves, and a fat, naked baby girl sat in the shade eating dirt. Her head was shaved, her ears pierced, and little bracelets dangled on her filthy, chubby wrists. The cook and three friends sat in the shade outside of the community house, drinking tea. Amir, the ten-year-old boy who had served me dinner last night, sat next to me, watching me write, exchanging words of Pashto for English.

A pack of four gray helicopters appeared over the mountains in the west heading southwest, high and far out of range. Certainly they could not see us down here. The cook saw them first and gave the alarm. Behind us, a hundred yards up on the northern ridge, a double-barrelled antiaircraft gun fired. Wham! Wham! Barrels pumping. Wham! Wham! The tracer bullets lifted to the clouds. The valley echoed. Then the old man with no teeth swung into action. He whipped the barrel around and fired, Kaboom! Kaboom! He watched the tracers, adjusted the barrel, squinted hard, and let loose a barrage with all the aplomb and steadiness of a seasoned thirty-year-old. From twenty feet away the sound was deafening. The helicopters kept going, but for the next hour you could smell the guns and feel the excitement in the village. With Amir, I went over to see the old man, now cleaning his weapon.

"What is your name?"

"Mazir Mahmoud." He smiled, his open, laughing mouth empty. He stuck out his hand, which completely engulfed mine. His was hard and brown and gnarled like a farmer's; mine was still soft like a city boy's. I asked how he drew a bead on a helicopter. Very methodically he showed how he judged a helicopter's speed and how he led it and when he fired.

"Have you shot any helicopters down?"

"No. They are afraid to come near."

"Where did the gun come from?"

"We captured it from the Russians and brought it here by camel." He proudly took my arm and stood behind me, directing me, showing me how to lead, like a father would show a son how to shoot a duck.

"I put this gun together," he said. "I taught myself how every piece works and how to fire it." He had piles of rocks braced beneath its tripod.

"How old are you?"

"I'm not sure, sixty-five, maybe seventy," he said. He smiled and shook my hand again. Mahmoud Shah had come over to serve as translator. He shouted the questions in Mazir's ear because the old man, the best gunner around, was virtually deaf. He had stood behind that gun in this hollow gully for a long time.

I sat next to Mazir at dinner. There were the men who were building a house, the gunners from on top, and other men from the village. Twenty men shared three bowls of bean curd. Again, I had my own bowl: this time scrambled eggs. I was embarrassed. The American egalitarian in me felt guilty for having better food than they. I tried to offer it to Mazir, to Amir, to the man on my right. They shook their heads and motioned for me to eat. It is their way. Another tenet of *Pushtunwali* is *melmastia:* A man shall be a good host.

After dinner I sat outside with the guard. He rested on his haunches against the wall, smoking, a rifle in his lap, his blanket wrapped around him and over his head. Each night the guard changed, and tonight it was his turn to walk through the village, through the bunker, and up near the antiaircraft guns.

The next morning my feet were better, and I hiked up the mountain to where two Hazara youths lived in a gray tent with a black and white puppy. They sat outside on the ground stoking a fire so the water in a black teapot would boil quicker. A few feet

away on the small, windy plateau was a well-cared-for flower garden; next to it an olive-green double-barrelled Russian anti-aircraft gun. They sat in its seats for me, twirled it around, poised the barrels by turning a handle. Mohammed Ali said he was twenty-four. Before the war he worked as a carpenter in Kabul, and his family lived in a small village in Ghazni Province in the mountains of the Hazarajat.

"There are no roads there," he said, "and there are wild tigers. Yes, even the white tiger, they say, though I have never seen it." He wore a ragged blue cloth around his shoulders, and his eyes sparkled when he laughed. Kamir, his partner, was quieter and not so happy-go-lucky. He had a severe face and a pencil-thin mustache and seemed to know what it is to be a Hazara among Pathans. Hazaras are of the Shiite sect of Islam, while most of the rest of Afghans are Sunnites.

The two sects formed centuries ago in a dispute among Moslems over the proper succession after the death of the Prophet Mohammed, who left no sons. The dispute led to the division of Islam into two political factions, the Shiites and Sunnites. Sunni means "custom" or "a way of living" propounded by the prophet Mohammed; the Shi'a are those who broke away. The Sunnites have taken their name from a collection of works on traditional law called the Sunna or the Tradition; that is, the sayings and actions of the Prophet, which are the second source of Islamic law (after the Koran). The Sunnites say they can nominate or choose the Prophet's successors. The Shiites say this can only come through divine right, through the succession of the Prophet Mohammed's cousin and son-in-law, Ali, and his descendants. The Islamic world is divided between these two much as the Christian world is divided between Catholics and Protestants. The Iranian Ayatollah Khomeini is a Shiite—most Moslems are Sunnis—and his broadcasts are beamed into the Hazarajat. But Mohammed Ali and Kamir do not have a radio in their tent, and when they go down the mountain to get bread or

to the stream to fetch water or to sit and talk with their friends below, they listen to the BBC. Their enemy is a common one.

Genghis Khan is one other reason that Hazaras are the lower class in Afghanistan. They have Mongoloid features, and it is a common tradition among Afghans that they are the descendants of the Mongol warrior who laid waste the cities of Afghanistan on his charge across Asia to the Danube. Tradition is a form of law in Afghanistan, and Afghans have long memories. Genghis Khan has never been forgiven for the destruction he caused 700 years ago.

Late that afternoon I went to the stream to wash. I found a spot where I thought no one would see me. I took off my clothes and washed them in the stream, beating them against the rocks as I had seen the women do. I laid them out on the flat stones behind me and hid naked under a tree thinking the hot sun would dry the clothes immediately. But I did not take into account that the sun would set more quickly over a mountain than on a flat plain. Gradually I moved my clothes higher up the mountain as the sun sank lower, until I sat near the top, stark naked, staring into the setting sun, waiting for my clothes to dry. It must have been quite a sight, but my friends, ever tactful, never said a word.

That night, after a dinner again of *khroot*, I climbed up the highest peak to see Matullah. The breeze turned to wind as I got near the top. I could no longer hear the bakers talking quietly in their tent down below. The community house where I had eaten disappeared from view. A solid stone house loomed in the night beneath a gnarled cedar tree whose branches grew only on the windward side. Next to it, four black perforated gun barrels reached to the sky. I stumbled over empty shells and knocked on the wood door of the stone bunker. I waited, knocked again. The wind blew. The door swung open, and Matullah stood behind his rifle and an eighteen-inch bayonet, thin as a stiletto.

"Matullah, it's me, the American."

He lowered the rifle. "Come, I did not think you would."

I ducked my head to enter. A teapot sat on the dirt floor. There were books, a quilt, a poster of Yunus Khalis with his Hizb-i-Islami insignia, a caricature of Babrak Karmal as a puppet and Brezhnev above him holding the strings, two sleeping bags, army blankets, two raised mounds of dirt which served as beds. Matullah had studied English in high school in Mazar-i-Sharif, forty miles from the Soviet border. He had gone to the stream that afternoon with his canteens to fetch water and learned there was a visitor. When he had come down for bread, he pleaded with me in English to visit him.

There was no sugar for the tea. I played with the radio, trying to find the BBC. I found the clear, confident, American-accented English of Radio Moscow and a score of stations with music from China to Arabia.

Matullah and his family had walked from Mazar-i-Sharif to Pakistan. It took a month. He was twenty-one and had lived alone on this mountaintop manning the Soviet antiaircraft gun twenty-four hours a day for a month and a half. He had two weeks to go, then would rotate to Peshawar and work as a clerk for another sixty days; then he would return. He was counting the days.

We sat on the ground drinking tea.

"Are there Communists in America?"

"Some, a few."

"Why don't you kill them?"

"Some people would like to."

"Do Russia and America hate each other?"

"They don't trust one another."

"Who is stronger?"

"America." He smiled, relieved.

Radio Moscow was offering up its daily drivel about Americans, Chinese, Zionists.

"Do Americans believe in God?"

"Yes, most."

"Do you?" He looked so young, sincere, innocent for a man who spent his days on a mountaintop firing a sophisticated anti-aircraft gun at helicopters, MIGs, and Antonovs.

"I don't know."

"That is too bad. You should be Moslem."

We drank more tea. It was getting late and colder. I played with the radio, and then I found a voice coming through in French; the announcer said it was Radio Monte Carlo, and for the next half hour we listened to rock and roll. He smiled and wondered at the strange sounds.

"Do you miss your family?" I asked.

"Yes. They are refugees. It is no good."

"Do you have a girl friend?"

"Girl friend?"

"A girl you would like to marry."

He was quiet for a while. "No, we are at war. It is hard."

This last thought made him sad, and he said it was time to sleep. He gave me his extra blanket and the quilt. I protested and he wouldn't listen. He took his rifle and found Radio Kabul and lay in his bunk listening to the music. A girl was singing. I listened to her and to the wind on this lonely mountaintop and, like Matullah, fell asleep dreaming.

In three days, one Antonov 12 Soviet transport, two MIGs, two packs of four helicopters, one with two helicopters, flew over. Mohammed Ali, Mazir, Matullah, and Kamir always fired at the MIGs too late. The Antonov and the helicopters never came within range. Mahmoud seemed to be right. The anti-aircraft guns kept the villages and the supply depots safe. But had the Soviet air force wanted to, it could easily take those guns out, which were sitting ducks on the top of the mountain. But it did not matter. No raids were launched. These villages had no strategic value. Perhaps they would come after them later; they certainly would if Matullah or Mazir ever connected.

* * *

The next morning my new escort, Nurisam, leaned against a tree, rifle slung over his shoulder, eating a handful of *jalghoza*, the small nuts which come from pine cones. He had a young handsome face, fine features, soft hands. We wound down the mountain and bore northwest over low undulating hills. We moved quickly, easily, through a valley, past villages, up to higher ground with only a few trees, then down again.

It was beautiful, like an American western Indian Summer day. We shared the pine nuts. The villages, only some of which had been bombed, were brown, small, part of the terrain, and peaceful; for the most part, there was no sign of war. At a stream-fed pool, three women chattered and laughed while they filled their jars with water. Their small sons and daughters sat in the dirt. The women wore black shawls over their heads, long wine-red cotton dresses; their black hair was braided. When they saw us, which of course was before we saw them, they looked away, grabbing their shawls with their teeth to hide their faces. The laughter continued. My escort looked at me, laughed, kept going. Small plots of land were separated by long low mud walls; a small boy watched a cow grazing; further on, a group of men with wood rakes cast the harvest in the air, separating wheat from chaff. Tranquil villages, green terraced pastures, cool water flowing by in narrow canals. Nurisam would always watch me, and he was a gentle man. He pointed out flowers along the way, trees, a cemetery, a village. Before long, I felt that I could trust him completely.

A man approached us. Nurisam covered his face with the part of his turban which hung at his side as we passed him. The man looked at Nurisam, then at me, said nothing, kept going.

Over the next ridge, we stopped and took turns target practicing with his Kalashnikov. We crossed a stream and came to a village, and he raised his rifle and emptied the clip, thirty shells, in the air. Little boys ran out, picking up the souvenirs. Shouts came from the men who had stood up to watch us. "Come, have bread with us!"

He smiled and said no. A man rushed out.

"Get rid of that turban. You are worthy of the best we have." He took Nurisam's off and gave him a bright black one with silver threads. Nurisam took it and tried to give me his. He was treated like a young prince. I had been told, back at the supply depot, that he was the younger brother of Jaluladin, the military commander of the province, to whose headquarters I was being ferried. He picked up a flower and put it behind his ear and gave another one to me; the fragrance was like perfume.

We came to another village, which was like an alpine hamlet. It sat on a hillside hidden among trees with thick trunks. The leaves were yellow, brown, and red, as if in New England. There was a delicious smell of pine burning and the sound of water cascading down the mountain. Nurisam was greeted by the men in the field like one of the family.

The house we entered was clean and cool, the cushions had small mirrors in them, and the ceiling beams were beautifully carved with designs reminiscent of the Tyrol. The windows were glass. Tea was brought to us on a metal tray and there was sugar. Mine was half-filled with sugar unlike his and, of course, much too sweet, but that, I was learning, was a sign of welcome and hospitality. We ate eggs and sugar, cornbread, and cool delicious sour yogurt. The man of the house and Nurisam discussed the fellow Nurisam had hidden his face from. Two tribes, a dispute, a woman. Everywhere it is the same: *cherchez la femme*. The host's young son came in and, seeing Nurisam, rushed over to hug him. He sat in his lap, and Nurisam let him hold the rifle. They pointed it out the window, and the boy, about six, fired. We had to go; we bid our kind host good-bye and pushed on.

By late afternoon we reached a stand of poplars at a narrow stream. We crossed and stopped at the base of a hill. There was a small shop with a wood railing in front at the intersection of two paths. Rifle fire came from the other side. I waited while Nurisam climbed to the top of the hill and returned.

"We must wait."

We sat under the poplars and listened. There were no bursts of automatic rifle fire, just single shots. A group of male Hazaras with small packs wrapped in cloth tied around their backs came by the other route, bought bread in the shop, sat in a circle in the shade and ate. Nurisam said they were probably going to a refugee camp in Pakistan. At sundown a dozen men with bandoliers and carbines came over the hill single file and down to the stream to wash their feet, their arms, elbows, and necks. They laid their rifles in front of them and bowed toward Mecca. Nurisam joined them and returned to explain, as best he could, why he could not go on.

He was of this tribe and part of a prominent family. A man from his tribe and a man from another had fought over a woman. There had been a battle. He took the end of his turban, placed it over his face. The man from whom he had tried to hide this morning was from the other tribe, and now Nurisam had been discovered. Another man would take me over the mountains.

Nurisam tried to give me money. He did give me his black silk handkerchief. We embraced and said good-bye, and I felt like I had known this man for years.

My new guide, one of the men who had fought, was ready, and as it was getting late, we had to go quickly. In a few hours we found a stone house on the side of a mountain in which to spend the night. The owner gave us bread and tea and a dirt-caked quilt for me to sleep under. My guide would go without. Before dawn the next day we were off.

We followed a narrow trail that gradually weaved upwards. The trees became fewer, the dry, brown, flaky soil more rocky. The higher we climbed, the more frequently we had to stop. The air got increasingly cooler, and the breeze dried our sweat when we stopped. We found a trickling stream of cold water; it was delicious. I drank less this time. We took turns carrying my pack, and we sat for long minutes watching the valley, the

mountains in the distance, a hawk in the sky, never talking. It was rigorous, stirring, and peaceful.

We met a man pulling hard on a rope hooked to his camel's nose. The animal was laden with two giant gunnysacks of wheat on either side and did not like the narrow, rocky, downward path. A camel can climb easily but does not like to descend with a load on its back. We met another man with a donkey, who had an easier time. They greeted us—"*Ah-salaam aleikum*"—and we returned the greeting—"*Astalah mashai.*" The words were not false. We rested at the summit. We shared some bread, raisins, and *jalghoza*. There were small patches of snow in the shade; the wind whipped our blankets, and the sun burned our faces.

We left the path and followed a narrow stream as it fell over rocks, working its way down. By midafternoon we reached flat ground. The sun was southwest. It was quiet, eerie. For hours we had seen no people, no birds, no animals. I could almost hear my feet echoing across the plain. It seemed as if this were the end of the world—empty, wide, windswept, magnificent.

Toward sundown, we came to a strong, rushing, milky stream and rows of broken clay walls, long-abandoned small plots of ground and other pathways. We walked past silent red clay compounds. The pathways were now of hard cracked clay. Wood doors were ajar. Holes and rubble showed where the bombs had dropped. Leaves rushed around our legs. It was quiet. The villages looked something like ghost towns in the American West, but, strangely, I knew I was not alone.

In the distance, a single waft of smoke rose from inside a red clay compound which stood alone on the plain. Coming closer, I saw an antiaircraft gun mounted on a tripod on a rock and a man sitting beneath it with a rifle across his lap.

My guide turned. "Jaluladin."

Against the gray jagged peaks in the background and the wide valley, the compound was small, insignificant. The whole valley seemed old and mysterious. It was of another world, another time. Genghis Khan's soldiers would have come across

here, thousands of them, on small fast ponies with clouds of dust rising behind, and when they had gone, it would have been as desolate and eerie as it was now.

Our arrival had been observed. A man approached us and, after a few words with my guide, escorted us into the compound. The walls were twenty feet high. Two giant thick wood doors that reached almost to the walls' tops stood open. The man led us down a walkway, under an arch, into a courtyard, past a group of men sitting around a fire, and up a flight of worn clay stairs. Outside a room, a boy about sixteen, wearing an Afghan army hat, held a Kalashnikov. We left our sandals by the door, lowered our heads, and entered.

As my eyes grew accustomed to the dim light, I saw there were ten men sitting in a semicircle, a lantern in front of them, and another man sitting across from them, his back against a cot covered with thick quilts. A *bokhari* stood in the corner. The room was adobe; there was a glass window and a carpet on the floor. A place was made for me near the man facing the others; my guide found a seat back against the wall in the dark.

Jaluladin, a mullah and the military commander for Paktia Province, second-in-command to Yunus Khalis, had tired deep-set eyes, a long black unkempt beard, and a cold. He looked sad and much older than his forty-three years. He was quiet for a minute, but, like the others, looked at me carefully. He wore white pajama-clothes, a thick green V-neck sweater, a skullcap over his bald head. A crumpled-up turban lay on the bed behind him. An automatic rifle with a mounted scope leaned against his bed.

A boy brought a pitcher of water and a bowl so I could wash, then a large plate of white rice topped with a nice glob of thick golden-brown honey and bread. Jaluladin motioned for me to eat and continued talking with the others. Because of the altitude or fatigue, I was hardly hungry, but not to offend, I ate; though all I wanted was to drink the entire pitcher of water.

Jaluladin addressed me, but I could not understand him. I was beginning to wonder how I would handle this when the man next to me leaned over and asked in English, "Is food good?"

"Terrific," I said. I tried to eat more, but couldn't. I leaned over and asked this man if I could have it for breakfast. He smiled—I saw a sparkle. He translated, and this, for some reason, got a laugh all around. And so began my friendship with Mallem, the translator, and my time with Jaluladin and his band of guerrillas.

"Did you have a good trip?"

"Yes."

"Are you tired from your journey?"

"No." I was tired, of course, but too excited.

"Where do you come from?"

"America."

Jaluladin stroked his beard.

"Why do you come?"

I said that I had come to learn about the human condition in Afghanistan, the courage and strength of the people, to know the *mujahidin* and the war. I said this hoping it would not sound pretentious. Mallem translated and there was a warm murmur of approval.

"*Ho-ah*—good. We are happy that you have come. You are welcome."

Jaluladin continued to stroke his beard. He looked tired, and there was no fire in his eyes.

"We will have time to talk. But you are tired now from your journey."

My orders given, I said good-bye to my guide, and Mallem, with a long thick flashlight, led me back down the stairs, through passages, and up to my new home.

I had come looking for a guerrilla leader with fire, purpose, compassion in his eyes; and Jaluladin did not impress me, though he had warmth. He did not exude a raw sense of power, though I sensed humility. Perhaps he did have it but did not

seem to show it, as I expected a Ben Bella, a Mao, a Ché, a Tito, a Ho Chi Minh would have shown it in their mountain camps. Maybe I—the Westerner—could not see it.

The next morning I was wakened before dawn by a man praying next to me. He went on and on, uttering each word, rocking back on his heels, pressing forward on his hands, his forehead vigorously reaching for the ground. Gradually my two other roommates gave in, rolled over, rubbing their eyes, peering out from underneath their blankets into the cold dark morning. We lay there. The man continued to pray. Mallem looked at me and shrugged. The other man said, in the clearest of English accents, "Don't worry, he's Egyptian, a fanatic. And a bad shot. By the way, the name's Guest, Ken Guest. Welcome to Shiekhot, secret mountain hideout of fierce guerrillas." I now had someone to talk to.

Ken was an Englishman. He had been here for four months, wandering from one guerrilla group to another, in the Panjshir valley, in Kunar, Nangarhar, Logar. He was skinny like a marathon runner, with long black hair to his shoulders, a beard, gaunt features; and he wore a Soviet winter army jacket under his blanket. He had three cameras, a small cassette player, a New Testament, and a thousand stories to tell. He had been a British Royal Marine. He had not had a bath in a month.

Finally the Egyptian finished his prayers, and Mallem returned with tea, no sugar, and cold hard pieces of yesterday's bread. Our room was on the second floor of the compound. It was six feet by twelve. There was a wood slat window at one end and a small wood door, actually two five-foot-high planks. Beyond, was our verandah, a ten-foot-square space, then clay brick stairs descending along a wall to a courtyard. Half a dozen *mujahidin* slept below us. Next to them were the horses and mules. To our left, above and below, were other rooms where men slept. In the large courtyard below were a stack of wood, open fires for cooking, and a *bokhari* from which the camp drew

hot water for tea. Beyond this was a storehouse, an ammunition cache, and a separate room where the heavy guns, mortars, and antitank rockets were stored. Above these rooms, on the second story across from us, was a small mosque, then an open space and the commander's room. The southwest corner was bombed out, a heap of rubble surrounded by a twenty-foot wall. The camp bakers worked in a small room which they had hollowed out there.

The Egyptian asked, in English, "Where are you from?"

"America," and this pious man lowered his head momentarily disgusted. I introduced myself. He followed.

"I am Major Rashid Rochman. What do you know about Anwar Sadat's death?"

I looked at him. How did he know? The BBC, of course. I explained what little I knew from what I had read in newspapers and magazines. Rochman seemed almost overjoyed, his eyes dancing, when I told him. It was frightening. He asked many questions about the assassination, about others who may have been killed. I had few answers, and he was disappointed. He wanted to know all I could tell him, how the attack took place, how many were killed. He drew lines in the dirt as I tried to explain what I knew. He wanted to know every detail. It would be the only time he was ever civil to me again.

"What are you doing here?"

"I have come to fight *jihad*, to drive the Communists from Afghanistan, but now that Sadat is dead, I can return to Egypt; and we can drive all corrupt foreigners, like you Americans, away. *Insh'Allah*."

Rochman said he was a former major in the Egyptian army, retired early for reasons he did not make clear. When he had gone outside, Ken said that he probably was a member of the Moslem Brotherhood. He prayed long and hard five times a day, and when not praying he read aloud from the Koran or went off to study with Jaluladin. He held all the Afghans in our com-

pound, for whom he had come to fight, in contempt. They, he found, prayed only two or three times a day, and then only short prayers, and were ignorant of the religion to which they subscribed. He was a phony. He came to pass himself off as a military leader and as a religious authority. He assumed the Afghans would revere him, a learned man who could fight, but Mallem and the others saw him for what he was—a hypocrite. The problem was that Jaluladin, their leader, liked him. Ken told me the story.

One year ago, Yunus Khalis's group bought or traded for— I could never get a clear answer from anyone—two SAM-7 antiaircraft guided missiles from somewhere in Pakistan. (The SAM-7 is a heat-seeking, low-level, surface-to-air missile launched from a tube fitted with a solid shoulder pad behind a pistol-grip firing mechanism. The Viet Cong used it effectively against helicopters and jets in Vietnam.) The missiles supposedly came from Egypt. From what I could find out in Peshawar, weapons from abroad enter Pakistan at Karachi and are sent within forty-eight hours up to Peshawar; there they are divided among the political groups most favored by the Pakistanis—though it has been alleged, it cannot be proved that the Pakistanis have taken the best for themselves—and then taken by camel over the mountains. The two missiles were sent to Jaluladin, but, like the mortars, mines, automatic rifles, and antitank guns had once been to him and his men, it was a strange modern weapon they did not know how to use. They fired it, aimed too low, and it hit the ground. Mallem, a former high school teacher acknowledged as an intelligent man, was sent to Pakistan for instructions. He returned, ready to shoot one of the dreaded helicopters out of the sky. Along about then came Rochman, disguising himself, so he said, as a journalist in Pakistan. But to the political leaders in Peshawar, he was forthright: He was a fellow Moslem with modern military experience ready to fight *jihad* with his brothers. Heady stuff. Plus, he could read

and write Arabic, the language of the Koran. He was to Ja-luladin, a mullah-commander, a godsend: He knew Arabic, thus he was far more intelligent than the Afghans around him.

Came the afternoon, yesterday, when they were to fire the missile. *Insh'Allah.* Mallem was ready; this was his day. But Rochman, modern military man steeped in the Koran, prevailed upon Jaluladin. It was God's will that he shoot the last precious missile. They prayed. Two helicopters came over, returning, as had been their pattern, in the late afternoon to Gardez after a bombing run over Urgun. They waited in a valley less than two miles from the compound. Rochman took the missile, and Mallem saw that the Egyptian had never held a SAM-7 in his life. But he faked it, fired, and hit the side of a mountain. "He killed many rocks," Mallem moaned. Jaluladin hid his disappointment. The helicopters swerved and one came back to see where the missile had come from. Everyone ran for cover, but the helicopter did not fire. On the way back to the camp, Jaluladin had said, "It was Allah's will." Ken had been forced to stay at the camp, and I had arrived a few hours too late.

"Was it God's will, Mallem?" I asked.

"I don't know, Mr. Jere. I don't know." Politely, he smiled.

Rochman had planned to stay and fight for many months. Now this morning, he was ready to leave. He returned from talking with Jaluladin. A horse would be made ready, and he could leave tomorrow. For the rest of that day I listened to him, argued with him, never gaining an inch. He hated me and all that I represented: I was not a Moslem, and I was American. At least I was not a Jew, he said. I admired his certainty but hated his self-righteousness, his cold eyes, his hate for me and for the Afghans he had come to help. He was the first man I feared in Afghanistan. In his rush to leave, he left behind a sheaf of papers which, like his other few possessions, he had guarded with his life. They were instructions with diagrams, in Arabic, on the workings of a missile.

* * *

Outside the camp walls were two captured single-barrel 12.7 mm antiaircraft guns, which sat openly on two small grassy knolls. A *mujahid* was to man them constantly. The morning after Rochman left, the steady drone of helicopters broke the morning silence. They came in from the east over the mountains, dropped down, and slowly approached us. There was no time to run. Someone doused the camp fire, and every man ran for cover so that from the air there would be no sign of life. I ducked into a room and hid in the corner, waiting. Every man was scared. I saw that the antiaircraft gunner was with us. They came closer, now were directly overhead. This was it. Every man's eyes looked up at the ceiling, waiting, waiting, waiting.

After what seemed an eternity, the helicopters kept going. They did not attack. Mallem later said he thought they were looking for where the missile might have come from. All I knew was that the gunner had run and that I and everyone in the camp had been afraid to die. No heroic stands with the antiaircraft guns, no attempt by fifty men to take them on with rifles, nothing but simple human fear or, perhaps, common sense. They wanted to keep this hideout a secret.

The next days were quiet, and a pattern developed in our lives. I got to know the men in the compound; and Ken, Mallem, and I became friends. Mallem, because he knew some English, was our roommate. Ken and I developed a bond that we would never have known had we met in the West. I was not accepted by the men in the camp, although they were curious and friendly and anxious to know me better.

We rose at dawn. Mallem prayed; Ken fetched water for tea from the community *bokhari*. I went to the stream which ran down from the mountains or to the small pool outside the compound whose water was brought by an irrigation canal, overgrown now with weeds. In both spots, the water was cold, delicious, invigorating. Thirty feet above the pool on a flat piece of ground below the antiaircraft gun, men prayed, facing west

toward Mecca. Often near the stream, one could hear birds sing-
ing in the trees and sometimes see a small flock of quail among
the scrub grass on the other side. We would have breakfast: five
or six glasses of tea—Duralex glasses, made in France, fashiona-
ble in Western homes, available in Bloomingdale's—and morsels
of bread. The mornings were cold and we would sit in our room
huddled in our blankets. According to Ken's British military
map, we were at around 7,000 feet. It was late October. I did not
want to keep track of dates. We lived like ancient men: we rose
with the sun; we planned our day around it; we slept when the
fire burned low at night.

At dawn the night sentry opened the giant wooden doors,
and the antiaircraft guns were mounted outside. A dozen ani-
mals—horses, mules, and donkeys—were led out to graze,
watched over by one of the younger *mujahidin*, of which, here,
there were at least five under sixteen. Most were deserters from
the Afghan army.

Aman Rulah, whose turn it was that day to watch the ani-
mals, is from Shir Khan, near the Russian border. He wore a
bandolier of bullets and was proud of the Spanish pistol that he
said he had captured, which he wore at his side. His turban was
white, and, like Ken, he had a Soviet winter field jacket. He had
been taken off the streets of his home town by the Afghan army,
flown to Herat for training, and posted to Gardez, not far from
here. The purpose is to always take a boy far away from his
home: It is tougher for him to desert if he has nowhere to go.
Aman escaped to the mountains and joined the guerrillas and
has, over time, proved himself. But that day, on a rotation basis,
he took care of the animals. I wondered about the man whose
jacket he wore, a man he killed, he said—someone his own age
perhaps; someone who lived only a few hundred miles north,
whose grandfather perhaps knew or traded with his; someone,
perhaps so like himself, Aman would not have wanted to kill if
he had known him.

The tending of the animals was not as menial as it might

seem, though. They were critical as fast transportation. There were no planes, no cars, no trains. One day, the command received rumors of heavy fighting in Logar Province. A man was dispatched by horse to see if the rumors were true, if they needed help. It was the fastest way to reach there. It took two days of hard riding to reach Logar and two days to return. Yes, there had been heavy fighting, the rider reported, but by the time he arrived, the fighting was over and the casualties many. The man ate bread, drank tea, and collapsed into sleep. He had ridden nonstop for two days, he said.

The main body of guerrillas, men whose loyalty was not in doubt, spent hours in the sun drinking tea, gossiping, doing nothing. There was no need to work; it was late autumn, the harvest was in, and soon it would snow. Their families were in Pakistani refugee camps. For days on end they did nothing. For the newer members of this group there was work. It reminded me of basic training in the army; new recruits had the worst jobs.

Kahir Mohammed was at the woodpile swinging an axe just after dawn. Next to the wall lay a stack of tree limbs which he had cut for the *bokhari* and the fires we used to cook over and huddle around. Kahir did not have an intelligent look about him. He was about six-feet-two and, in his Afghan army hat, long ragged Harris tweed coat too short in the sleeves, and army boots with neither shoelaces nor socks, looked like an awkward farm boy who could throw a javelin 300 feet. We became friends, two outsiders, and he told me his secrets in English. Before the war, country-boy Kahir was a carpet dealer in Herat.

"I have many friends in Germany, France, Holland, America. I was very rich man before Communists come. But I have some money still." He lowered his voice, "In Iran and . . . other places."

"Where? Zurich, Luxembourg, Beirut? Come on, Kahir."

He smiled sheepishly. "I cannot tell you."

"How did you come here?"

"One year ago, police come to my house where I live with my mother and put me on a big plane to Gardez. There they make me police, but I no like because they say I must fight. I will not fight my brothers. So I come here. I walk. But this no good either."

I had to admit chopping wood in the mountains, eating gritty bread, and sleeping in the dirt were not the same as sitting on a soft carpet, listening to Western music, drinking tea with Western girls, and sending money to Switzerland.

Many times in the evenings after work, this lonely man would sit by the stream and smoke hashish with Akbar, the camp baker.

Since I had arrived there had been no meat in the camp. One afternoon, Kahir borrowed a British Lee–Enfield .303 rifle, not a Darra-manufactured replica, but the eighty-year-old real McCoy, accurate up to a thousand yards—a rifle used to great effect in the Boer War and, Ken said, still used by British snipers. Kahir took four bullets and went off into the hills. Shortly after sunset, he returned with two quail in his pockets. We roasted them over an open fire, and they were delicious. While we ate, he brought out two unused .303 cartridges. Two bullets: two quail.

The next day, I joined him with three others. We took Kalashnikovs and Lee–Enfields and went to stalk quail like commandos stalking an elusive enemy. It was meat we lusted after.

The quail were 400 yards away when we first spotted them in the field across the stream. There were six. Each man had four bullets. The wind was in our faces, and we spread out and stalked them bush to bush, tree to rock, fifty yards apart. Kahir was our leader. The wind died down; we waited. The quail moved on, unaware. The wind picked up; we advanced. They took flight up a rocky mountainside; no matter, we went after them, rock to rock. I watched as these men moved up the mountains after quail. They blended like deer into the mountains, and

they waited patiently. This went on for two hours. Finally one of the young men stood up, aimed, and the quail were gone over the top. Kahir cursed him. The wind was now getting cold, the sky was gray and bleak, and we were disappointed: Our hearts were set on meat. We were sick and tired of bread and tea.

A half a mile from camp on the way back, Kahir froze. A lone bird stood on a rock 200 yards away. We knelt down. Kahir rested the barrel on a rock and squeezed off a round. The shot echoed and the bird fell.

Kahir was almost a prisoner at the compound. He was free to move about, but he could not carry a Kalashnikov. Mallem said if he worked hard and proved himself in battle he would be accepted, but I knew he wouldn't make it. He said he would leave one evening after prayers and walk to Herat. It would take him weeks. He would sneak in to see his mother, then he would cross the border to Iran, to get his money. Afterwards, he didn't know.

"I am not a fighter. I do not like to live like this. I will go, maybe to Turkey, to Germany, to America. I have no papers, but I have friends who have bought my carpets."

After prayers, he went to the stream to watch the stars and smoke hashish—alone, huddled under his blanket. He had no home left, and when he went west to Herat, would he be safe, and would his mother be there, and could he cross into Iran and get his money, and would his friends who bought carpets from him long ago and drank tea in his shop remember him when he came knocking at their door in Hamburg one night?

By midmorning the sun was warm enough to bask in. Jaluladin was in his room; Hekmatullah, his secretary, was with him. Ali Jan, his bodyguard, stood outside, mugging for my camera, wearing sunglasses. Hekmatullah emerged, shouted at a man down in the courtyard, disappeared inside again. He was Jaluladin's right-hand man, a skinny, high-strung, pompous know-it-all who gave orders to everyone and was hated by all.

His authority rested only in his relationship to his boss, to whom he was dedicated and for whom he carried the hatchet. I had to laugh. He reminded me of a lot of people I knew from my days as an aide in the Senate.

One morning he went around camp checking to see how much ammunition each man had. He came to a quiet old man who normally kept to himself and demanded to see his bullets. The old man looked at him, then quietly placed his cartridges on the blanket. Hekmatullah counted them and demanded to know where the rest were. The old man, whose turban was dirty and whose cheeks were drawn, sat cross-legged with his rifle across his lap. He opened his left hand, and there was a shiny .303 cartridge in it. He said quietly, "This one is for you. It will enter your head one day when you are walking along the road if you ever call me a thief again."

And there was Akbar, the baker, who often came to have tea with us at night. He slept alone in the southeast corner of the camp in the same room in which he baked bread. His hands and movements were soft, and his eyes green, when not bloodshot. The baked clay oven sat in the corner of a room, a conical cistern with a hole at the top and roaring flames inside. I went to see him, and he stood behind the oven, peering at me, his eyes glowing like a cat's. The shadows of the flames danced on the wall. His helper, a thin boy of about fourteen with beautiful eyes, stood near him. The bread would be ready by sunset. Every day it would be ready, flat, brown, crisp unleavened loaves, like medium pizzas, enough for every man in the camp. He was being diligent today—no more hashish. Because one day, he had had too much, and he heated the oven up hotter than ever before, and with his eyes glazed by the fire and the weed, he beat and pounded the dough and slapped it against the hot sides of the wall. The more he worked, it seemed, the hotter his passion. He got more water, extra salt, and the rest of the wheat; and he worked and sweated until the flame was low and the wheat almost gone and the char had run its course. And that

night, he finally came down from his trip to the moon. There were fifty men in the camp that night, but there was enough bread for many more. There was bread for breakfast, and the same bread for dinner, and for breakfast the next day, and dinner again. The day after, there was no bread at all.

The weather got colder. I slept in spurts, and I woke up shivering and found one morning that ice had formed around the small pool outside the wall. There was a small fire in the courtyard, and a place was made for me around it. I had been here maybe two weeks, and I still did not feel a part of them. Ken did; he'd been here a month and had been under fire with them.

There was no food one morning.

The weather got worse: The wind was colder, the trees were almost bare, and there was ice every morning now over the pool where we got our drinking water. My feet had not healed, and now I had a cold. We took a five-gallon tin can, cut a hole in the side, and built a fire with cedar kindling in our room. The smoke was so thick we couldn't stand up and had to crawl to the door, but it was worth it. Outside, men huddled around small fires in the predawn cold, but tea, eternal tea, is hot and soothing on a sore throat. The word for tea in Pashto is *chai*. The word sounds essentially the same from Morocco to China: always—in Turkey, Iran, the Soviet Union, Egypt, Afghanistan, India— *chai*.

Jaluladin sent Ali Jan over with a glob of honey, part of his special Dutch brand requisitioned from the bazaar in Gardez. The sun rose over the gray peaks and into our faces, and its warmth changed our spirits. We spread honey on the bread and took it with tea, this Continental breakfast.

Hekmatullah walked in and announced to Mallem, whom he hates because Mallem knows English, that the commander would take the foreigners up to the ravine to where the heavy

armor was hidden. Ken and I exchanged looks; Jaluladin had kept himself apart since that first evening. Hekmatullah's manner was condescending. There was no reason we should go. Jaluladin, who had met other journalists before, probably saw some merit in the trip. He'd been around. He had traveled to Pakistan, Iran, Saudi Arabia, the Emirates. He said he received money from private businessmen in the Persian Gulf. If he had decided to use us, then the honey was a fine start. A man who can provide food has power over another.

The horses and mules were saddled up, and we set out south across the valley before the sun was directly overhead. There were four men on horses, two on mules, ten more on foot. Jaluladin led. With his Soviet AKS-74 with the mounted scope strapped across his back and his wide white turban, he was like a Sioux chieftain. In three hours we reached the ravine, and around a bend, hidden beneath cedar branches, was the secret cache: two old T-54 Soviet tanks, undoubtedly captured from the Afghan army; a World War II vintage 57 mm Soviet mountain gun; a 57 mm Russian recoilless rifle; half a dozen new RPG Soviet antitank rocket launchers. We boiled water for tea and had *khroot*. After prayers, a man named Bader Khan drove one of the tanks, and some of the men climbed on for the ride. It coughed up chunks of black smoke, making a great roar as it clambered up and down the ravine. Khan Walli, Mallem, Jaluladin, Ali Jan, and a few others smiled and posed for pictures like proud schoolboys on their big twentieth-century toy, but it was a pitiful sight—these were useless relics. They said they would drive them back over the mountains before the snows came and use them to attack Gardez in the spring. We all laughed and had a grand time, but, in truth, it was sad. When the tanks were out in the open, clanking across the plain, the helicopters would destroy them. They were so happy showing us how they would die.

The men and mules would return by the same route; I

would go back to camp on horseback by a different path with Hekmatullah and men named Akram and Mousa. Mallem looked at me. "Be careful, Mr. Jere."

The four of us rode further up the ravine and into a valley surrounded by two peaks. The ground was soft. There were cedar trees. The horses picked up; Hekmatullah took the lead and turned to watch me. We reined in and took a path leading through a narrow rocky gorge and into a small valley that was like another world.

On the slope on our right, little children and their mothers stood in silence, staring. Behind them were the caves in which they lived. They were barely covered in rags. A small cedar fire burned; a single donkey stood nearby. A stream flowed next to us. I asked to take a picture, but Mousa said no.

"Maybe they will think it is a gun or something to steal their souls."

I wanted to stop, but the men said no. We kept on, and I felt that I had entered the Bronze Age.

We rode through the far end of the gorge and onto the plain. Mousa clicked his teeth; the pace quickened. They looked at one another, then at me. Here it came: another test. But this one I was ready for. I had watched Hekmatullah rewrap his turban a few minutes before. The plain was wide, with low undulating hills, stones, and scrub grass. The sun was about to set, and our shadows were long. I swung out to the left of Mousa, pulled even for a second with Hekmatullah to show him where I was, and dropped back. I let my imagination go: the wind, the sun, the horses' hooves, like the Sioux riding free and wild across the Great Plains. Turbans for headdresses, blankets wrapped around them, rifles slung across their backs, laughing in the wind. I leaned over, pressed my knees and heels in, and hung on. Luckily we had had horses when I was a kid. We all took off.

I pulled even with Hekmatullah, raised my hand in the air, and cried "Geronimo!" I couldn't resist; he deserved it, and we

raced across the plain. In five minutes it was all over. The horses were frothing. We slowed them and walked. Mousa and Akram grinned wide like happy ten-year-old boys. Hekmatullah rode ahead.

That night we had potatoes from the bazaar in Gardez, onions, salt, and a bouillon cube from Paris cooked in a black pot over an open fire. Akbar had kept his cool, and there was fresh bread and small hard candies to suck with the tea. We sat in our blankets against the wall, while Mallem stirred the pot. Mousa, Aman Rulah, Kareem, the old cobbler, and the elderly man who was the night's sentry joined Ken, Mallem, and me. I wanted Kahir to join us and looked for him, but he was nowhere to be found. I wondered if he had gone. Mallem poured the steaming mush into a bowl. Ken offered the prayer.

We tore off chunks of bread, dipped them in, and began. Each man ate his small portion slowly. A pitcher was passed around, and we drank from the spout. Mallem, in his quest for the perfect stew, had added too much salt. Later, other men joined us, chewing tobacco, spitting it on the floor where I would sleep, talking, drinking tea, stoking the fire in the middle of our room.

In time the others left, and the three of us were alone, friends talking freely. Outside it was cold and overcast; tonight there were no stars. We sat around the fire, needing each other's company. We were more and more a family within this family of guerrillas, hidden—or trapped—in the bombed-out walled clay compound, somewhere in the mountains of Central Asia.

Mallem was melancholy. He lay propped up on his elbow, his blanket drawn around him, listening to the voice of a woman singing, surely about love, on Radio Kabul. This morning, he had sung to himself as we hiked up the ravine. I tried to teach him to whistle.

"But Mr. Jere, I no can."

This gentle man, who was forever writing English words

and their Pashto equivalents in a small grimy notebook, was only twenty-five, yet behind his vulnerable, smiling, mischievous face, he seemed well over forty. His wife had died five years ago in childbirth, when she was sixteen. Tonight, he talked about her.

"It is no good for a man to be alone, Mr. Ken. A man should marry; a man should love God; a man should be free. And if God smiles, a man should have children."

There was a girl—"very, very pretty, Mr. Jere," he said, smiling, but totally serious—he had had his eye on for some time. He had seen her in a refugee camp in Bannu, Pakistan, months ago, and he had thought about her daily ever since.

"But I have no money. My village bombed, my family gone, I am alone."

"Do you like to fight, to fight back?"

"Fight? No. I don't like to fight. But I must."

"Is it good to die?"

"Yes. Yes. This is good for us. It is for God. We go to *Janat* [Paradise]. This is way of God."

In this holy war against Communism, if a man is killed in battle, he is a *shahid*, a martyr. He goes directly to heaven; he is not held to account for his earthly sins. But if a man dies running, he is a coward. He cannot go to heaven; he cannot be buried with Moslem rites; he becomes a ghost, his family forever ostracized.

"Is it better to live or to die?" I asked.

"Not important for us. Important is this: to live the way of God."

"It is more important for you to fight for God than to win?"

"Yes. Yes. We fight until the death."

I thought how they—all of us—had run for cover when the helicopters had come over. Fear. In spite of *Janat*.

Mallem was not a fanatic. He had been the principal of a boys' school in Gardez. He had completed high school, and he had an inquiring mind. He loved to joke.

"The world is crazy, crazy, Mr. Jere," he would say, always laughing, and you knew he wanted it to be put right.

"Mr. Jere, you crazy!" he would say, too, with a twinkle in his eye.

The girl he wanted to marry was twelve, and her father wanted $5,000 in Pakistani rupees for her. Mallem had only some books, a Kalashnikov, the clothes on his back, and his old father in Pakistan. He asked me about my home, my family, the village where I live.

"Is your home like this?"

"No." And I hazarded to tell him that I lived in a city bigger than Kabul, where there were even two buildings over 100 stories high.

He thought for a minute.

"How long does it take to walk them?" he asked. He looked at me with that questioning, yet believing, look in his eyes.

"I don't know."

"You must find out, Mr. Jere. I would like to know."

"Yes, Mallem." But how could I explain an elevator to him?

"Where is America? Does it take long to walk there?"

I pointed west. "Over the mountains. It would take a day if we flew as fast as the Russians' jets. To walk it would take many months, and we would have to cross a great body of water, bigger even than Afghanistan, to get there. This is called an ocean."

He sat quietly, thinking about that for a long time. "Ocean, Mr. Jere? I no understand. How can so much water be?"

I explained it to him again, and still he could not understand. I told him that when here it was afternoon, in America people were still asleep, their day not having begun. This, too, he could not understand. Yet Mallem I would trust with my life. And I know too that if he had to, he could make it in someplace like New York.

The music had stopped on the radio.

"Are the women also pretty in America?"

"Yes."

The next morning there were six inches of snow on the ground. Our world was totally silent, mysterious, and more dangerous. If the helicopters came—if the Antonov was looking for us when it flew over low yesterday—we could run, but there would be no place to hide outside the walls, no place to blend in with the countryside. Also, no supplies could come over the mountains—again no sugar. We had tea, potatoes, bread, and wood for the fire. We were out of salt. Mallem went off to scrounge for some, his purple shawl wrapped around him like a prince in Tamerlane's army. So we stoked up the fire, put a music tape in Ken's cassette player, and told stories and tales about characters, the many characters who had come to Afghanistan.

There was the legendary Italian Rafaello, a former horse trader from Mazar-i-Sharif, a devout Moslem who supposedly could discuss, in Arabic, fine points of the Koran and ride any horse he sold. He spoke Pashto, Persian, Urdu, his native Italian, and the language of his adopted homeland, Australia. The most devout Moslem among Afghans, he could drink beer and swear like an Aussie. He became a free-lance journalist. He had a deal with an American television network, but when it reneged, so the rumor went, he sold his film in Europe for $25,000 and headed for his ranch in the outback.

Guillaume first showed up in Peshawar at Dean's with a scarf, sunglasses, and a ring in his ear. His mission, so he said, was to assess Soviet tactics in the mountains and to return with remnants of their weaponry. He was seen in Konarha Province traveling with a group of guerrillas, listening to Wagner on his Sony Walkman. He appeared at Dean's in Peshawar a month later with an RPG Soviet antitank grenade launcher. He wrapped it in a Dean's white cotton towel, caught a bus to Islamabad, and has not been heard of since.

IN AFGHANISTAN

* * *

Half a dozen men from an American military magazine showed up at the Intercontinental Hotel in Peshawar one day in jeans, cowboy boots and hats, and registered as carpet salesmen. All of them. The Pakistani police appeared and quietly asked them to leave.

Anthony Davis, an English journalist based in Bangkok, had been waiting a month in a small Afghan village just south of the Amu Darya River for a group of guerrillas to cross and raid into the Soviet Union. He wrote a letter to his friend, John Fullerton, in Peshawar, and it arrived by hand a month later.

"It's a good life here, old boy. The living's easy, there's honey and yogurt. The leaves are bright, and the fall weather is brisk and pleasant like a fine English autumn."

The boy who delivered the letter to the hotel said John should answer, and so he did, and the boy took the letter that arrived a month from then, dirty and crumpled, at a small mud-hut village on the steppes of Central Asia after changing hands a hundred times. But it got there.

Aernout van Lynden, Dutch ex–Royal Marine, became the first journalist to sneak by the military checkpoints and into Kabul. Once he spent forty-eight hours in the bottom of a well, hidden by his guide, Shir Naabi, the same man who I had met at Dean's Hotel, while the fighting went on above him. In Kabul, Naabi brought him Coca-Cola every day. He had his dispatches carried out to Peshawar from there and sent to Islamabad, where Reuters wired them to Europe and America.

A French journalist with Agence France Presse went in with two horses. He somehow knew what to expect and was right. His first horse died underneath him, in Registan, the wasteland between Kandahar and Pakistan.

* * *

Hectario Mo, an Italian journalist for *Corriere della Sera*, a stocky forty-four-year-old, went in with Steve McCurry and Peter Juvenal, an English war correspondent and expert on guerrilla warfare. On the way in, Mo gave his shoulder bag to an Afghan to carry for him, and the next day the man was gone. When he came out ten days later, Yunus Khalis, with whose group he had traveled, paid him twice the value of everything in the bag.

One night, Ken Guest and a cocky young man whose name was Abdul Mohammed were talking. The stars were bright and the moon was full. Mr. Ken had said how extraordinary it was that the Americans had actually sent people to the moon. Abdul went to the doorway and looked up at the sky for a long time. Then he sat down again and crossed his legs.

"Not possible. I cannot see them." And that was the end of it.

The door opened. A cold wind blew in, stirring up the dust. We had a visitor—a fat bearded Pakistani squeezed through the door and flopped down on the ground.

"Good morning. My name is Abu Zar Ghaffari and I am columnist for the *Nawa-i-Wayat* [Voice of the Times], the largest daily newspaper in Pakistan."

Our secret mountain hideaway was getting a little crowded.

Abu spoke English, Urdu, and Pashto. He was an arrogant, opinionated, strange, romantic Punjabi who would never shut up. "I came here in 1979, '80, and now I come in the fall of '81." Pakistan, being on Afghanistan's eastern and southern borders, was the nation second-most affected by the Soviet invasion, yet, "I am the only Pakistani journalist to visit Afghanistan. And I had to borrow the money from my wife, who does not understand me. She thinks I am crazy.

"You Americans think we Asian men treat our women like animals; it is the other way around; my wife controls the money

in our house; she gives me an allowance, which is how I could come here."

He took leave from his newspaper in Lahore—they would not send him—and caught a bus to Islamabad, changed, and took another to Peshawar. He had his contacts and made his way in with a horse and guides, much, I suppose, as we had. How he loved the Afghans. They were all that the Pakistanis—"like the Indians, a slavish people"—were not.

"They are proud men. They walk with their backs straight. They look you in the eye. They believe in God, and they are not afraid to fight. They are men. They are free.

"The Pakistanis did not fight for their freedom, like, for example, the Algerians. The British gave it to them. They do not know what freedom is. They are not free mentally and so do not understand its value. Pakistanis are not interested in Afghanistan. Sometimes I believe the government only talks about Afghanistan so that it can get money and F-16's from America to protect itself from Indira Gandhi.

"Look, Mr. Van Dyk," as he always politely addressed me, "I will tell you the difference between my country and Afghanistan. Pakistan prefers food to freedom; Afghanistan, freedom to food. Pakistan prefers slavery to death; Afghanistan prefers death to slavery. How else could two to three hundred thousand Britishers rule four hundred million people? One hundred thousand Russians cannot control fifteen million Afghans."

This fiercely proud man who despised his country and much of the world had come looking for an ideal—strong noble men, in a perfect state. He, like most men, saw only what he wanted to see. He was the type of man who would love to cry out, like the handsome young Saint-Just, "The world has been empty since the Romans."

The next morning I went outside to be alone, to get a drink from the stream, to sit and do nothing but contemplate the still white valley, the jagged peaks, the water rushing by as it had for

thousands of years. A young girl, dreaming of love, might have drawn water here, or a young man, dreaming of wealth and glory, stopped to drink, a woman to wash clothes, an old man, to wash his arms, elbows, and neck before praying. There was a peace in the world that does not come in the city, and in Asia there is a world without time that does not exist in the West. A man can watch the water flow and a bird fly and take joy in it. There is a beauty here which can give goosebumps.

The drone came first, destroying the silence, then four specks like hummingbirds in the distance appeared in the south. I did not move like the first time; I could hide under a rock. The helicopters were returning to Gardez after a bombing run over Urgun. Before, they had followed the ridge; now they came toward us, growing from hummingbirds to hawks. Rughi, the sentry on duty, a man who lost his right hand throwing a plastic booby trap, raised the red bullhorn and sounded the alarm. The antiaircraft men did not run like before. No one ran from the compound. A man is too easily seen in the snow.

"This time we get it," I thought. "We're next."

Ken, Mallem, and Abu were inside. Before, I had panicked; this time I sat there, curious and excited. The helicopters were within range now, but the guns stayed silent. The great hawks bore in, 800, 600, 500, 400, 300 yards away . . . A line of gray smoke from the *bokhari* rose to the sky.

"The fools, why didn't they put it out?" The helicopters turned north. Either they did not see the smoke or the guns because of the sun or, for some reason, did not care. They knew where we were. They would return. But for the moment, we were spared. I wasn't as scared this time. Does it get easier as you go, or do you have to keep cutting it closer to the edge?

That night, the fire in our stove, fed by dry cedar sticks Mallem had found, sparked and crackled. The smoke made you cry. A black pot sat precariously on the tin-can stove boiling potatoes, onions, salt, and our last French chicken bouillon cube.

Tonight there were Mallem, Ken, Abu, Kahir Mohammed, Khan Walli, the camp's best mortar man, and Bader Khan, who normally kept to himself and thought little of the foreigners. But Mallem's stew was becoming popular; soon we would have to turn them away or start charging at the door.

Tomorrow, Walli said, fifteen men would go to Tamania, an Afghan army base, and attack it with mortars. Until then, I did not know Tamania existed.

I slept poorly all night. My resistance was getting lower. The cuts in my feet had not healed, and my sore throat and cold would not go away. The fire had gone out, and I lay there shivering while the others slept, lay there thinking about friends and family. I was not lonely, I just thought of them. They did not, for some reason, seem so far away, although the world in which they lived did not exist. Outside, the wind blew and inside, Abu snored peacefully.

I woke feeling miserable. The sun was already up. Mallem was still asleep, lying on his back, his purple *pattu* over him like a shroud over a dead man's body. He stirred, rose up on one elbow, smiling.

"Prayers, Mallem?"

"Not today." He smiled sheepishly. "Bad sleep." He covered himself again like a delinquent child.

Ken had brought the tea. I would have given anything for some sugar.

Two mules were brought out and saddled with rope-frame packs. Khan Walli and Kahir loaded one mortar, twenty-six shells, four RPGs. When the animals were ready we walked them through the main gates and congregated with the others below the antiaircraft gun and the rock where men prayed. The sun shone brightly, and the snow was already melting. The men gathered around in a circle like players do around their coach before a game. It was *Azon*, the call for *jihad*. Jaluladin prayed and each man bowed, then raised his hands to the sky, palms

upward, to receive the blessings of Allah. For a moment it was silent; then each man, single file, passed underneath an unwound turban held by two men over the path. A Koran lay wrapped in the cloth. They shouted, raised their rifles. I had an eerie feeling passing beneath the banner, for I was now with them. We walked along the stream, enjoying our strength and the brisk morning air. The water rushed noisily past, singing, it seemed, over the rocks. There were trees nearby, and the snow was soft beneath our sandals. We left the stream and turned north along a goat trail, through a gorge, and then down onto a wide plain; there was gradually less and less snow until, down on the flat sandy wasteland, there was none. We sauntered on, like a group of boys going on a picnic, bantering, singing, joking as if no one had a care in the world. Mallem, trying to whistle; Kahir Mohammed, with a rifle slung over his Harris tweed; Aman Rulah, with the Spanish pistol; Rughi, one-armed; Khan Walli, forever smiling; Ken, in his Russian jacket and shoulder-length hair; and among the others, Islahan, the loud, overbearing, overweight, arrogant character who considered himself commander by virtue of being the younger brother of Jaluladin. No one could stand him. He had fat greasy cheeks, a two-week growth, a new silk-threaded turban which stuck out a foot around his head, and he held his rifle by the barrel, propped on his shoulder.

The excitement turned to boredom, boredom to fatigue. The sun climbed; the ground became hotter. The sun had passed over us when someone shouted, and I turned to watch a man on horseback approach at a fast gallop. It was Toothless One, a slow, fun-loving army deserter with shiny black hair and a bright dumb smile, with our lunch—hot baked bread, wrapped in his turban and tied around his waist. Hearty shouts of welcome. Now at least we wouldn't starve. More banter, jokes, and laughter until Islahan made him climb down and carry the bread while he mounted up himself, the better to ruie us. In the heat, tired and hungry, I despised this man.

We reached a deserted, sun-baked village with magnificent thirty-foot walls, giant shade trees, stagnant irrigation canals, and craters where the bombs had dropped. Khan Walli showed me a patch of saplings that were cut off evenly four feet high, as if with a scythe.

"Helicopters."

The helicopter machine guns fire so rapidly that their bullets cut like a blade across grass.

There was one house within this deserted maze that was occupied. We entered and inside it was cool and dark. Red-black pieces of meat hung from a wood beam; a pile of onions lay in the corner; aluminum pots, clean and dull, were neatly arranged next to them. In another room, hotter because two wood window openings in the slanted ceiling were propped up allowing light to enter, a skinny old woman with a shawl drawn over her eyes and held in her teeth put out cushions for us to sit on. Her braided hair was stringy and dyed red, and her ankles were wrinkled and as brown as the dirt. She wore several bracelets and around one ankle a narrow band, like young women in America and Europe. Chattering, giving orders to everyone, she directed us, demanding, I suppose, that we sit and make ourselves comfortable. The fifteen warriors, mindful of who was in charge here, took their places. The man of the house sat next to me. A cloth was spread out, and we had bread and green tea with small candies. I took as many as I could get and stuck them in my pockets. I was tired and the walk had made my cold much worse. This tough American wanted to sleep for five minutes, but the host wanted to talk. They always do.

The villagers had fled to Pakistan. "I fought *jihad* in Kashmir many years ago, and after that I said I would not leave again. They can all run; I'll die here." He stared ahead.

"How old are you?"

He stopped to think, reflecting, no doubt, on the Kashmir war of 1947, when Pakistan, within a year after independence, fought India over Moslem Kashmir—the death of comrades, the

great cause when his spine tingled with passion, and the years which have now blurred together.

"I was in my forties in Kashmir. I must be seventy-five or eighty now."

Kashmir, the high point of his life. Now he could relive it and contribute to Islam by running a safe house for guerrillas. It gave him purpose. We shook hands and he stood straight as he watched us go.

The fort was still an hour's walk away. We would take the mules and split into two groups. It was hot; the ground was hard and cracked. It had not snowed here, and the fields had not been irrigated in two years. My throat was already parched from the dust.

The compound from which we would fire the mortar was once the home of a rich man. The walls were twenty feet high with turrets at the four corners; the courtyard was overgrown with brush; and the rooms were empty. Other abandoned compounds of white sunbaked adobe were spread out for half a mile around us.

Five hundred yards west, a square adobe prisonlike fort with towers and barbed wire strung across its high walls dominated the plain. It was our target. Mousa and Kahir with rifles left to scout out the other compounds; three men took up positions on three turrets, and Rughi, who would serve as forward observer with his fine pair of binoculars, sat on a ledge just below the turret nearest the fort,

Khan Walli and Mallem set up the Chinese mortar, carefully adjusting the calibration. Other men put firing pins in the clean gray shells, each one a rocket a foot long. Toothless One went off in search of water; one of the men, Yaqub, built a small fire for tea—certainly the most stupid move of the day. The smoke would give our position away. But who cared? They were having fun, yakking like a bunch of schoolkids. Islahan stood around, hands on hips, giving orders. Mallem asked who had brought a radio. A radio? A fire, tea, now music to mortar by?

But no. A radio was critical because the Afghan army operated on a frequency which can be tuned into on a normal transistor radio. The guerrillas could judge the effectiveness of their mortar attack through messages that the Afghan army sent out. If the mortars fell on target and the fort had to call in for helicopter support or decided to come out after us, we would know it immediately. No one thought to bring the radio. Islahan shrugged. Mallem showed concern. "This not good."

The mortar was ready. One by one, each man took a shell in two hands, shouting *"Allah O Akbar"* for courage, and dropped it down the barrel. A blast—cheers—and in the distance, boooom! Tea was drunk, the mortar sight recalibrated, more shells, calibrated again, more shells. I watched with Rughi and saw smoke rise from inside the compound. More shells, more tea, more jokes.

Then the tables turned—Kawhom! Kawhom! The tanks or artillery from inside began to hone in. They did not know where we were, but on both sides of us and behind us, the shells began to fall. I'd never been under fire before. My heart pounded, raced, and I saw that I was not the only one afraid. The mules became skittish, and their heads had to be covered so we could load them. The rounds kept coming. *Come on, man! Let's get outta here. Now!* We strapped the mortar on, and the RPGs, and cleaned up the compound as quickly as we could. There was nothing to do but walk out quickly and keep the animals quiet. We split up into four groups instinctively. We walked. The shells came in. We walked. A shell landed twenty yards away. We hit the dirt. We got up, kept going. The tanks never came out after us. In half an hour, we were out, safely beyond range.

The sun had set, and we did not have a lantern. We had eaten all our bread at the safe house. Now Mallem, Kahir, Aman, Ken, and I plowed through the night. After four hours, I was dazed, dizzy, weak—a combination of my cold, no food, freezing weather. The stupidity of the day. To what end? This, it seemed, was the Afghan at his worst: no planning, no purpose,

no results. The men stopped to pray, and I all but fell asleep in the sand. We pushed on. It was so dark that we could not see five feet in front of us. We stumbled over rocks and Kahir cursed; he, too, thought the whole thing was stupid. I knew now he would leave as soon as he could.

Then Mallem began to sing softly, at first to himself, then a bit louder. Kahir and young Aman and, behind me, Khan Walli joined in.

No, it had not been so stupid after all. My fatigue disappeared. We were six men walking in the night, six men who could easily have been hurt or killed a few hours ago; and if we were all tired and hungry and mad that Jaluladin had made us do this, we were here, together, alive. The sky above us, the earth below, friends around me. I felt, for the first time, no longer an outsider.

Sometime before morning we sloshed through the stream and pounded on the giant plank doors. The sentry let us in. There was no food, no fire, no tea. We built a fire and heated water. Our eyes were glazed with fatigue. After the tea was gone, we fell asleep on the floor.

Two days passed. My cold got better. The sun returned; the snow melted. Abu was with Jaluladin in the commander's room. Ken was reading James Michener's *Caravans*. Mallem was cleaning his rifle. The morning wore on, and more and more men, from who knew where, arrived for the special event. There were 200 men in the camp, resting on their haunches, their rifle butts on the ground in front of them, sitting in small circles or alone like lazy dogs lying in the sun, waiting. "Today Rasheed returns," was all Mallem would say.

In the early afternoon there was a great shout and two rifle shots, and the men rose and filed out behind the fort to greet the visitor, who arrived on foot with his armed escort. Jaluladin was there to meet him, and when he shook his hand, 200 *mujahidin*

fired their rifles into the air. Kareem, the cobbler, got so caught up in the excitement that he grabbed a Kalashnikov and, having never fired one before, missed emptying a thirty-bullet clip into Jaluladin by two feet.

The man was brought to me. He had deep dark eyes and black hair combed back.

"Good afternoon, sir. Welcome. My name is Jagran Rasheed. We are happy that you have come to witness our struggle."

Jagran Rasheed was a former major in the Pakistani Army. He had been forced out for reasons that he said he could not divulge. Instead of walking the streets of Lahore, another lonely man with another dream that will never happen, he came to Afghanistan to fight *jihad*. And here the small, chainsmoking, literate, intelligent man was a hero, a man of many battles, many friends, many admirers, a man living his dream.

In honor of the Pakistani's visit, a sheep was slaughtered. The long knife with a mother-of-pearl handle sliced across the animal's black throat, and the red blood stained its white coat and the ground around it. That night, every man in camp had a few overcooked morsels of mutton. I chewed it forever, imagining the taste which had been boiled away.

Rasheed was forthright. "Two years ago these men knew nothing of mortars, RPGs, tanks, automatic rifles. Now they do, because I have taught them." Mallem nodded. I talked with Rasheed off and on for two days, and though I did not like him—he imparted a certain feeling, rather like rubbing the back of a cold snake—I came to respect his mind and his convictions.

He came to us while we ate. He would never join in, preferring cigarettes. "It is good for a man always to be a little hungry," he said.

I asked his opinion on the state of the war.

He began at the top. "A leader has not yet evolved in Afghanistan. He must be a fighter, first of all, commanding re-

spect. One has yet to emerge, though Masoud in the Panjshir Valley is doing an excellent job. But do not forget, he is a Tajik. [The Tajiks, original Persian owners of the Afghan soil, were conquered by the Pathans, who have ruled Afghanistan for two hundred years.] Jaluladin has emerged among us. He is now the leader for all of Paktia Province and for all of southeast Afghanistan."

"Southeast Afghanistan?"

"Go see for yourself. It is true. About one year ago, we began combining forces with other guerrilla groups for attacks on Gardez, Urgun, and Tamania. Initially, the problem was booty: dividing up the plunder. You Americans had the same problem in Germany. The different groups who were before aligned to political leaders in Peshawar—for whatever reason: arms, family, money—now band together in Paktia to fight. All major weapons—anything over 7.62 mm—are kept by the strongest group in the battle. Smaller weapons—rifles, pistols, mortars—are kept and divided among each man in the group or sold on the open market. Each group gives the number of men who will be fighting beforehand. All machine guns, tanks, and artillery pieces are priced according to what the going rate is in this region—Paktia, Wardak, Logar, and Ghazni provinces."

Ken called it the "Paktia Pirate System." It was ingenious. Pure and simple capitalism, a material incentive added to that of the spiritual to fight. If a man captures a weapon, he can sell it on the open market in, say, Miram Shah, where in November 1981, the going price for a good Soviet Kalashnikov was $2,800; if the weapon is large, a party in Peshawar will buy it for eighty percent of its market value and supply it to its men to use.

"What about the tanks up the gully?"

"Jaluladin bought them with party funds for $50,000."

Two tanks for $50,000.

"We have nine operational tanks in Paktia. If a group can find fuel, it can use the tanks. We have no central fuel supply."

Again I imagined a group of these guys riding across the plains, turbans flowing, rifles in the air, on a convoy of tanks. Helicopters would take them out in a minute. It seemed a stupid thing for a guerrilla force even to consider. Were they, too, becoming fascinated with technology? Two tanks for $50,000, and we had not had any sugar in this camp for two weeks.

"So, where does all your money come from?"

"The political leaders in Peshawar are rich. Gul Badeen has a Swiss bank account. Qaddafi and Khomeini have been trying to buy them off. The Arabs give money to the Pakistanis, who divide it among each political group—the more fundamentalist receive the most—who in turn give it to their commanders to buy food, weapons, and to pay men to fight."

"I'm living with a group of pirates."

"How would you do it? Eighty percent of what we have we have captured from the Russians and the ridiculous Afghan army. We get few, if any, arms from the West. What your president says and what he does are not the same things. And you wonder why we do not trust Americans. Anyway, how did America become rich? It was the incentive of capitalism. We are no different from you."

It was too much. The Paktia Pirate System. At first it seemed corrupt, but these people were at war. Their villages were burned; their loved ones, killed or gone; they lived on bread and tea. It was basic survival. What if I had a wife and children, and someone came in from the air and destroyed all that I knew? I would probably fight back in any way that I could. I would probably kill for a rifle so I could sell it to feed my family, buy a horse, a radio, a camel, a plow.

"Where did all these men come from today? It is as if they have come out of the mountains, somehow alerted by your presence through some mysterious Asian telegraph system that I cannot comprehend."

"There is a hard core of fighters in every *mujahidin* com-

mand. In these mountains there are 350 men, with 10,000 men
on call. This is Paktia Province, and so every man has a rifle; it
has been in his family for a century. [He meant a .303 caliber
rifle, ideally a Lee–Enfield, or more likely, a replica manufac-
tured in Darra or other villages in Pakistan's tribal belt. Many
had Kalashnikovs that they wore on their shoulders as proudly as
an American Indian might have once worn a scalp, symbols of a
kill. Jaluladin, as commander, carried an AKS-74 Kalashnikov—
with an unnecessary mounted Chinese scope—a new rifle rarely
seen until this war. It was a symbol of authority, an ornamental
staff.]

"Every village has its emir, and every village has its own
defensive fighting unit. Commanders meet at a *shura*, a strategy
session, and form a battle plan. Men are needed; there are only
thirty, forty, as you know, in this fort. But as I have said, there
are others on call. Drummers sound the *dhool;* men go off in all
directions by horse to reach those men beyond the sound of the
drums. Each man brings his rifle, tea, bread, sugar—enough to
last five days. If a battle is imminent, extra bread is made."

I thought of Akbar, wondering if he'd be stoned or sober.

"For every 1,000 men available, we will use 400. We will
average 60 dead, 100 wounded. The majority will fight again,
whether with one hand or one arm."

I thought of Rughi, with his red plastic bullhorn and one
arm.

"Our morale is better, also. Two years ago we were fright-
ened. We did not know what mortars or mines were. Now we
are hardened. The young are coming up. They have seen what
the helicopters have done to their villages, and they are ready to
fight. They are like the Vietnamese were, the Palestinians are,
and you Americans probably once were before you lost your
way. You will not help us fight for our freedom, so we must do it
ourselves in our own way. We live by our wits; we capture arms;
we steal; we fight among ourselves. We are not as you want us to
be. We are a guerrilla army fighting for our God, our country,

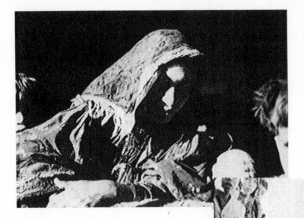

Kahmir's wife and
some of his children
in their home,
a Koochi tent,
in 1973.

Kahmir's daughter,
cooking bread outside
the family tent.

Kahmir's tent seen from
a short distance.

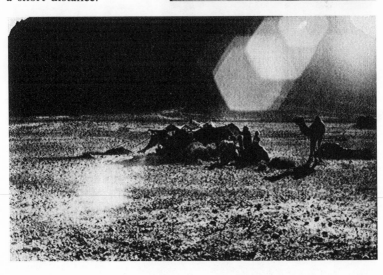

Children in a refugee camp near Peshawar, Pakistan. Two boys stand outside of a camp store in front of a stack of cucumbers.

An arms merchant brandishing a replica of a Soviet officer's pistol, hand made in this gun shop in Darra, in Pakistan's North-West Frontier Province.

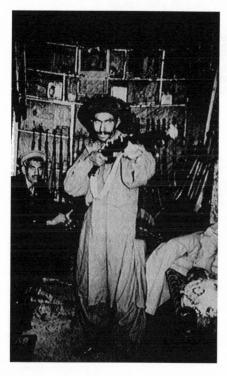

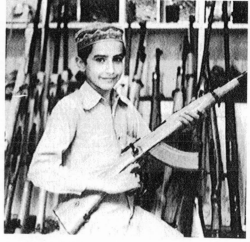

A young Pakistani displays a rifle manufactured in his father's gun and ammunition shop.

A Pathan poses with his newly purchased rifle in a Darra gunshop.

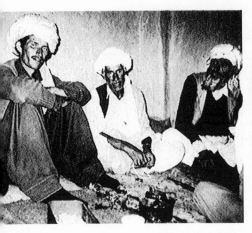

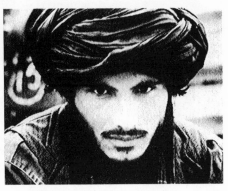

Escorting me for two days, Rahim, who disliked me at first, became my friend after I bandaged the wounds of a villager injured in a helicopter attack. He's resting here at Suran Markez after our trip. Chunks of brown sugar are in the container.

Jahan Gul, once a farmer, now a *mujahid*, sits in front of a stack of ammunition crates at a secret hideout along the Pakistani–Afghan border.

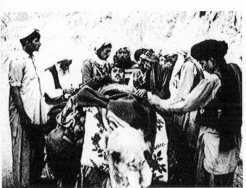

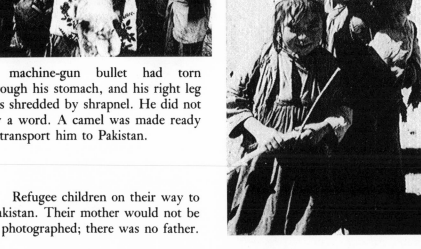

A machine-gun bullet had torn through his stomach, and his right leg was shredded by shrapnel. He did not say a word. A camel was made ready to transport him to Pakistan.

Refugee children on their way to Pakistan. Their mother would not be photographed; there was no father.

Mazir Mahmoud, who thought he was sixty-five or seventy, manning the captured 12.7 mm Russian antiaircraft gun for which he is responsible. Virtually deaf from the noise, he is considered the best shot in the camp.

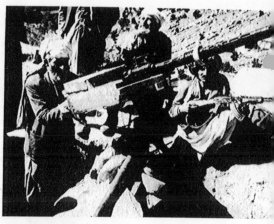

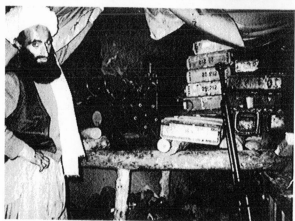

At Suran Markez, Mahmoud Shah, a mullah, showing ammunition and an antiaircraft gun stored deep in an underground bunker.

Matullah, with the four-barrel captured Russian antiaircraft gun he mans, waits and watches alone on a mountaintop sixty days at a stretch before he is rotated back to Peshawar.

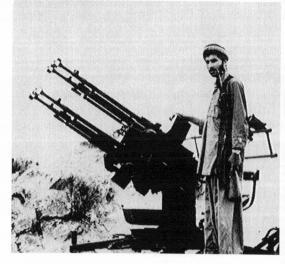

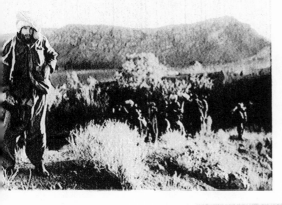

Outside the walls at Shie-khot. I look concerned because moments earlier helicopters had flown overhead. Men scattered and were, by then, regrouping.

Inside the compound at Shie-khot before the snow came. I'm on the horse.

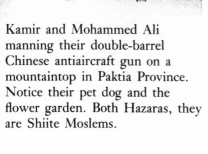

Kamir and Mohammed Ali manning their double-barrel Chinese antiaircraft gun on a mountaintop in Paktia Province. Notice their pet dog and the flower garden. Both Hazaras, they are Shiite Moslems.

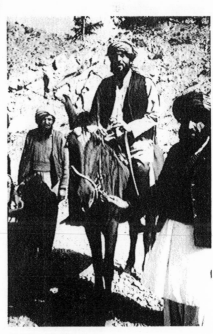

Major Abdul Rashid Rochman on the horse. A former Egyptian army major, he came to Afghanistan to fight *jihad*, leaving after "killing many rocks" with a SAM-7 to return to Egypt to fight underground now that Sadat is dead.

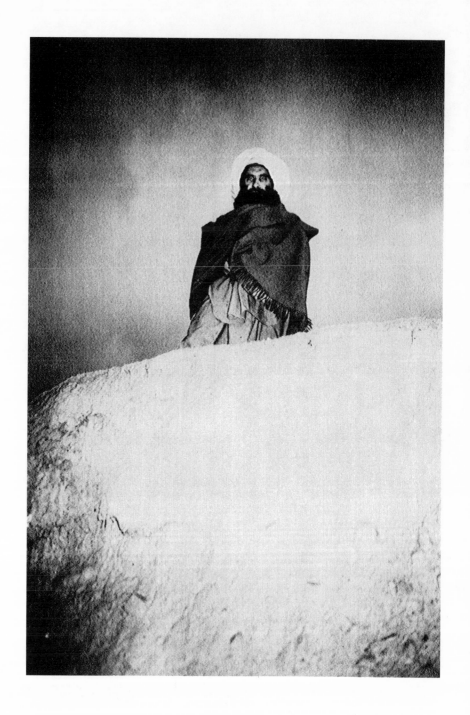

Jaluladin, the mullah-commander of Paktia Province, standing on the rock from which he and the *mujahidin* at Shie-khot bow to Mecca.

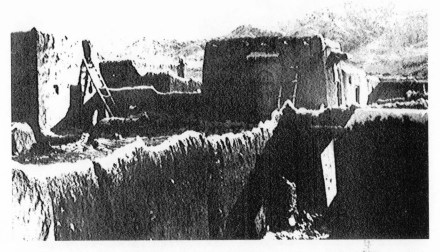

The compound at Shie-khot in the snow. Formerly a walled village, it is now the secret mountain headquarters of the Yunus Khalis guerrilla group.

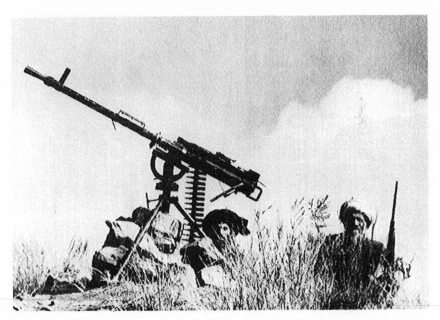

A captured 12.7 mm Russian antiaircraft gun outside the walls of Shie-khot.

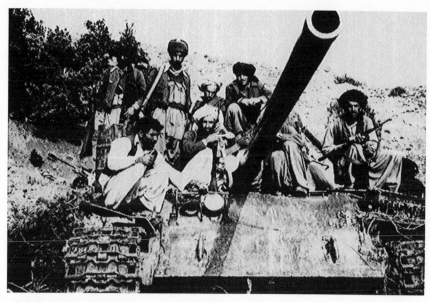

Jaluladin (in the white turban), Mallem (on the far right), Bader Khan (bareheaded), and Ali Jan (Jaluladin's bodyguard, in Afghan army hat) on a Soviet T-54 tank captured from the Afghan army.

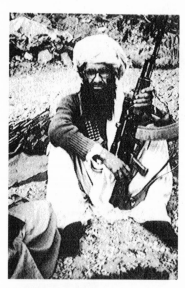

Jaluladin holds his Soviet AKS-74 assault rifle with unnecessary Chinese scope. This rifle was never seen before the Afghan war.

Khan Walli cleaning an RPG, a captured Russian antitank rocket launcher.

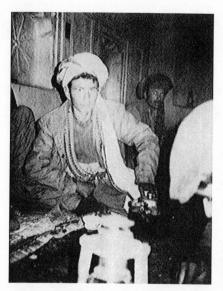

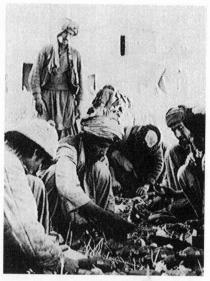

Aman Rulah, an eighteen-year-old former Afghan army officer from Shir Khan who now fights with guerrillas in the mountains of Paktia Province.

Preparing the mortars before the attack. Kahir Mohammed, the carpet dealer–sharp shooter, is second from the right.

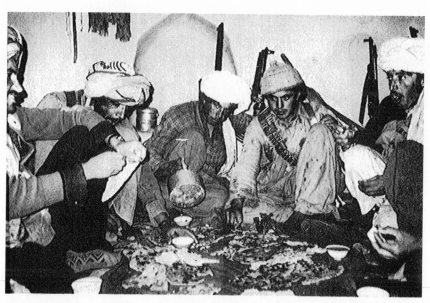

A meal of bread and tea at a safe-house a few hours before the mortar attack on an Afghan army base. Islahan is tearing the bread; Toothless One pours the tea.

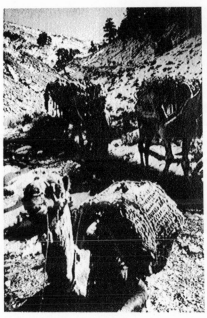

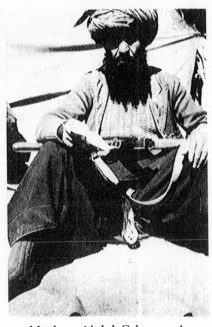

A camel caravan at a mountain pass
in Paktia Province. The elevation
is about 10,000 feet.

Mavleve Abdul Cahagor, the
mullah-commander at Naka, a
guerrilla hideout in the mountains,
Paktia Province.

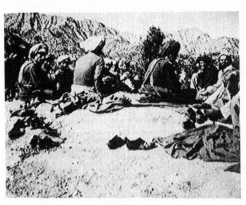

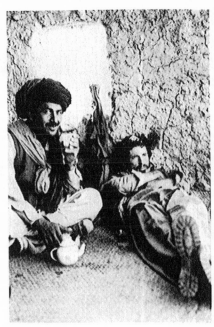

With sandals off, *mujahidin* hold a
meeting—always in a circle—in
the mountains at Naka.

Mallem and his friend, me; I'm
pouting after having been kicked
by a mule.

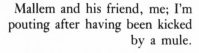

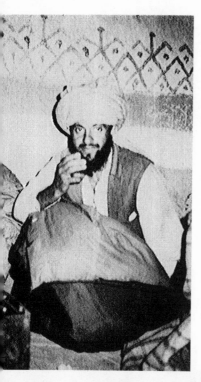

Mirz Ali, a commander who had to sell a rifle to provide food for his men, so he said. With him we ate two chickens, the first meat he and his men had had in two weeks. Notice the radio, the American sleeping bag, the drawings on the wall.

Two cousins, sixteen and eighteen, who fight with Mirz Ali at Durmanden.

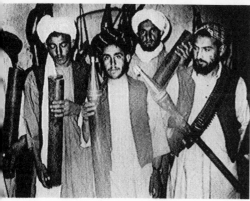

A group of *mujahidin* displaying antitank rockets at their hideout in Mahalajat near Kandahar.

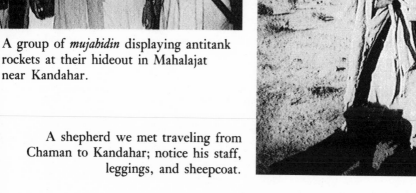

A shepherd we met traveling from Chaman to Kandahar; notice his staff, leggings, and sheepcoat.

On the left is Ahmed
Khan, a guerrilla
commander who lost at
least twelve of twenty-
eight men in a two-day
battle near Kandahar
and who risked some of
his men and his own
life to save mine; I
pose, slouching, on the
right. Khan cradles a
Kalasnikov; I have a
telephoto lens.

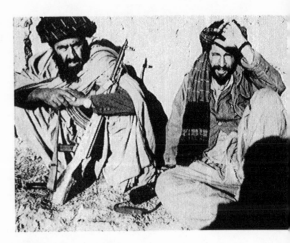

On the left is Rasule,
who deserted us.
Ahmed Khan
is on the right.

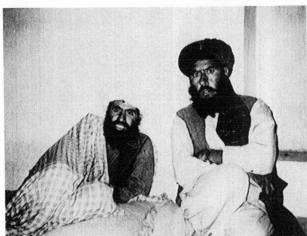

A group of *mujahidin*
pose near Kandahar.
The legendary
Khoudai-dad Shahazai
is third from left.

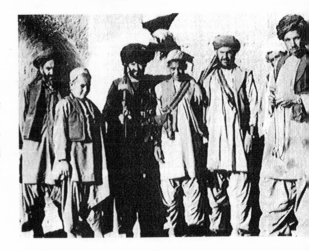

Bandaged poorly by me, a young *mujahid* had just taken a bullet through the shoulder. Though he has fled the Afghan army to join the resistance, he still wears his army hat.

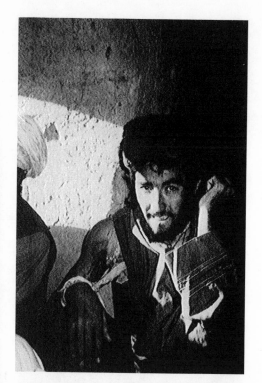

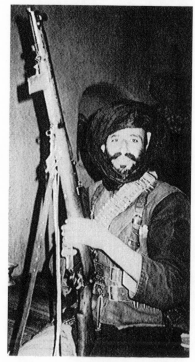

Khoudai-dad Shahazai. The locket contains a quotation from the Koran. A spittoon is on the ground behind him.

Ismael, a commander of thirty-eight guerrilla groups and a father of eight, holds Kalasnikov bullets in his right hand and hashish in his left. He trades a kilo of hashish for 1,000 Kalasnikov bullets with Russian soldiers, using an Afghan army intermediary.

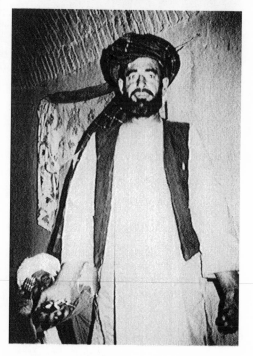

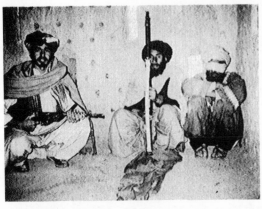

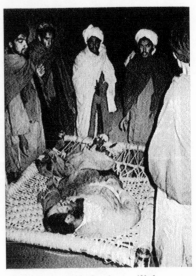

Sadul Den and Mousa guard a suspected spy in a *kishmishkhana* near Kandahar. Moments after this picture was taken, the house was overrun. He was machine-gunned either by the men he was possibly spying for— the Afghan army—or by the *mujahidin*.

A dead *mujahid* who will be carried on the rope litter back to his village.

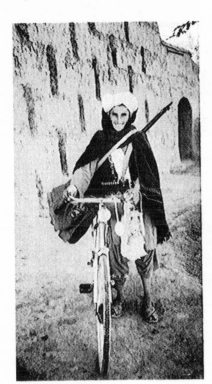

A young messenger on his way to spread the alarm of an approaching attack by Afghan army soldiers, helicopters, and artillery. The house behind him is a *kishmishkhana*, a hideout where I and the *mujahidin* stayed until the attack.

Yussuf on the far left, Alishan sitting on the camel, Ismael (barely visible), Shahazai, and me, wondering about it all, facing sideways.

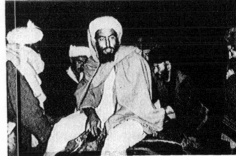

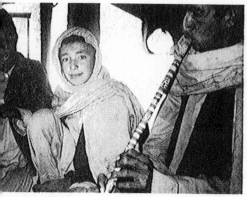

Boys playing a flute in the desert while I wait for the way to clear of tanks so I can head south to Pakistan.

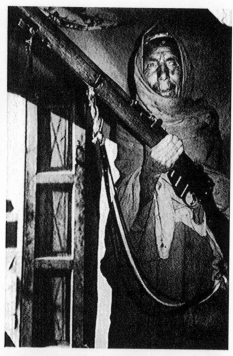

An old woman who said she would fight with her rifle if all the men were gone.

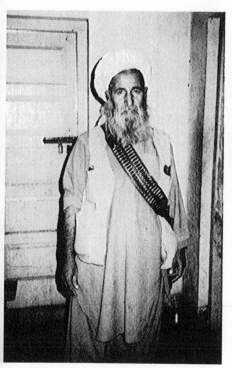

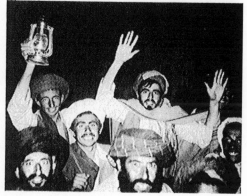

Waving farewell to me are Shahazai in the lower left, Ahmed Khan next to him, and Sadul Den with both hands in the air.

Yunus Khalis.

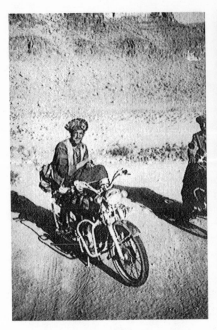

Motorcycle guides.

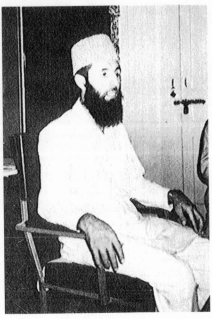

Gul Badeen.

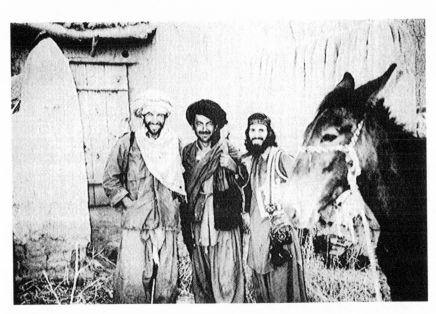

Author, Mallem, Ken Guest, and friend.

our way of life. You Americans were that way 200 years ago, but now you are rich, smug, and decadent."

I protested, but his eyes were now fierce.

"If you lived here, you would be like us; if we lived in America, we would be like you. I prefer it here."

"I understand. Why doesn't the West help you?"

"They are afraid of us. The West thinks we are all crazy Moslems—like Khomeini—who want to convert you or bury you. The West does not want to give us what we need to fight the Russians, because it thinks we will turn around and someday use these weapons on them. America remembers the Shah and what happened there. So it lets us bleed. After all, we are only crazy savages with turbans in Asia."

Maybe he was right. It was not just the Shah, Khomeini, and Qaddafi. It went back further than that, to the Crusades and a Christian West that tried to capture Jerusalem from the Moslems. Saracen soldiers got as far as Tours, and from the east they came to the Danube. The West, particularly America, is afraid of both Communism and Islam.

"What should the West give you?"

"We need guns, medicine, missiles for helicopters."

"Missiles?"

"If the West were not afraid, it would give us optical-guided heat-seeking missiles. The American Red Eye [U.S. equivalent of the SAM-7] will not work; we need something we can guide all the way to the helicopter."

"Optical-guided missiles?"

"*Insh'Allah.*"

The next morning Mallem, Abu, Ken, and I, six armed escorts, and a pale gray donkey left for Urgun. I said good-bye to Aman, Walli, Bader, Rasheed. I looked for Kahir, but he was not around. No one had seen him. Last night, I guessed, he finally left. That wonderful crazy carpet salesman, who liked quail and hashish and hated to fight—I hope he makes it. Ja-

luladin bid us farewell, and we headed south over the mountains.

We walked all morning, climbing gradually up into the mountains. The wind picked up as we rose, and the snow got deeper, but the sun was hot, and the glacier-fed water was delicious. We passed under a large cedar tree, like those overlooking the Oregon coast, sticking out from the side of a cliff. The tree's branches pointed east, in the direction of the wind. By early afternoon we reached a *chaikhana* and stopped for tea. The *chaikhana* was stone, round like a corral, with no roof. An old man had a fire going, and the tea was hot. Half a dozen camels rested on their knees nearby, chewing their cuds. A group of men and young boys stared at us. I smiled; they smiled back. Again there was no sugar. I began to dream about the stuff.

Three men made a bet as to who was the best shot. One was about eighteen, one middle-aged, the other an old man. They picked a stone across a ravine, maybe a hundred yards away. One bullet per man. The boy shot, grazed the stone on top; the other fellow grazed it on another side. The old man, who looked about sixty, steadied his rifle, closed one eye, squeezed the trigger, and hit the center. Murmurs of approval all around. He smiled and patted his rifle, proud of himself.

Four young boys struggled with gunnysacks of wheat as big as they were that they attempted to hoist on each side of a camel. I asked them to pose for a picture and saw that one boy, with high cheekbones and large doe eyes, white sunken cheeks and a delicate mouth, was one of the most strikingly beautiful people I have ever seen. I felt sorry for him, because he seemed to sense it already.

We pushed on, climbing. The tea had helped. I felt like a little boy. The sun, the blue sky, the jagged peaks, the cedar trees, a trickle of water, six armed men walking along, companions, not saying a word. It was peaceful. Only Mallem's occasional cry broke the silence, when he yelled at the donkey, who didn't want any part of it.

Another caravan approached, winding down the mountain.

The gray air sprang from the camels' nostrils. Each one's tail was tied to a rope that led to the nose of the animal behind it. The lead camel had a small bell attached to his neck, dangling from a purple and red cloth. The caravan's packs were empty, and the ten animals and five teenage boys, the oldest of whom looked sixteen, passed on.

We crossed the mountains, descended, following the free glistening stream. In the mountains, most pathways parallel water, and a village will eventually appear nearby. We entered an alpine valley. The stream widened; and there was grass, cedar, and pine trees, and round domed dwellings covered with branches, animal skins, and furs; gray smoke rose from one, but we saw no one. A black dog barked. We kept going. We climbed up through a forest of lodgepole pines, keeping to a narrow dirt path. It was soft, covered with pine needles.

Finally we stopped, lost. The camp we sought was nearby, but where? All we could hear was the wind in the trees. A man fired two shots, which echoed through the mountains. No answer. We walked on. Then we heard a shot. It came from the south. We quick-marched toward it, up a hill, and on a small plateau saw an antiaircraft gun and then a stone house built into the hillside. Nearby, thirty men sat in a wide circle, barefoot. A man came over, unsmiling, and put out his hand.

"Ah-salaam aleikum."

We pushed by the blanket door, walked up two stone steps, and entered a dark room. The adobe ceiling was low, and the dirt walls had wood pegs from which hung rifles and ammunition belts: a few Kalashnikovs, a submachine gun, two Indian self-loading rifles—probably captured in the Indo-Pakistani War ten years ago—the rest single-shot .303s.

The way in which the room was heated was remarkable. A man sat on the ground near the door, two steps down. He fed cedar kindling into a fire which burned underneath the floor. The fire was only two to three feet in, and we sat twenty feet away from him, yet the floor beneath us was warm.

Tea would be ready shortly. One by one, other men joined

us; and we stood up to welcome each one, shaking hands, embracing slightly, head to the left, head to the right, head to the left. We went through the litany: How are you? How was your journey? How is your family? Your father, your grandfather? and so on. Everyone talking at once, no one listening, it seemed. It was terrific. I could practice my meager Pashto and pretend I was one of them. It was a game. How long would it take before they realized who I really was? Each man caught on quickly enough but entered into the spirit of it. A man entered, I stood up to greet him, and we talked. Those already there waited to see how long it was before the newcomer caught on. It cracked them up.

Tea was served, and we had a choice of sugar—*ghorra*, hard brown chunks, or *burra*, refined white—a regular restaurant up here in the mountains. A small black-and-white kitten paraded into the circle and into the lap of the man who had greeted us. He rubbed the kitten's ears, its eyes closed, and the commander talked.

Where were the foreign guests from?

America, "Englistan," Pakistan.

Their eyes lit up. America! This was good.

Why had we come?

"To observe, to explain to the West the war that you fight." This, duly translated by Mallem, was reflected upon by these men as they stroked their beards, murmured among themselves, and passed around a small tin of snuff. We were the first foreigners they had seen in two years. I tried to explain that I was a journalist, but this meant nothing to them. Ken said, "BBC," and they understood. They stared hard at us, again searching for the character of these strangers who had come to them. As we were representatives of the BBC, they would have much to tell us. We could pass on that information to wherever that voice was which daily brought them the news of the outside world. Ken, however, was anxious to leave. He'd been inside for two months now and couldn't take much more. It was still daylight, and he

wanted to push on, to reach another village perhaps, a few hours' walk nearer the border. Mallem translated this, and the commander refused.

"You do not leave. It is law of Afghanistan that you stay."

Ken was adamant and wanted to continue. He stiffened his English upper lip. The commander would have none of this and looked hard at him and said, very plainly, "No!" There was no question of arguing with him.

"It is an honor for us to have foreign guests here." He ordered that two sheep be purchased from a nearby village and slaughtered. Would we like rice? I leaned back and closed my eyes as if in a dream. There is indeed a God in Heaven. Meat, rice, a warm floor to sleep on.

The commander, Mavleve Abdul Chaagor, led us outside. A man let off a burst of antiaircraft fire, and fifteen men fired their rifles into the air. Mavleve smiled; we were welcomed. It was my first sixteen-gun salute and I loved it. Another man, at the bidding of Mavleve, climbed on a horse, cantered down the hillside, and spurred him to Urgun to bring the commander of that beleaguered city.

Mavleve gave orders that we should not leave the camp. We would be eaten by wolves or shot as Russians. I promised to do what he said. Anyway, I was dreaming of mutton turning gently on a spit, roasted to perfection over a sizzling fire, hot rice with raisins, and tea with cane sugar for dessert. I took off my turban, my blanket, opened my shirt, and sat in the mountain sun. A gentle breeze ran through the cedar and pine trees. A fire crackled and an American sleeping bag was brought out for me to sit on. A camel, two donkeys, two horses, grazed nearby. The thirty armed men sat in a circle continuing their discussion quietly. A man trudged up the hillside, bringing a bucket of water from the brook which ran below. Another man chopped wood.

This camp was called Naka, and three days ago, Mavleve said, it had been under intense helicopter fire. This day, it was a

picture of quiet beauty. By sundown fifty more men had come to pay their respects to the visitors. The machine-gun fire had brought them from the surrounding villages. Mavleve called them to prayer, nearly a hundred men, their rifles beside them, kneeling in unison on a windy hillside. Fortunately, they would not stay for dinner. After they left, Mavleve led Ken, Abu, and me across the gully to a bunker built into the side of the hill and covered with branches. Inside it was dark and warm. There was a *bokhari* in the center. A tarp was brought out and loaves of warm bread set before each man. Three huge bowls filled with rice and raisins were brought in by young boys. I sat on Mavleve's left, Ken and Abu on his right. Then a boy brought in a bowl of steaming mutton and placed it before Mavleve. He broke up the morsels with his hands and passed them out. Ken, Abu, and I, the honored guests, were served first, and with the best portions. Unknown innards were placed in front of me.

I choked them down, my dreams of roasted meat shattered irrevocably. Another bowl was brought in, this one filled with great gobs of greasy "white meat." Again, Mavleve broke it up, and again, we were served first. The men stared as I tried not to gag on these chunks of fat as big as my hand. Another bowl was brought in, and, at last, I was awarded three small pieces of boiled mutton for my heroics. The sheep had been roasted, but then boiled to oblivion.

"How much did the sheep cost?"

"Five thousand Afghanis." Nearly $100. "A good cow costs 12,000 Afghanis. The war has driven prices up."

"Where did you get the money?"

"Peshawar."

Mavleve wanted to describe the battle of Urgun. He explained how the fight began:

"We attacked the fort at night. We knew where the mines were. Our contacts inside informed us. When the lights came on, we retreated; then we attacked again and fell back. In the

morning, they came out after us in a convoy. We laid back and attacked again from behind rocks. We retreated back into the mountains and waited and attacked again, then waited and attacked again. We used forty *mujahidin* to a group, and we had five groups, and we estimated 1,000 enemy, all Afghan army, no Russians. The battle lasted ten days. The helicopters came in morning and evening from their base in Gardez. We had one wounded, and we believe the enemy lost 200. In the past year, 12 *mujahidin* were killed and 450 enemy."

"Can you prove this?"

"We will show you."

I had heard this before. You could never see the results of battle, "because the bodies are always carried away," they said. I was becoming more and more skeptical. The battles, like the bodies, always remained elusive.

He went on: "We destroyed twenty-five trucks, four tanks, five armored cars."

"Where are they?"

"They are too far away."

A man brought in a gunnysack and dumped the contents on the floor in front of us, proof of their victories. The booty was junk—belts, rubber boots, ripped gray shirts—that wouldn't sell in an army surplus store.

Mavleve continued: "We control the countryside; the army must stay inside their forts. Without airplanes and helicopters, they cannot do anything, though we do not have anything with which to kill them. There are 1,800 *mujahidin* in the mountains, and only 250 have guns. If a man captures one, and he already has a gun, he can sell it. I do not stop him. He is away from his village ten months a year; he cannot farm because maybe jets have burned the fields with their fire guns"—he must have meant tracer bullets or napalm, though I had not seen evidence of any yet—"or his family is in Pakistan."

Mavleve wanted to keep talking. This was his only chance to talk about their lives. Two lanterns hanging from the ceiling

gave off a flickering light, showing the lined faces of twenty-five men, each one staring, curious, wondering about their visitors.

"We will fight the Russians and the Communists until we die. Nowhere in the world do people stand up to Russians as we do. I have been fighting *jihad* for three years, first with words, then with my rifle. The Russians had no choice but to come in."

I looked closely at this mullah-commander with the stern, dark brown uncompromising face, clear resolute eyes, and strong thick arms.

"What kind of government would you like?"

"One according to the laws of the Prophet, like in Saudi Arabia."

"What about Iran?"

"Khomeini is no good; he is too hard on his people. We do not like him, killing without investigations into truth. This is not Islam."

"Who will rule?"

"Allah will decide. This is what people want; this is what we all fight for; it is democracy."

Was that for my sake? It led him to other thoughts.

"Russia has no Book, Prophet, or God. America has these things. America is our brother. We fight also to stop Russia, who wants hot water and oil springs in Saudi Arabia. Russia wants that we are part of Russia. It does not want Islam; it wants Communism. Never. Never."

Mallem translated and Mavleve's men listened quietly. He never once raised his voice, but the resolve was unmistakable.

"I tell you these things because even BBC and Voice of America do not tell the truth; they do not know."

His thoughts on Islam and Khomeini triggered some of my own.

"How are disputes settled here in the mountains?"

"According to Islamic law. Before *jihad*, the government tried to settle it. If a man committed a crime, bureaucrats came

up from Gardez or Khost to settle it, but they were too corrupt.
They always wanted money. It is better now."

"How?"

"Two months ago, in the next village, a man came from
another village and slept with the wife of a man who was away
fighting *jihad*. They committed adultery, and they were killed."

"Yes?"

"We convened a court. There were three judges: myself and
two other mullahs from other villages. The crime had been wit-
nessed by three people, which is necessary under laws of Islam,
and these people testified before us. We studied the Koran and
talked among ourselves and decided that according to Koranic
law, they should be stoned to death."

"And they were?"

"No. They were shot. The chief of their tribe preferred it."

So, the chief does rule over the mullahs, I thought.

I looked at Mavleve closely. There was no remorse, no
defensive looks. He had spoken quietly, thoughtfully. To him he
had done what was right. It was a serious subject, and he took
his role seriously. There had been no questioning. The room
was silent.

Ghaira, or defense of property and of honor, is another tenet
of *Pushtunwali*, the code of the Pathans. The husband's honor
had to be avenged. The adulterers had to be killed. The man's
honor, and that of his family, must be upheld because property
passes on through him. It was the economic order of things, and
this was a law older and stronger than any in Islam. The Koran
says: "And come not near unto adultery. Lo, it is an abomination
and an evil way."

"What if a man steals?"

"Not so long ago a *mujahid* stole another man's rifle. He, of
course, was found and admitted that he committed the crime.
His hand had to be cut off, but this time I made certain that it
was his left hand."

Before, I did not have the courage to ask how the adultery was witnessed by three people, and now I did not have the courage to ask how they cut the man's hand off. Mavleve saw me cringe.

"It must be done. Otherwise, crimes will continue," he said, again quietly. "It is how it must be. For murder, a man is killed; for thievery, his hand is cut off. It is the law of Koran. If a man accidentally kills another man, he must give the dead man's family 100 camels."

"There are probably not twenty men in Afghanistan with such wealth."

"It must be done. It is the law. If, in a crime of passion, a gun or a knife is used, this weapon must be used to kill the murderer. If a man kills with his own hands, it is different. He must pay 100 camels."

Of the men listening and watching so intently, half of them were teenagers. I pointed my next questions to them: Did they want to ask me any questions? Did they want to add anything to what Mavleve had said?

A boy answered, "Whatever our leader and teacher says, we agree with him."

Mavleve was the only one who could read or write here. There was no such thing, it seems, as rebellious youth. They sensed, some perhaps knew, that there was something else out there beyond these mountains. They watched me closely, curiously. Tonight, every teenager prayed just as intently and as unashamedly as his elders—perhaps the pressure was too great not to, though I doubt that—and they were just as proud of their Kalashnikovs and their cause. I suppose they had all seen battles and death. There were no questions in their eyes. They stared straight at me. They, unlike Western youth, would never have the luxury of rebelling against their own system, their parents, of choosing from many choices in life. Still, there was longing in their eyes.

The conversation was over. The lanterns were dimmed. Two of the younger *mujahidin* rolled out a quilt for me to sleep on, and another provided me with a blanket to use as a pillow. I went outside to get a drink of water, and I thought about our conversation. The sky was black and filled with stars which seemed almost on top of me. The wind was now cold. Religion is such an absolute force, and God is so much more evident, if not certain, here, away from all the barriers of modern civilization— all those things that we have created which keep us away from our true selves, which take up and supposedly save our time: news, fashions, gadgets, computers, endless forms of entertainment. In spite of them all, we are all so uncertain, so burdened with sadness, with self-pity, guilt. Islam as it is practiced in these mountains might seem abhorrent, but it is right for these people. It gives them answers. These men are sure, not concerned with midlife crises or whether they are secure or not in their own skin. They know God. Their Islam is severe, but I could not mock it. It gives them peace, which is more than we have in the West.

We are politically free and spiritually chained in the West; here it is the opposite. I wonder if this is not in some way better. But then, too, I knew that if the roles were reversed, if these teenagers had grown up in the West, they would not be the way they are. I laughed to myself, wondering what Mavleve would do if I took him to the first floor of an American department store, among the crowds and cosmetics. But these are two worlds, Afghanistan and the West, that cannot be compared.

Too much food, maybe, but I slept poorly and woke late to the chant of twenty men praying and kneeling in the darkness. We had tea, cane sugar, and bread, and listened to the news, first on Radio Kabul, which reported that 150 bandits—*mujahidin*— were captured in the fighting near Logar. My companions laughed and shook their heads.

"It is not possible."

There was no Voice of America up here, but the BBC came in clearly. The World Service announced in English that the space shuttle went off today. Was I on the same planet?

Two young boys stacked the tea glasses, five on top of one another, and took them outside to wash. The sun was up. Twenty yards away, two young men with broad smiles, shaved heads, and dull features sat on their calves, kneading bread dough, rolling it on a stone, slapping it, adding a dash of water, whacking it against the side of the oven which went four feet into the ground.

Mallem and our escorts threw a blanket over the donkey's eyes, the only way the stupid animal would allow a load on his back. He kicked the first load off; they tried again. The dust rose. Curses and laughter all around. Finally they tied his halter to a tree and threw the blanket over his head again. Four hefty men pressed themselves against the donkey's flanks and gently placed the pack on his back. For a moment the animal was quiet. Then something clicked, and he kicked out; the pack fell. Everybody roared with laughter.

Mavleve took a bullet out of his pocket and with a grin said, "Maybe this will help." It had a red line around the tip, an armor-piercing bullet, which, on the open market, cost 100 Afghanis, nearly two dollars. It cost $100 for a sheep. This war, this attempt at Communism in the cities of Afghanistan, had brought, thus far, capitalism to the mountains.

Mavleve tried to make me take the bullet. I didn't need that to remember him by. He put his hand on my shoulder.

"You will leave us now, but we will send a guard with you to see Matieullah."

It took an hour for six Afghans, these people who have been working with animals for centuries, to tie that one pack on that one white donkey with a mind of its own. Our elderly guides with single-shot .303s would return to Shie-khot as they had

come, empty-handed. Jaluladin's camp, less than two days away, had guns and ammunition and no sugar. Naka had bags of sugar and not enough bullets to go around. Any truck driver in the U.S. would say to bring one and return with the other: very simple, one would think. But this was not, it appears, how things worked here.

The animal finally ready, we retired beneath a pine tree for a glass of green tea. Another man, who had appeared this morning but stood quietly back, came over. He was tall, lanky, in his fifties, unshaven, and bald. He looked at me, carefully, seriously, for what seemed like minutes.

"We need three things," Mavleve said. "Our first priority is a hospital. Our second is something to kill helicopters with. Third, something that will eat tanks." Mallem sat opposite us, translating. "We want nothing else."

The other man, who, it turned out, was the commander from Urgun, spoke:

"We will fight. We are not afraid. But we now know that we cannot fight alone and win. Nonetheless, we will fight. Always. *Insh'Allah.*" And then, in a dramatic gesture, he stood up, moved, perhaps, by his own words. "It is better for a man to die in battle than to die in bed."

We left the mountains and entered a valley which was wide, with signs of cultivation. A narrow irrigation canal ran parallel to the stream whose water was ice cold and sweet. Small plots of grass appeared, divided from the other terraced farmland as in Southeast Asia, but there were no people. Two of our armed guards led, then came Ken, a guard, Abu, a guard, me, a guard, and a quarter of a mile behind, whistling while he prodded the donkey, came Mallem, followed by another guard. It was cold. We had not had anything to eat all day except the tea that morning.

Abu was hurting, though trying to hide it. He came around

a bend, slipped on a rock, and fell. I was the only one who saw him. He was fifty yards ahead, and he landed face down on the rocks next to the stream, fairly bouncing when he hit the ground. He lay still for a second. By the time I got there, he was awake, though dazed, his face quite cut up. We bandaged his cuts and put him on the donkey, who didn't, for once, seem to mind the extra weight.

By evening we saw a plateau and adobe houses. The two lead guards had started a fire with some scrub grass and stood by it, warming themselves. Another man was with them. He had given them some bread that he had carried with him. He said there was a village not far.

We arrived in the evening. You could feel the stares as we walked through the village. Young men and boys perched like ravens on stacks of rough-cut logs. They sat on their haunches, dark blankets thrown around them, dark turbans down around their foreheads. There were big stacks of cedar logs and children with fat cheeks and chickens that ran in our path. Below, on the left, was a stream and cattle, sheep, horses, and camels that were used for transporting the cedar logs to Pakistan, I assumed. There was a warm, comforting smell—freshly cut wood and sawdust, like a score of towns I knew as a kid in Washington State. It reminded me of lumber mills and of running cross-country races through towns with the same pungent smells in the air. It was a lumber depot. Cedar logs were cut, rough-planed by hand, then loaded two to four at a time on a camel's back and taken to Pakistan.

Paktia was one of the few provinces in Afghanistan where there were trees. Centuries of cutting and burning with no thought of reforestation had turned much of Afghanistan into a brown, dusty, desolate land. Before the war, the government in Kabul required a permit before a tree could be cut, but now there was no government, only survival. Greedy men, hungry men, cut all that they could, loaded it on a camel's back, and sold a 400-pound log in Pakistan for $200.

The village was rich. In addition to the animals, there was glass in the windows and a small shop lit by candlelight. While Mallem and our guides went to find lodging, Ken and I bought a pound of stale, moldy cookies. The shopkeeper, with the aplomb of the bazaar merchant, weighed our goods on the metal balance he held in his hands, took our Afghani notes, gave us change, and nodded thanks as if we'd been coming there for years. Two little barefoot boys stared at us in amazement as we spoke in our alien tongue.

Mallem returned. We would stay here tonight. Jets had been through here and scorched some of the fields, but now they said it was safe. We took Abu to a compound where he could rest for the night. Ken and I waited outside the mosque while the men prayed. Beneath the floor, there was a blazing fire six feet deep. I imagined Nebuchadnezzar's furnace. In the half-light, two men led Mallem, Ken, and me to a large walled compound that sat alone on the edge of a cliff. The wind whipped our blankets, and we could see the stream far below. We pushed open the heavy wood door. Inside the courtyard were two donkeys, a stack of hay, and near the house there was a woman drawing water from a cistern. She looked up quickly; and before she drew the veil over her eyes and turned away, I saw that she had jet black braided hair, long silver earrings, and something quick and bright in her eyes.

In over three weeks inside Afghanistan, I had not seen a woman up close. Those we had passed had turned away quickly, hiding their faces with the shawls that covered their heads and shoulders. At a stream or beside a fire, I had tried to catch their eyes, although I had been told never to talk to or even look at them. The Afghans dedicate their poetry to women, but they seem to treat them like animals. "We don't want them cluttering up our lives," one man said. It seemed true. Like a man's animal, she was private property, not to be shared. If a man saw a woman, he might want her; therefore, hide her.

She rushed inside. We waited a minute, removed our shoes

and sandals, and walked through the opening, almost stumbling over a goat tethered in the passageway. We walked up two steps and entered a large room. The floor had been swept clean. There were aluminum pots in the corner. The woman moved quickly and gracefully around the hard dirt floor, bringing out cushions for us, tidying up, lighting a lantern. She was barefoot and wore silver jewelry dangling like bangs from her forehead. The chest of her dress was filled with mirrors the size of fingernails, and the hem was embroidered in purple and gold. Her wrists were covered with bracelets. In the far corner of the room, a wooden baby cradle, attached at either end by two strands of rope, hung from a wood beam. She served us tea, and while she prepared our dinner, she sang quietly to herself and pulled on a fifteen-foot embroidered cloth that was tied to the cradle.

An old man who appeared to be our host said that the village had been bombed a year ago. The villagers had fled to Pakistan, but now many had returned. They were afraid, but they would stay; this was their home. They did not have much food because the jets had destroyed their fields with fire. His son—this woman's husband—was in Pakistan with a load of wood but would return in a few days.

The woman asked him if we would like warm milk. Yes, of course. It would be impolite to say no. She cleared the glasses away, brought out a cloth, and put a flat loaf of bread in front of each of us and a community bowl in the center. Then she took her baby from the cradle and sat in the corner. The milk was delicious, and the bread was like butter in my mouth. Mallem said only a woman could make such bread, and all we had eaten was what men made. I told the old man it was the best bread I had ever tasted, and I saw her smile.

The other men talked about the war. I wasn't interested. I wanted to talk to the woman; Mallem knew it and for the first time told me without a smile not to do something. When we had finished, she took the pan and the cloth and left the room. The talk continued until the old man took the lantern and said it was

time to sleep and led us through the goat's home to another room. We climbed quickly under the cotton quilts.

The next morning while the men prayed, I went outside to wash. She was at the cistern, drawing water. The sun was not up, but it was light. I stopped. She looked up, and I smiled and said good morning. She looked directly at me and smiled back. She had perfect white teeth, and her eyes were bright and laughing, and the whole world was wonderful. She held up the water jug, as though to pour the water in my hands, and I started to walk over. Just then, the old man appeared in the doorway, and she put down the jug and brushed by him into the house. He pretended not to notice and walked over and poured the water for me.

The name of the village was Tarakhil. We left an hour later, and for the first time, my mind was on what we left behind, rather than on what lay ahead.

We walked for six hours, past a cascading waterfall and along a path soft with pine needles, then down to where the ground was hard brown clay, cracked from the sun. The air was hot, dry; there were few trees.

A village appeared—a few adobe houses, a truck, and an olive green, double-barrelled Russian antiaircraft gun. Thirty men emerged to greet us. We shook hands. Some embraced us.

"You must stay. There is so much for us to tell you. The fighting is bad. We have not seen foreigners."

We took off our shoes and went inside a cool stone hut. A straw mat lay on the floor. Abu, whose cuts had stopped bleeding by now, was feeling sick, exhausted from the journey and the sun. Matieullah was slim, with a black trimmed beard; a fine-looking man, but for some reason I didn't trust him. We had tea, and he talked about himself and the war.

"A big battle ended two days ago. We attacked Urgun from the west. Other men came in from the north. We destroyed 53 tanks, captured 110 Kalashnikovs, and killed 120 men. We lost

twelve. But then Russian jets and planes came from Sirdah to relieve the siege. We fell back. Now we are afraid they will come to attack us here."

Was there proof of this battle? Only half the men had Kalashnikovs. I didn't believe him.

We had good meat and brown gruel in a bowl for lunch, and I was sick for the next hour. Matieullah wanted us to stay but was afraid of helicopter attacks and thought it was better if we left. Matieullah had a truck. He would have some of his men take us to see another mullah-commander. Matieullah perhaps sensed that I didn't trust him, and he wanted us to go. Abu, on the other hand, refused. He asked me to go outside.

"Thank you, Mr. Van Dyk, for our conversations and for fixing my cuts. Please forget what I said about America. You know I really don't mean it. You go. I am going to stay."

The enemy was approaching; and he, in his dreams, could die holding them off, like a true warrior, the Pathan he so desperately wanted to be.

The flatbed truck was ready. It was an old Russian make and looked like a '56 Dodge. The shift was on the floor; the dials were in Cyrillic; the clutch was completely gone. Matieullah said they captured it from the Afghan army. The Russians gave them nice equipment. Abu watched us climb on, steadying himself with a stick now used to walk with. His eyes were bright. He was happy to stay. He did want to join these people. He was more like Rasheed than Rochman: a Punjabi who read history books and who hated his own people because their backs were bent over, groping for scraps, trying to survive. It was the human condition that he knew too well.

The truck bucked, backfired, rumbled. Mallem sat up front. Ken, ten men, and I climbed in the back. There were sacks of sugar on the floor. We bounced over rocks and ruts and on to a dusty dirt track. Abu stood on a hillside with his new friends and waved. He was home. The truck kicked along; I

thought it would fall apart. We picked up speed. The track evened out, and the wind swept by, and ten *mujahidin* were having the times of their lives. I found Ken's cassette player and put on some Western music. The truck raced along. The road narrowed, and we entered a deep rocky gorge. Sheer walls of granite ran up on our left and dropped down hundreds of feet on our right. At the bottom was a wide rushing stream. We tore around corners, and the back right tire was an inch from air and open space. I couldn't look and turned back to the music. The sun went behind the mountains; the wind became cool. The turbans of ten laughing young men, armed to the teeth, flapped in the wind. I leaned back, watched the sky, listened to the music build; and I would not have traded this moment for all the money in the world. It was suicidal, magnificent, and I knew we'd be all right.

We finally came down out of the gorge. A sloping grassy hill appeared on our left and a cluster of mud-and-stone houses on our right. Three girls saw the truck coming, stared, then as we approached, turned, and covered their faces with their ragged cotton shawls. It was sad.

"No tailgate Romeos in this war," Ken said.

The young men in the truck were trying to show off, but there were no girls to wave to them as we roared past the village. I felt sorry for them and had an acute sense of loneliness as we drove on. We stopped to pray, and as these young men bowed in the dust toward Mecca, I wondered if their thoughts were on God or on those girls we passed a while back.

The truck turned off the road and drove a hundred yards up a gully. From there we walked to a house with a black flag flying from the top. It was dark. Mallem, Ken, one of the young guards, and I walked in the open door. The others sat down outside on their haunches and passed around tins of chewing tobacco.

A man sat on the floor writing with a fountain pen by a

lantern. There was a tin spittoon beside him and an RPG lying on the ground. He wore a solid black *pattu* embroidered in red around his shoulders. His face was lean, his beard full, sleek, and cut. He did not look up when we entered. He was alone. There were no other houses around. I had no idea why we were here or who this man was. We stood before him for a minute. The mullah, not impressed, did not rise or offer his hand. He told us to sit down and looked hard at each one of us, through us, as though his eyes were capable of sending laser beams to our brains.

"So, you have come to see the butchered people of Afghanistan. Why?"

I knew that I should not mince words with this man. "Curiosity."

"Is that all?"

"We have come to look at the human condition of Afghanistan, to see what you people are made of, why you fight against incredible odds, to find the source of your strength and your courage."

"Do you believe in God?"

Mallem said yes. Ken and I hesitated.

"Then you have no strength. A man cannot live without God. Our God is Allah. You have your God. Afghans are Moslems, but the Koran does not dictate our lives. We adapt ourselves to it. I speak the truth. And that is why I am here alone. Other mullahs do not like me. But we are fighting— Jaluladin, Mavleve, Matieullah, many others—to preserve our society. All men of God—whether Jew, Christian, or Moslem— must fight against Communism. Because Communism destroys a man's soul. If a Russian slaughters a goat, we will never eat it. If a Christian kills one, we will. A Christian and a Moslem can marry, but a Moslem can never marry a Communist. That is why we feel close to the West, but the West does not understand this. It is afraid of us. That is why you do not give us arms."

He spoke quickly and Mallem had a tough time keeping up. He was a lonely, ostracized man, but for some reason these men had thought to bring us here.

"We are fighting the West's battle, which, unfortunately, is our own." Now he leaned forward, his eyes fairly burning. "If in truth, we are fighting for a just cause, then why, why in the name of God, does not the West help us? Only China and Egypt do. We will fight, but we are helpless against helicopters. We have fought for three years. We can maybe fight for two more. Then we, as a nation, and we are a nation"—he poked his pen into the air—"will be forced to migrate somewhere else. The Russians have thousands of tanks; we have only a few rocket launchers. But helicopters—against these we have no defense. We must combat them, and we have no means. They win only because they have these. It may not appear so, but we fight. The West has no means to see our battles, but you must tell them. You must. We need you."

He brought out a tin bowl of walnuts for us and showed us how to break them with a hand-sized rock. He spat a wad of chewing tobacco into his spittoon.

"Do not pay attention to the political parties in Peshawar. They are divided. Inside we fight as one. In Paktia Province we have selected Jaluladin as our leader. All groups unite behind him. In other provinces, it is the same.

"Before going to battle, we have a *shura* to decide upon a plan. Then we fight together. Every man is a *mujahid*, and every child will be. It is a false rumor passed around in the West that we fight among ourselves. War unites men; it is peace which divides them. Man is an animal, a warrior, but man can also look at the stars; he can be a poet; that is God in him. He can kill and he can love, and he can love God and he can love women.

"When you were with Jaluladin, you met a man, no doubt, a Punjabi, who fights with us, whose name is Rasheed. I will tell you a story: One night, our plan was to attack a town where

there were Communists to kill the leader of the local Communist militia. Our spies told us where he would be. We attacked. It was dark. But someone inside his house had a machine gun and fought back furiously. Finally Rasheed and his men stormed the house and silenced the machine gun. The man we sought was dead, but on top of him lay his twelve-year-old daughter with the machine gun in her hands. Rasheed broke down and cried, and left us the next day. Perhaps he has come back now. It is the law of Afghanistan that a man should never harm a woman. It is as much a part of *Pushtunwali* as it is for me to offer you tea and nuts. Even if we have little, we must offer what we have to you. It is our way."

"What kind of world would you like to have here? What about the king? He is in exile in Rome, but would not the people unite behind him?"

"Maybe they would. I, for one, cannot accept him. The king is why we have Communism. He kept the people poor, and that is the breeding ground for Communism. This king of ours and his friends ruled for forty years, and he gave us only jails, poverty, illiteracy, and ultimately a rule that has made us all homeless. I am alone; I cannot marry because of *jihad*. I must fight."

"What will you do now?"

"I have 600 men who will fight. I get my arms and money from Peshawar. My life is war. It is now winter. Our goals are to lie low until the spring. We do not have enough blankets or food, but we will hold on. And then, in the spring, when this valley is rich with flowers, we will fight. Even old men and women and children will fight. Our women and children now know the sounds of war, as before they knew the sounds of birds."

We slept on his floor that night. The next morning, Mallem, Ken, two of our guards, and I set out due east over the mountains. The others returned to Matieullah with the truck. Before

we had walked an hour, four helicopters came over the mountains in the direction of where we had been yesterday.

The sun rose; it got hot. I took off my black blanket, threw it over my shoulder, put the cassette player in my field jacket pocket, turned on the music, and let it carry me along. Mallem walked in the rear, rifle over his shoulder, Ken ahead of him, our two guides in the lead. Their rifle straps were beaded black and white and red, like an American Indian's. They wore knives and heavy leather bandoliers and talked nonstop.

Around noon we arrived at a small village untouched by the war, at the intersection of two pathways. There was a whitewashed tea house, and above the door someone had hung the recently severed head of a goat. We drank tea and then took the path that would take us to Durmanden. I turned to watch Mallem, his ragged purple *pattu* like a cloak on a chevalier blowing in the hot wind, his Kalashnikov over his shoulder, and Ken, with his long straight brown hair, American Civil War hat, Russian Army jacket, camera, gaunt face, black beard, bright smile; I thought of the thrill he sought in action, danger, his love and hate of war, his longing for the poet-warrior hero.

Mallem smiled. "You crazy man. Sing song. Sing song about America, Mr. Jere. Sing a song about love."

We walked along a bone-yellow path that met yet another dirt track. We met and passed small camel caravans, three animals or as many as ten loping slowly along: some with sacks of grain, others with loads of wood, still others with families. We greeted one another and walked on. "Peace be to you. Keep up your strength. How is the way?" The lead camel always had a bell which tinkled lightly strung to his neck, and after our greeting, it was the only sound in the land.

We arrived late at night at Durmanden, a small, abandoned, solitary fort on a rock at the end of a gorge. A river flowed below. There were abandoned homes of rock and clay dotting

the hillside. The wind blew, always the wind. It whipped through jagged holes in the adobe walls and inch-wide slits in the single-plank wood door. The guard took a stick from the fire and showed us where we could sleep. There were already a dozen men on the floor, so we curled up close together, shivered, slept, shivered, and woke after dawn. The room by then was bare. There were blue, pink, and white stick figures painted on the wall like Indian drawings in the American Southwest. The men were together on the roof, bowing west in unison.

Across the small courtyard was a room with gaping holes that looked out over the valley. A boy started a fire with brambles and what smelled like dried cow dung. An old man laid the dough for our morning bread on a black iron plate which rested over the fire. A black teakettle sat on two rocks next to it. A dozen men and boys sat around a tarp, wrapped in their blankets, waiting patiently for breakfast. We greeted them in Pashto; the men nodded and the boys smiled. The boy brought over a stack of glasses and poured the hot tea, and we sat there, slurping together. There were chunks of brown sugar, and eventually hot gritty bread.

Mirz Ali, a bald, sad-eyed man, was the commander. He said he had been a lumber merchant before the war. He was tired from having traveled all night. A man was killed two days ago when these men attacked an army base a few hours' walk from here, and he had escorted the body back to the man's village, stayed with the widow, and returned this morning. He apologized and did not to talk much; clearly the man's death had hurt him. He said the dead man had two daughters and a son, and his wife had cried all night before they had buried him the next morning.

"I have sons and a daughter also," he said.

We were to stay here two days. The commander said that men from Waziristan, the tribal belt in Pakistan near the border, had been holding up some of his men, stealing their weapons when they crossed into their territory.

"They are men who will shoot you in the back. There are three routes back, and we will have to see which one is safe for you. We have captured some of these bandits and put them in jail, and in retaliation they have captured some of our men. So we must stop the war against the Communists to settle this.

"The problem is booty; the war has turned some men into outlaws. Our villages were bombed, and many people fled over the border to Pakistan and left their land. Now it is parched because men do not work it."

We had more tea, and he explained his difficulties. "Prices are very high. A man works the war instead of the fields. He captures a rifle in battle, sells it in Miram Shah—if he can get through the bandits—and with this supports his family. A kilo of sugar costs 62 Afghanis; a kilo of beef, 160 Afghanis; ten Kalashnikov bullets cost 500 Afghanis, that is $1 a bullet. A Kalashnikov, $2,800. [In Beirut, the same rifle costs $900; in Tehran, $1,800.]

"I am sorry, we are very poor, but tonight, in your honor, we will eat two chickens. We have paid for them and for the sugar and other food stored under this house by selling a rifle. I have 2,000 men under my command spread throughout these mountains; among them, there are only 300 rifles. My organization is good, our morale is higher than it was two years ago, but our land is destroyed. We must sell guns to eat."

We finished our tea. He went off to sleep. Our two teenaged guides took some bread, wished us well, and left to return to Urgun. I took my toothbrush and a piece of soap and walked down to the cold milky stream. I took off my clothes and lay in the water, brushed my teeth, beat my pants and shirt on a flat stone, and did nothing for the rest of the day except dream of chicken for dinner.

I stayed away from camp, too, because I needed the solitude. Privacy was such a rare thing. It is hard to live, eat, sleep, travel twenty-four hours a day with men you did not know a few weeks ago. There was no use complaining about my lessening

resistance, cuts, lack of food. I would be out in a few days. This was home for these men. Mallem sat on a rock in the sun, cleaning his rifle. He would get us out safely.

At sundown Mirz Ali came down to the river and sat there. As the sun began to disappear, he carefully washed his hands, face, neck, his arms up to his elbows. Would I come pray with him?

"No, I am Christian. I will pray here."

Mirz looked at me for a second, then, accepting my answer, smiled and returned to his men waiting on the roof. He climbed the wood makeshift ladder, cupped his hands, and began the call.

Later, Ken came down. "Mr. Jere, old boy, dinner is served."

We returned to the fold. Twelve of us sat around the floor, ready for dinner. I was fairly salivating at the thought of a breast of chicken à la Afghan, the skin crisp, the meat tender and juicy and white.

"A glass of wine, Mr. Ken?"

"No, I would prefer a glass of cold milk, thank you."

"Milk with chicken, Mr. Ken? Never do."

I sat on Mirz Ali's right. Dinner for twelve, ages fifteen to seventy. There was a lantern in the center and two bowls. In one I saw only greasy film, like oil in a dirty harbor. In the other was what could only be gizzards, hearts, and all those things which Afghans, and my mother, swear by and which I cannot stand. So, once again, they did it to me.

Mirz took a handful, broke off portions, passed them around. He gave the guests more than the others. Each man ate slowly, savoring his food. Normally a meal in Afghanistan takes about ten minutes, like lunch in a fraternity.

"Do Afghans like this?" I asked Mirz, holding up a blue-gray gizzard, wishing for all the world it was a leg.

"Yes, it is the first meat we have had in two weeks."

I rolled it in a piece of bread and choked it down quietly.

How grateful I was later for the slivers of boiled chicken which followed. We sopped up the grease with pieces of bread, licked our fingers; one man, truly satisfied, belched loudly. A boy brought out a bowl and a pitcher; we rinsed our hands and dried them on a cloth that had not been washed in years.

Mirz said that we could leave tomorrow morning. Of the three routes back through the hills, one was free of bandits. We would have a mule to go with us. Glasses were produced, and the boy poured hot green tea to the brim. An old man had a tin of *miswah* and shoved a pinch between his bottom lip and gum, below where there were once perhaps a nice white row of teeth. He passed the tin around. As there were no spittoons here, they spat against the walls or out the open windows. When I remembered the men in the lumber mills who chewed tobacco and spat in the sawdust and baseball players chewing and spitting on television and the brass spittoons in the corners on the floor of the U.S. Senate, it didn't seem so bad. A source of energy, perhaps. Just don't sleep too close to the wall.

How different it was from tea drinking. A man delicately wrapped his hand around the glass, cradling it for warmth, then drank it slowly, at the end throwing it back like a shot of whiskey, then slapping it hard on the ground to show that he was finished. Place it down quietly, and it will be refilled.

Mirz said even though there was a trail free of bandits, Mahmir, a tall, swarthy, ruthless-looking man who had shown up earlier, knew the land well and would go with us.

Mirz wanted to know why I thought they received no help. I tried to explain. He listened quietly, rubbed his cheeks with his open hand, looked at me, then at the floor. He said little. There was absolutely no sense of bravado in him. He was shy, distraught, and lonely—a thoughtful man stuck fighting a guerrilla war. I had the impression he would much rather have been at home playing with his children or, if he could, reading a book. He seemed too gentle to fight, but then, those who do not pound their chests are usually the best.

It was dark; the mule was ready. We all shook hands, shivering in the cold. Mirz walked with us for the first mile. Then he stopped and gave me a handful of raisins and nuts. He embraced us tightly and stood there in the middle of the dirt track, a very solitary man crying silently at the world, until we were out of sight.

We climbed southwest. The sun rose; the ground became hot. Cairns, two or three stones on top of one another, marked the trail. A flag now and then dangled from the top of a pole stuck in a pile of rocks three feet high, six feet long. I counted ten in four hours. We passed what once were *chaikhanas*, now piles of rubble. Finally there were more trees, and as we got higher, snow in the shadows, a stream trickling out from underneath. The wind blew refreshingly. I took off my blanket, my fatigue jacket, and threw them on the mule's back.

We came upon a family coming from the opposite direction, perhaps refugees returning to their homes. It was an image which I could not resist. There was no father; the woman carried her son, and behind her was her six-year-old daughter, a darling girl dressed in a long red and black dress, a red shawl, earrings, jewelry dangling like bangs on her forehead. On her shoulder, she carried her baby brother—fat cheeks, runny nose, wide eyes. A perfect picture. I ran to the mule to get my camera, but in my rush approached him from behind and to the left. The animal turned and kicked me in the back. The blow lifted me and sent me sprawling. Even the mother smiled. My companions roared, but quickly rushed over to see if I was all right. I don't know whether my back or my pride hurt more. I picked myself up sheepishly, laughed, shrugged it off, and felt it.

We continued on. I was mad about losing the picture. I swore if that blasted mule came near me again, I would grab a rifle and blow his head off. I hated him.

We came to a tea house perched on the side of a mountain.

A few camels and donkeys were tethered near the opening, chewing their cuds. I needed tea and a rest. The travelers inside made room for us on the straw mats. There was no laughter here; the talk was not good. Apparently the Russians had been bombing everything in the open along this section of the border, trying to cut off the flow of arms. Helicopters had been seen that morning, flying low over the next mountain range, probably seeding the passes with mines. Those again. I still had a piece of one I'd picked up on the way in. Plastic, half the size of a man's hand, and green like leaves, brown like dirt, gray like rocks. They were dropped by the thousands along the border. I suppose in war it is fair to cut off the enemy's arms supply, but they were horrible. It is not a man who gets it as often as a little girl looking for firewood, a boy tending sheep, a mother with a baby in her arms. For a moment, I quit wallowing in self-pity.

Mallem was quiet. Ken and I looked at one another. This former British Royal Marine loved the idea of combat but not the prospect of walking through a mine field.

Two boys, about seven and eight, in dirty pajama-clothes, skullcaps, with pudgy hands and bare feet, walked around the mat, pouring tea, collecting greasy Afghani notes. There was a small *bokhari* in the center, a few rifles leaning against the wall, sandals at the doorway. I asked Mallem where the boss was. He asked one of the kids. He looked at Mallem and said that he was.

"How old are you?"

"Eight, I think."

"Where is your father?"

"My father was killed by helicopters. My brother and I are now in charge. We have two sisters and our mother. We must support them."

There are children in Afghanistan but not childhood. I wondered if that boy, so much like a man, would ever laugh like a child, if he would ever play or have a father to lean on. That eight-year-old was older than I was.

His little brother sat on his haunches at the doorway, washing out glasses with grubby little hands, and did not look up when we left.

In a few hours I forgot all about the boy. My back was aching. We descended from snow level and walked along a wide riverbed that sloped gradually, a two-foot-wide blue stream on our right. I was falling behind and drinking more and more water. A village appeared and a group of about ten men—not *mujahidin* but tribesmen from this area—sat near the water while their horses and camels drank. They had rifles, but I paid no attention to them.

Just then, Ken spotted them on the ridge to our right. Seven women were walking single file, like soldiers in step. Each had a goatskin filled with water balanced on her head. Their left arms held the skins, and their right arms swung freely at their sides. There was a breeze, and their long black shawls blew out like capes on Spanish noblemen. With the sun behind them and about to disappear, their shadows reached down to the riverbed. I remembered the men but took out my camera and turned to take a quick picture, determined not to lose this one. Before I could bring them into focus, I heard the bolts of ten rifles slam shut and I knew. I quickly put the camera away. I shouted in English, "I didn't take it, fellas. I wanted to, it would have been beautiful, but I didn't. Look, I understand. It's O.K. Don't shoot." In Paktia, the most backward province in Afghanistan, it seems a woman is private property. To take a picture is to steal part of her. They lowered their rifles. I waved and walked on.

We were five: the sixteen-year-old boy who was our mule skinner, Ken, Mallem, Mahmir, and me. Three rifles, one mule, one weak foreigner.

The riverbed narrowed. It was still light, though the sun had set behind the mountains. Then we heard an explosion and stopped. Mahmir cocked his rifle. We rounded the bend and saw a group of men. A camel went down; another lay on its side. A third stood stoically, swaying on three legs; the fourth leg ended

in a mass of blood below the knee. Two men held the second camel down, while another cut deeply into its throat with a machete as long as his arm. The animal's pitiful cry filled the gully. I pleaded with Mallem to have the other two shot quickly instead. "No," he said, "it is Koranic law that they be slaughtered."

The men with the camels would not go any farther. There were unexploded mines all around us—I picked up a few which had blown—and twenty minutes earlier, they said, two men had had their feet blown off. We stood watching, mesmerized by the horror. It got darker. Mallem was nervous and said we must go. Mahmir and the boy hesitated. What about the mule? It would surely step on a mine as the camels had. But we had to go. We couldn't sleep here; who would dare lie down? There was a small caravansary a few hours' walk ahead where we could sleep. We stared at the ground before our feet; every rock, leaf, tuft of grass was a possible mine. We hesitated before each step, waiting, wondering; it was enough to drive one crazy. Mallem, Mahmir, and the boy stopped to pray; I silently joined them. Ken sat there. I don't know what he was thinking.

It was now night, and we could not see the trail. Mallem would lead; the boy and the mule would follow, then the foreigners, and Mahmir would guard the rear. We walked on, at first frightened, and then casually. There comes a point when there is only one thing to do: accept it—fate, God's will—and keep going. If it comes, it comes. We walked nonchalantly, whistling, even singing, like scared schoolboys through a graveyard. Sometime in the middle of the night, stumbling down the mountainside, we reached the caravansary. I could only make out a few dark houses. The pain in my back had gone deeper, and my head was on fire. I was sweating and shaking feverishly.

Two houses were full, but room was made for us in another. We tethered the mule, found room in the middle of men sleeping on a straw mat. I put a wet scarf on my forehead, took two aspirin, and drank water. Mallem gave me his blanket and

said to keep warm. I dozed, dreamed, prayed, and sweated through the night. I found myself getting delirious and shivering uncontrollably. When I awoke, I was alone on the floor. The air was fresh, and the pain and fever had passed. I'd always wondered about that saying, whether it was "Feed a cold, starve a fever," or "Feed a fever, starve a cold." Now I know—starve a fever.

Outside, the boy and Mahmir were loading the mule. Crackling fires lit the predawn sky, and fifty camels sat on their legs, their heads erect and arrogant while the men loaded them. Women dealt with children, and men shouted out orders; boys tied up family belongings—black teakettles, red quilts, plastic jugs. They were refugees returning to Afghanistan.

We continued our journey, taking a path that crisscrossed through the hills, thus avoiding the main routes to the border. It got hotter as we descended to the wasteland around Miram Shah. We hadn't eaten since yesterday, but we were almost out, incentive enough.

The ground was now flat, rocky, and dusty; and in the distance, like a mirage in the desert, were the outlines of buildings. We split into two groups and walked past two military checkpoints. By evening, we reached the Yunus Khalis headquarters, pushed back the giant metal door, and inside found a row of water urns. There were rooms with tables, typewriters, a mimeograph machine, and up above, telephone wires which could connect us to the outside world. We were out.

Two men took us to an upstairs room and brought us tea with sugar and milk. We drank it all slowly and fell asleep. We woke an hour later, when two boys stood over us with a bowl and a pitcher for washing. They returned with bread, small bowls with chunks of meat and warm greasy gravy, and for dessert, a bowl of green grapes, the first we had had in a month. Never had a single grape tasted so tangy, cool, and refreshing.

Then two men appeared with a plastic bag of cookies and another with a pot of milk-tea. It was Abdullah, the man who had brought me from Peshawar. He still wore the turban I had traded him. I still had his. With him was Mohammed Hakkim, who had come to get me at Dean's a month ago.

"We have been expecting you for many days."

"Well, had we known, we would have hurried right out."

We talked and drank tea and told stories like a group of old friends. Others came up to us. We were told not to leave the room for fear of the Pakistani police.

Hakkim was visibly upset when I told him about the mullah commanders I had met and the stories of crime and punishment. In fact, he was incensed.

"You have spent one month in the most backward province of Afghanistan, and now you will return to America with a wrong view of our country.

"Our hands are tied. The political parties from Peshawar, whose leaders either come from prominent families or are crooks, have power only because of their ability to supply guns and money."

I said that I understood and not to worry. I was more interested in the character of those who actually fought, lived, cried, laughed, died, and prayed inside. Political parties only existed because Pakistan willed it. They would go if America really wanted things to change, I thought.

Hakkim spoke: "First, we need the mullahs. They are good fighters. But ultimately they must return to the mosque. That is where they belong. There is only one man to lead, and that is the king."

"The king? The old boy living in splendor in Rome?"

"Yes. If only he or his son could fight and join the *mujahidin*. But the mullahs would not stand for that."

Then Mallem offered a word. "Yes, the king. We all want the king."

* * *

We slept until six the next morning. By nine, the *mujahidin* were ready to transport us to Peshawar. A Toyota pickup with a covered canvas top and a rope litter in the back was brought into the center of the courtyard. I climbed in the litter.

"You must not speak before Peshawar, Mr. Jere," said Mallem. From now on I was to be a severely wounded *mujahid*. A guard would ride in the back with me. Ken would sit up front between two others.

I stood there for a moment with Mallem. I wanted to give him something.

"Well, Mr. Jere, you crazy man," and he smiled that wonderful laughing smile of his.

"One month. So long, so short."

"I no understand."

"Nothing, Mallem."

We shook hands. It was too awkward to embrace. We swore to meet again.

Abdullah, Mahmir, the boy, and a dozen others crowded around, waving, laughing, and with a hurrah sent us on our way.

We skipped the main road for the first two hours to avoid the military checkpoints and bounced along a desert track. The bed was like a trampoline, and finally it came crashing down, broken. My coccyx seemed to be in one piece. We came to the main road and, after a few hours, stopped under a tree at a village for lunch. My guard brought a metal plate of corn, spiced chunks of gristle, and bread. I ate under the gaze of a hundred urchins fascinated by a wounded *mujahid*. I lay there, looking tough.

We drove on, and at the next checkpoint I thought it was all over. The driver tapped the window to signal another cable blocking the road. I pulled the blanket up and closed my eyes.

The Pakistani officer peered in. Then after a word with his companions, he climbed in the back with me. He would ride with us to the next checkpoint. He sat on the hump above the right tire, staring at me; and I, the tough wounded Afghan, stared back, narrowing my eyes at this intruder. We looked at one another for half an hour, and then I no longer cared. I rolled over and turned away. It was like walking through the minefield: There came a time when I no longer cared. If he catches me, he catches me. Two hours later, at the next checkpoint, he hopped out.

We got to Peshawar, stumbled out of the truck, and I ever so nonchalantly walked up to the register at Dean's and asked for a room. The clerk took one look at me, then at what I had written.

"But you are Afghan! Why do you write U.S.A.?"

I loved every second of it.

I read my mail, but none of it interested me. I went to my room, turned on my fan, took the longest, most refreshing bath of my life; then I climbed between clean white sheets and slept until I could sleep no more.

The next day I got my bags from Munchi and drank many glasses of milk-tea with him and his family. I went to see officials at the American Consulate. We talked for two hours. I told them what I had seen and showed them Rochman's papers about the missiles. I was certainly an inexperienced journalist. I did not know what their jobs were, but they asked me many questions, and I gave them answers and got nothing in return. Perhaps I did not know how to ask.

Mahmoud, the tribal chief I had met in Washington, had his men waiting for me at Dean's and insisted that I come to his house for dinner. We had a rice pilaf with generous chunks of chicken, spinach, tomatoes, cucumbers, yogurt, tea, and fruit. It was too much for my now shrunken stomach.

He wanted me to go where his people were. There, he said, the mullahs were not in command. Oh, some were, but they were all subservient to him. The chiefs ruled.

"It is custom; it is law. I let my men take arms and money from whatever political group in Peshawar. They fight for Afghanistan, not for the groups here."

There were other men present, and one was dressed in Yves St. Laurent combat: camouflage pants, safari jacket, scarf, polo shirt, sunglasses, a gold watch, and many chains. He spoke excellent English and French and talked about Marx and SAM-7s and fancy commando raids against Soviet military installations. He signed his name "Commander Ahmed-irshad Zekria" and said he had his own army. I asked how he paid for it. "It is not easy. We have so little money. I had to sell a diamond ring in London."

I tried to write the story, but couldn't do it. I was emotionally spent. The next day I got Munchi to take me to Islamabad. I had no money, but I did have a credit card. I went to the Holiday Inn because I had been dreaming of its swimming pool, that giant, clean, turquoise bath, for weeks. I checked in and found the pool had been drained. I walked around the hotel, feeling like that pool looked.

I wrote a story about the failed attempt to down the helicopter with the SAM-7 and mailed it to Mike Kaufman in New Delhi. Then I sent him a telex from the Reuters office telling him I was out. There was no response. I went to the American club and had dinner. The bar was jammed, smoky; the music penetrating; the floor sticky with spilled beer.

I left, walked back through the night to the hotel, and placed a call to Arthur Hill in Washington. Two hours later, it went through. I wanted someone to talk to, to tell I was out, and to see what newspapers or magazines were dying for my dispatches. Arthur talked casually, as if we had seen one another yesterday. He had no leads—oh, a mercenary magazine was interested, and maybe National Public Radio. No one else.

I hung up, totally depressed. No one cared. I had gone through all of that, and, not only did one of my best friends not seem to care, it looked as if I might not be able to sell anything. I sat on the bed, staring out the window. It was two in the morning. I looked at the television, the sanitized glasses, the furniture, the Holiday Inn overkill; and I thought about where I had just been. I knew that what my gut told me after we passed the mine field was true. But I wasn't finished yet. I had seen the mountains. Now I wanted to see the desert.

It doesn't matter what anybody else thinks, ultimately. It is what a man thinks about himself deep inside that counts. I had to see a battle. I had no wish for death, but I wanted to see how men acted in the face of it. Perhaps I wanted that scar.

In track a man loses a race as much as he wins it; races are won and lost many times before the race is begun. The race is the limit man places on himself. This was like running a race; I wanted the accomplishment. I wanted to be able to look at myself in the mirror. I wanted to live life to the ultimate degree, to push beyond where my mind would naturally, out of human fear, stop me. A child athlete, like Nadia Comaneci, the gymnast, could do extraordinary things, partly because she did not know fear or defeat. In athletics, as in the rest of life, when you learn fear and defeat, it is harder. But the best athlete is the one who learns fear, then defeat, overcomes them, and wins. If I could overcome the ultimate fear, if I had that courage, then I could do anything. I would not have to prove myself to anyone.

Epictetus said: "Don't you know that all human ills and mean-spiritedness and cowardice arise not from death, but from fear of death? Against this, therefore, fortify yourself. Direct all your discourses, readings, exercises thereto. And then you will find that by this alone are men made free."

Jesus said: "And you shall know the truth, and the truth shall make you free." Belief in Him meant eternal life, overcoming death, man's greatest fear.

The phone rang. It was four in the morning. It was Arthur.

He apologized. He did not know what he had been thinking; he understood, even though he couldn't. He mentioned Vietnam, where he had been a combat officer, and asked me to come home. It was over, I had made it. "Now come on back, and we'll find somebody to publish some stories." I wanted to cry. Friendship it seems, like love, is so very hard, and equally wonderful. That might seem funny to some, childish, sentimental, but my heart went out to him.

I knew now I would go to Kandahar. It was across the desert, and the fighting was fierce. I told Arthur. He was quiet.

"Well, then, go. Go if you've got to. I don't want you to, but I know you'll go."

I hung up. My instincts said to go.

The next morning I sent a wire to Kaufman telling him of my plans. He had not answered mine from yesterday. (I found out later that he was in Bangladesh.)

I put my clothes in storage in the hotel, and this time traveling as light as possible—Afghan clothes, sandals, cameras, medicine, the *Times* letter, $100, passport, notepads, pocketknife—I caught a flight to Quetta, Pakistan, a dusty, hot, Wild-West–type town in the center of Baluchistan, which stretches from Pakistan through Southern Iran. We flew over a landscape as barren as the moon until an oasis of sorts appeared—buildings and a few trees—and we landed.

After some haggling, I found a taxi, a '70 Dodge with a tape deck, and for thirty-five rupees got a ride to the Lourdes Hotel. The driver, a fifty-year-old, toothless, fat, smiling Baluch, found a tape he thought I'd like—Chuck Berry. He laughed when he saw me smile and turned it on full blast. I rolled down the window, leaned back, let the brisk morning air rush through, and to the pulsating beat of American rock and roll, rode the Dodge into town.

Lourdes, like Dean's, was once a small British military barracks, a single-story series of rooms, each with a cot and clean sheets and, at Lourdes, an oil-burning heater and sometimes hot

water. There was a small dining room, a telephone in the office, a lawn with tall trees, a circular driveway, and the presence of many eyes. I signed the register as a free-lance writer. Behind the counter, a man with a thick mustache and a sports coat over his pajama-clothes asked, ever so politely, what I had come to write about. I said to study the nomadic tribes of Baluchistan. He smiled, offered a few suggestions, and didn't believe me for a minute. He assigned me a room in the back with a padlocked door.

There was a European sitting at a table in the front lawn. I introduced myself. He offered me a seat, and we had breakfast together—eggs, toast, marmalade, tea, an English breakfast— and because we were both alone and partly for the fun of arousing the suspicion of the half-dozen people staring at us, we fell into a fast, lively conversation. His name was Denis Metzger, a former banker who had had enough. He was here to set up a refugee hospital with funds from the European Economic Community. The Pakistanis thought he might be a spy and would suspect I was part of his operation. My instincts told me I could trust him, and I told him my plan. He said he trusted only one man, the old Pathan driver who spoke some English and German and was reading a paper over in the shade.

"He knows everything and everyone in this desert; he has to be careful because the government controls his license to drive, but he's good. He'll take you where you want to go; if you tell him not to say anything, he'll be quiet. Just be sure you're not followed."

I walked through the bazaar and down the main street, what Denis called "the Champs-Élyseés of Quetta," to get some medicine, the feel of the place, and to see if I would be followed. I didn't have a plan. I realized a part of me did not really want to go back inside. I returned to Lourdes.

Assefy, in Paris, had given me a few names in Quetta. The first was Zaman Durrani. I gave the old driver, Akhmed, an address and asked if he could take me there.

"That is Zaman Durrani's house."

"You know him?"

"I am a Pathan. Durrani is leader of our tribe. I will take you to him, but we must be careful. He is watched."

That afternoon, the old man drove me through the bazaar, a mass of men, carts, dust, and pollution, down a long boulevard with giant poplar trees and high walls, across railroad tracks to a wood frame house with a blue door. I knocked.

A man led me into a room with a thick red and blue-black carpet and fifteen Afghans sitting on the floor drinking tea. I was told to wait. They stared intensely at me. I smiled, said a few words of Pashto, and they grinned.

The louvered panel doors opened, and Durrani entered the room. He had fine black hair combed back, a lean dark face, long thin hands, a ring on his left hand. His smile was more refined than open. We shook hands; and he invited me into a room with chairs, a couch, and a coffee table in the middle—a Western room. I had become accustomed to talking to Afghans without the artificial barriers of tables and chairs to separate us. It was like the difference between eating food with your hands or eating it with a knife and fork, praying with your shoulders next to a man or praying in cold wooden pews, sitting together on the floor or sitting with a table between you. Durrani was a fascinating mixture of East and West, a man who knew both worlds, who on the surface seemed at home in both. But a man who is part of both is not fully at home in either, an outsider in both. He was a lonely elegant man, a cosmopolitan, spiritual, intellectual Afghan tribal chief.

He opened a pack of Dunhills, lit one with a Dunhill lighter, kicked off his sandals, and pulled one leg underneath him.

"What can I do for you?"

I hedged. I said I was here to write a series of stories for the *New York Times* on Afghanistan, hoping that I was not lying. His manner changed.

"In two years, many members of the Western mass media have come to look at Afghanistan, but they come to fulfill their own preconceived myth of my country, a land of fierce fanatical Moslems who fight Russian tanks with swords and treat their women like animals. Is the *Times* different?"

I told him what I wanted to do. "Yes, the West, particularly the Americans, see you that way. But they are afraid. They see Khomeini and Qaddafi and tremble. It is the Christian West versus the Islamic East, the Crusades, the sword of Islam in Tours, at the Danube, screaming Iranians shouting 'Death to America!' on television. Sadat, with his understanding of the Western mass media, became acceptable; he knew he had to win the American public over, just as he had to go to Israel. If the Afghans are to win over the West, they must somehow show that they are like us. Otherwise the Americans will ignore you, and you will lose your power. Afghanistan will become part of the Soviet zone of influence because no one will care. It is the nature of man to be concerned only with what goes on around him."

Durrani listened carefully and stared hard at me. He had lived in New York two years, but he was still Afghan.

A boy with a Prince Valiant haircut entered with a tray and a tea setting for two and a small bowl of cream-filled cookies. Durrani poured mine, then took his own. He began: "Afghanistan is a tribal society at war. The Western left thinks it is a feudal world fighting against history, a primitive nation fighting the enlightened Marxists of the Soviet Union. They are hypocrites. My nation is at war with the Soviet Union. The left will not help us because they think we are cruel to our women; we are not progressive liberals or social democrats. The right, Mr. Reagan, Mrs. Thatcher, talk but do nothing."

A lock of his hair had fallen over his forehead. He leaned forward in the chair, raised his finger to make a point. He took a long sweet drag on his cigarette, thinking.

"I am watched by the Pakistanis, even as we talk. You see, I

know that we must act on our own. A man, like a nation, cannot expect help from another man unless it is in that man's interest. So I must act alone. There is one law in the whole world: It is the law of the jungle. I run guns into the jungle of Afghanistan."

He pulled on the cigarette.

"Let me tell you the condition of Afghanistan, the human condition you mentioned to me earlier. Afghanistan is a tribal society with very complicated rules. These rules, laws, go back centuries. The West cannot pass judgment on us. How dare America, a nation only 200 years old? The six political powers in Peshawar have no laws with which to rule; they have only guns and money. You cannot buy the soul of an Afghan with these. Ninety-five percent of Afghanistan is illiterate. The country is at war, in the midst of a revolution, and bleeding to death. The only thing we can hold on to is the ancient laws of our tribe. In the East, it probably takes a hundred years for a political system to take hold. And a political system needs a culture."

"But, wait a minute. You said Afghanistan is in the throes of a revolution. Pakistan controls the political parties in Peshawar. All money, all guns, are funnelled through Pakistan, which divides the money and weapons as it sees fit. The fundamentalist parties get the most. I spent one month in Paktia Province, and it seemed that most of the commanders were mullahs."

"That is in Paktia, the most backward of provinces. The chief rules—not the mullah. Mullahs exist because they are good fighters. No spiritual leader has ever ruled in the history of Afghanistan, and none ever will. No Afghan would allow a mullah to put him in a religious straightjacket. An Afghan is too free for that. We have a saying: 'Every Afghan has God and a gun.' He doesn't need a mullah; we are not like Iran.

"I will tell you a story. An old man came to me for arms. I said to him, 'Why not go to Yunus Khalis? He recently received a shipment of arms.' This old graybeard, a tough fellow from the desert, cried out, 'Does anyone know who is the father of this Yunus Khalis?'"

Khalis, the man whose men I had traveled with.

"The future leader of Afghanistan will be neither a spiritual leader nor a political upstart from Peshawar. The leader must be a great man. It is extraordinary, actually. We are Moslems; our god is Allah; but we must kneel to a statue."

I told him about the girl carrying the bed, her husband the teapot, the men who cocked their rifles when I tried to take a picture. "You spoke of culture. What about the role of women?"

He smiled and poured more tea.

"Aren't all men the sons of mothers? You are familiar with the *Pushtunwali*, the code of the Pathans? It is a stronger force in our lives than the Koran. *Namus*—the honor of a woman. Everything we sacrifice for our life, and life is a sacrifice for *namus*.

"I am a chief. I follow the rules of my tribe, and because of this I am respected. My wife is the chief of this house. I do not have any money. In all the years I have been married, my wife has run the finances in my home. She was a schoolteacher in Kabul.

"Women are revered in Afghanistan. It is to them that we dedicate all our poetry. Our women are strong, but we want to treat them as delicate creatures. You have seen that women wear red and black dresses. This is an ancient custom, so that they will stand out in battle and never be harmed. Women can vote in Afghanistan; I have heard that women have been gunned down in the streets of Kabul for demonstrating against the Communists. But in the countryside, as in your rural areas, it is more conservative. But how can you judge? It is a shameful act for the woman to earn the income in a Pathan society. It is a thousand-year-old custom that a woman should obey her husband and that, in turn, a man must protect a woman. A camera, for men in the mountains, is a strange thing. Those men were protecting their women when they saw you raise it. They did not know, perhaps, what the camera would steal from them, perhaps part of their soul. To these men—to any man—is it not the most shameful thing to lose a soul?"

"In the Soviet Union, women are doctors."

"In the Soviet Union, women sweep the streets. You would never see that in Afghanistan.

"We must speak of revenge, *badal*, another tenet of *Pushtunwali*. If a battle breaks out between two tribes, and six men from one tribe are killed, then six must be killed from the other tribe. If, however, a woman marries into the other tribe, the *badal* is over. Over half of all rivalries are ended this way.

"But this will not satisfy you if you must compare Asia and the West. You cannot. I will give you one example. I read your news magazines; you can buy them here. I have lived in New York. I know, but only as a man, what it is like for a woman to walk down your streets at night, always afraid. Don't forget, my wife was there with me. It is a terrible thing to be afraid. It is a worse thing for a woman to be raped. Can a woman think about it, her hidden personal shame? How many women in New York alone must live like that? Is that any kind of a life? You may think, as a Westerner, that our laws are primitive, but in forty-five years, I have never heard of a single rape in the Kandahar countryside."

Long orange-rust sunstripes ran along the room, separated by dark shadows. It would soon be time for prayers.

"What is it like inside Kandahar?"

"It is bad. The fighting is fierce. There are many helicopters. I received a report from my men today that the fighting is worse than they have ever seen it. I have twelve wounded men; I have no way to get them out."

"Your men?"

"Since my family and I escaped, I have been doing what I can from here. It is not much, though. I recently bought 500 rifles with 150 bullets for each man. One rifle cost 8,000 rupees [$800, approximately]. This is very expensive for our tribe. I bought them on the open market in Pakistan. They are old British Lee–Enfields, no match against helicopters. But what can I do? We get no help from the West. I ask myself, 'Where have our Western friends gone?'"

"No help at all?"

"None. Not even medical supplies. The West doesn't care. It gives money for refugees, some anyway, but that is only to assuage the liberals' feelings of guilt. If we can only hang on for a few years . . . We can't win a military victory, but we will win a moral one. *Insh'Allah.*"

I said I wanted to go inside, and he said I must go with one of the political groups. But I wanted to go in with a tribe. "Don't you work with the political groups?"

"They are opposed to the tribes. They want the power. At your Embassy in Islamabad a man once said to me, 'You are not united. How can you expect to win?' I said that we were more united than NATO. I will kiss the hand of any man who throws a rock at a Soviet tank, regardless of his tribe. If there is unity, our guerrilla war is over. In Afghanistan, every man is a commander. Go talk to the groups. Then if they won't take you, and you still want to go in and witness *shubkhun*, come to me."

"*Shubkhun?*"

"It is Persian. In English, it means 'blood in the night.' It is the war we fight. It is winter. There are no leaves in the trees to hide under. There are no mountains in which to flee. The desert is flat. Helicopters can see for miles, and soldiers and tanks can move freely, so we sleep during the day, and when it is cool, under the cover of night, we attack. But a visitor does not need to worry. We are Pathans. I would instruct my men to guard you. There is a saying, 'A Pathan is a very good friend and a terrible enemy.'"

We stood up. I grabbed one last cookie as he showed me to the door. The *Azon* had begun. I waited while my driver prayed, and then we drove, by a different route, back to the hotel.

I told Denis my plans that night at the China Café, a Chinese restaurant with Pakistani flavoring. We had a table in the corner but when approached stopped talking. Denis trusted no one. Men on motor scooters had been following him, watching him come and go. Sometimes they questioned him directly. He

was there to set up a refugee field hospital. The Pakistanis, however, worry about a Baluch independence movement and what the strain of so many refugees will ultimately do to their already inflated, struggling economy. There had been already over 300 border attacks by Afghan army troops or helicopters.

We walked back to the hotel. The streets were vacant, the night surprisingly cold. There were no lights, a bicyclist or two, a dog, no cars. We talked about life in New York and Paris, the girl he left behind, his former job as a banker in London.

"My heart never welled up inside when I was hustling clients like it does when I see some of those Afghan kids in the camps. I really want to put this hospital up and bring in a team of French doctors to see if I can do it.

"And you want to go back inside?"

I nodded and dug my hands into the pockets of my fatigue jacket.

The next morning I asked Akhmed, the old driver, to take me outside Quetta, supposedly so I could photograph some of the nomadic tribes I had come to study. We drove through the bazaar and headed east out of town. The low adobe houses fell away, and we came on about 15 or 20 black tents 200 yards off the road. Akhmed pulled over, and we waited a few minutes for the dust to settle. I saw motorcycles parked behind us a few hundred yards down the road. We moved on to another encampment, and again the motorcycles appeared. I would have to find a way into Afghanistan and worry about them later. I told Akhmed I wanted to talk to Afghan political groups, quickly. He said he would try to arrange something and would come for me at eight the next morning.

The Yunus Khalis office was on a clean, narrow, paved street with a gutter on one side. It was cement block with an iron gate, a guard with no rifle, and a poster identifying it. Three small rooms opened onto a small courtyard. There were twenty

men, no weapons. I asked for the man in charge and was taken into a cool room with a carpet. Green tea was brought in.

Who was I? What did I want? Someone spoke a little English; another, some German. The man had worked in a factory in Frankfurt. We talked in both, and I threw in as much Pashto as I could, which was little, equal to my German. But this was the south; they preferred Persian. They stared and asked me many questions about Paktia and the Peshawar office.

I must wait for Ebrahim, who was in the bazaar. I drank many cups of tea, waiting. Ebrahim was a thin freckled young mullah who spoke English and was more interested in my Casio watch and whether I would buy him an English dictionary or even get him a visa to America. I had heard it many times before. "I will take you to Kandahar, and you will take me to America, yes?"

One heard that sort of thing from young, educated, frustrated Afghans in Peshawar. They were in the minority; but disillusioned by the war, the suffering and hopelessness of their people, they wanted out. I thought of some of the Afghans I had met who drank every night—*"pour oublier mon chagrin,"* one despondent French-educated leader told me. But that was in the West. It was not so much for his country that he drank, but his lost position, and that he could not, would not, fight. I pitied him, but sympathized. Ebrahim was another opportunist looking for a way out. I didn't like him. He was too anxious to please. But he was also in charge.

"Kandahar is very dangerous. There is much fighting, many helicopters."

I pressed my case. He said he would call Shir Naabi, the twenty-two-year-old commander and right-hand man to Khalis in Peshawar. I should return tomorrow.

All decisions are made in Peshawar. It seems, therefore, the Peshawar-based groups were in contact with their field offices along the border, possibly the length of the entire Paki-

stani–Afghan frontier. And, if I must be approved by Peshawar, my chances of going in with one of the other groups was decreased. Only Khalis knew me. I assumed that by going in with one group, I had set myself against the others. Anyway, I wanted to go in with Durrani's men. The political groups had less influence down here. My instincts told me to go back to Durrani and forget the others, but I wanted to test these groups and decided to wait. I also wanted more time to let a few scabs form on my feet and legs.

The next day there was no word from Peshawar. I went to other offices. Who was I? What did I want? More tea, more stares, more questions. I said Kandahar, and they all shook their heads.

"It is very dangerous. There is much fighting."

Ebrahim continued to give me the runaround and no longer said, "my friend." No one in Quetta would take me. I called Shir Naabi from the hotel. The connection was bad, but I'm sure the many people listening in understood well enough. He said no, he was sorry, but it was too dangerous. "Is not a month in Paktia enough?"

No, I wanted a more complete picture of Afghanistan than that which would come from visiting one region.

Knowing how tough and resourceful Naabi was, I assumed he did not want me to go in because the Khalis group perhaps did not have the influence here that it had in eastern Afghanistan and because they'd already done a lot for me. This was true enough. Also, I had not gone to see Naabi when I got out or Khalis either. I had improperly and incorrectly assumed that Abdullah and Hakkim would pass the word along that I was out. At the very least, it was impolite. They had done much for me.

When Naabi said no, I walked in the bazaar and found a rickshaw to take me to Durrani's. He was not there, so I left a note that I wanted to go in with his men. I took the rickshaw back to the bazaar and walked over to a teahouse to write a few letters. There are perhaps four teahouses in Quetta where a man

can sit at a table for hours, have a cup of tea, some pastry, conduct a little business, play cards, backgammon, read a newspaper, write a letter, like the few remaining coffeehouses in Vienna and the cafés in Madrid. The differences are the number of flies and the prices.

I wrote letters to Mike Kaufman in Delhi, Craig Whitney and Bob Semple in New York. I told them I was going back in. I did not know if anyone knew anything, if the story I had sent Mike had any chance of ever being published. My gut told me yes, but I was superstitious and did not want to think about it now. The two letters to Mike, I later learned, were, as he put it, "two out of maybe three or four letters that have gotten through to me from Pakistan in my two years in India." There was no direct telephone communication between the two countries; a call must go by way of London. There is no direct telex communication either, it must go via Hong Kong.

A man was waiting for me when I returned to the hotel. Durrani wanted me to come over that night. I must take a rickshaw from the bazaar. Do not let the hotel know. The hotel staff, seeing the Afghan there, knowing about the phone call, would certainly know by now what's up. But what did it matter? I would deal with them later.

I caught a rickshaw to Durrani's. He was waiting for me. There were about thirty men in the outer room.

"What happened with Khalis and the others?"

"Nothing. They say the fighting is too bad."

"Still you want to go?"

"Yes."

He called two men in. They did not shake my hand. He told them what he wanted.

He turned back to me. "These men will take you to Kandahar. Rasule here is one of my best men, and Alishan will be your translator."

"You knew all along I would be back?"

"Yes."

177

I looked at the two men. I liked Alishan better. He had a severe face but was shy and smiled. He wore white baggy trousers and top, a gray sport coat, black shoes and socks, a long black beard, a black turban and played with worry beads. Rasule barely looked at me. His eyes were without emotion. He wore a white turban and played with the end of his mustache as he listened to his chief. He was a mullah.

We would leave tomorrow morning. I must be here at 7:30. No one must know.

"Bring everything you have. You can leave here what you don't take." He stopped, took a long drag on the Dunhill. "Do you have any money?"

This I didn't like. For a split second, I wondered whether I was being taken. I didn't have much.

"Some."

"It will cost $300 for a taxi to Chaman and to go by motor scooter across the border. We must pay for these things. Also, you might have to bribe some people."

I did not know it, but it was a test. Durrani trusted no one. I was not the first journalist to come to him. I did not know then how shrewd he really was or how important the money would be.

I had fifty dollars, two credit cards, passport, and my now-crumpled letter from the *Times*. I showed him what I had.

"I can get money in Islamabad when I get out. I can't do it now."

"That's O.K. We will do that later."

He read the letter carefully. It said only that the *Times* had first rights of refusal, nothing more. He knew that I knew he was taking a chance. He stared for a second. Decision made.

"Tomorrow morning, then."

We got up. I shook hands with Alishan, who smiled. He was nervous about speaking English.

"You teach me Persian, I'll teach you English."

"Good."

Rasule said nothing.

Denis had had to fly to Islamabad and then to Karachi. I paid my hotel bill and ignored the questions. Where was I going from here? Did I need a car? There were no flights that day.

I had dinner alone at the China Café and returned to my room by nine o'clock, packed, and went out to the lawn. I ordered a pot of tea and wrote a letter to Denis, asking him to contact the embassy if he had not heard anything in three weeks. I gave him Durrani's address, my parents' phone number in Washington State, Arthur Hill's in Washington, D.C. I took the letter over to the desk. A boy with long curly hair, a scarf around his neck, and a blanket around his back, huddled next to the stove, reading. He nodded and looked at my pajama-clothes.

"Mr. Youssaf [the manager] say that it strange that you leave tomorrow. There is no flight to Islamabad or Karachi." (The only two cities to which there ever were flights.) There was no need for an answer. He had just told me to watch it.

I went back to my room, did a series of pushups, situps, stretching exercises, a daily regime to keep fit and relaxed.

I got up at 4:00, wrapped the turban around my waist, put on my shirt, jacket, my blanket around me with the pack on the inside. I avoided the hotel front and walked across a field, down a back alley to the bazaar. I found a *chai* stand and sat on the side of the road like a day laborer, waiting for daylight and the streets to fill. I walked on, bought three tangerines, and waited again. It did not seem I was followed. The streets began to fill. I drank more tea at another stand, waited, and at 6:30 took a rickshaw to a fruit stand near the tracks. I waited until the driver left, then took a back street to Durrani's. It seemed clear. I knocked.

Alishan, Rasule, Durrani, his son, and three others were waiting. Durrani gave Rasule 3,000 rupees and Alishan a pistol. He showed him how it loaded, then pulled the trigger a few

times. It was not a comforting sign to learn that your guide had never used the weapon he was supposed to protect you with. Rasule wore a leather bandolier and a pistol under his blanket. I put on the turban, and we walked out of the main room. The men rose, looked me over carefully. Durrani lifted his arms parallel to the ground, the palms of his hands facing upwards, and they prayed quietly in unison; was it the same prayer that was offered when we went off from Shie-khot to mortar the army base at Tamania? We shook hands, embraced, and they followed us outside. A Toyota sedan waited. Durrani, who had not smiled all morning, shook my hand again.

"May God be with you."

Again, I sat in the middle. The driver, another man, Al-ishan, Rasule, and me. Again we drove into the bazaar. Three men got out, but this time they returned, Alishan with a carton of Kent cigarettes, the driver with an Orange Crush, the other fellow with a plastic bag of candies. Within ten minutes the asphalt road was bordered on the right by dust-brown flatland and on the left by a railroad track; beyond that, wasteland. The road was patched, bumpy, like streets in New York City. We passed a village checkpoint with a cable across the road, soldiers in sweaters with epaulets and black belts. They looked, waved us on.

Durrani had told me a story the night before. His oldest son had been a student at Kabul University, first in his class. He was awarded a scholarship; he chose medicine and went to Czecho-slovakia with eleven other students. He did well. When Hafi-zullah Amin, who had been the Afghan ambassador to Prague, came to power in 1979, he ordered the twelve students returned to Kabul. An old German from the Sudetenland heard about the order and came to young Durrani. "You must flee," he said.

"There were only six of the twelve students around that night," Durrani said, "but they fled across the border to Austria. The next day, the other six were flown to Moscow, then Kabul,

then to Polachari Jail, where they were shot." Durrani knew six students were killed, and for six months he and his wife did not know whether their son was among them. Then a letter came secretly from Germany. "God chose to spare our son. We were fortunate. It was then that we planned our escape to Pakistan."

This story began to sink in as I found myself speeding back to Afghanistan.

The road began to twist. There were no trees. The terrain was rocky, barren. The ground was still flat. A vapor hovered in the air above the road. Then we began to climb. A bus packed with men on top and spewing out clouds of ugly black smoke crept and leaned ahead of us. Our driver decided to go around on the left, on a curve. An oncoming truck swerved out, we ducked in, and like a golf ball going by your ear, I felt the breeze. Near the summit, there was a small army base: a half-dozen wood-frame barracks, walkways lined with stones painted white, and antiaircraft guns wrapped in canvas on three small plateaus.

Unfortunately, our driver seemed to think his car was a horse, and he let it loose on the downhill side. Chaman appeared on the plain below and looked bigger than it was and more modern. We drove down what I assumed was the main street. There were flatbed carts with small oranges, others with ba-nanas—for some reason, they sold one or the other, never both—rows of small shops selling cashews and pistachios, rope, pots and pans, blankets, turbans and caps. We headed east through a warren of baked brick homes and crumbling walls with domed tops, then on a dirt track which led farther out into nothing.

We pulled up before a small house with a gray canvas top. I was told to go quickly inside. One step down, there was a single cool room, straw mats on the floor, a spittoon, a *chillum*, or water pipe. Rasule went off with the driver.

"We wait here," Alishan said.

"How long?" I should have known better.

"We wait." Alishan did not smile.

Outside, the wind blew in gentle gusts. Two hours passed, three. Now and then small heads peeked in, curious children in long filthy shirts, bare feet, and stiff caps around which they wrapped turbans. In Baluchistan, these caps have the front cut out as if some playful young boy had cut a wedge with a pair of scissors. Men came in, nodded, shook hands, sat against the wall. One tried the water pipe; others took snuff. I tried to write. A thousand flies swarmed around us. They congregated on one's lips, as if searching for saliva, anything moist. The wind picked up, and we covered our faces with our turbans. Alishan and the old man pulled their blankets over them and lay like mummies. It became difficult to breathe. When the wind died down for a few minutes, two boys brought lunch—a bowl of onions cooked in oil, a loaf of flat bread for every two men, and tea. We slopped it up, using the bread as a spoon, licked our fingers, wiped our chins with the backs of our hands. A few contented ones belched. I sat quietly.

A solid fireplug of a man with a black beard, now greasy, apologized to me for the food.

"We have not received anything in three months, not even wheat for bread. We are refugees here. This food comes from Afghanistan. We are ashamed that we can't offer you better."

I said it was good and all that I needed.

Alishan explained where I had come from and why I was there.

There were four tents and two dozen hastily built baked brick homes in the camp for 500 people. The Pakistanis said they could have their rations, but only in Quetta. This camp, however, was a haven for the *mujahidin*, who came here to rest, and a way station for refugees. It was also Durrani's gun-running depot.

There was, as usual, a lot of talk while we ate, and afterwards the older men passed around the water pipe. Tobacco, no hashish. Alishan had a Kent. I missed most of what was said, except that which was directed to me by Fireplug. Alishan, with his severe uncertain look, translated carefully:

"He says, 'I believe in my God, and I believe in Islam. I do not believe in Gul Badeen, Rabanni, and those others.'"

"What about Khomeini?"

"Iran? Iran is digging its own grave."

There were grunts and nods and puffs of approval from his friends.

There was a continuous movement of men who came to smoke the pipe, chew, talk, and look at the visitor. I had to again learn to sit quietly. I tried to write poetry.

The sun set, the sky turned black, and I could finally go out for a walk. The ground was warm and dusty, and the heavens were filled with millions of stark white stars. A boy accompanied me to the village outhouse, a gully 200 yards away, 4 feet deep, 50 yards long. We walked back by a different route, and I could not see ten feet ahead of me, yet the boy walked confidently.

We returned and dinner was served. Two boys, ages four and five, brought the pitcher of water, poured while we washed, gave us a filthy cloth with which to wipe our hands, disappeared outside. They reappeared, like caterers in Georgetown, with two bowls of soup called *shorwa*. It was pieces of bread soaked in grease, and there was a small metal bowl with three pieces of mutton for me. The bread had been stored in a folded-up rug in a corner.

While the postprandial snuff, waterpipe, and cigarettes went around, a truck approached outside. It pulled up to the entrance, and two tough young men with rifles stood over us. Rasule came in behind them and announced to Alishan that we would leave at dawn. The two young men looked hard at me, then left. There was much commotion outside, harsh whispered voices, scurrying feet; then the truck left. Alishan said it had to travel at night. The guns were transferred here and then taken inside Afghanistan. Always at night. "It is the only way. *Shubkhun*," Alishan said.

There was more smoking of the *chillum* and more talk, talk, talk. I curled up in the corner. Tomorrow we go. I wanted to, and then I didn't. Like before a race: You want to and you don't.

I found myself thinking about home, yellow leaves, flag football, cross-country races when my lungs burned from the cold air. I thought about my first trip outside the United States, reading Kazantzakis in Greece, playing Beethoven's piano in Bonn, walking along the Seine at night. In Quetta, I had written in a splurge of emotion the lines from the preface to *The Last Temptation of Christ:* "I loved my body and did not want it to perish; I loved my soul and did not want it to decay." It was as if this journey to Afghanistan was my own personal odyssey.

At dawn a man cupped his hands and called us to prayer. Soon, before the sun had risen, a child cried, a rooster crowed, a fire crackled outside. Alishan, Rasule, and I were alone. Others joined us. A man entered with a metal tray on which there were ten Duralex glasses, an enamel teapot, and a small tin can of sugar. Carefully he put three spoonfuls in each glass and then a stream of hot black tea. Another man brought a radio, and we sat huddled in our blankets listening to the BBC Pashto Service.

But then the wind came up, and we hid behind our turbans, waiting for the storm to pass. Rasule went off and returned by midmorning with bad news.

"It is too dangerous today. We will travel tonight." He did not say why. Another day in this ten-by-ten hovel, not allowed to leave for fear of being discovered. "A stranger, no matter how well disguised, would be noticed immediately," Alishan explained again—as if I didn't know. At noon we ate yesterday's onions and oil, this time without tea.

Then came a sound familiar to everyone in the world—a motorcycle. Two Honda 90s. So, this is how we will go to Afghanistan. Mohammed, eighteen, with no front teeth and a wide infectious smile, would drive one; Alishan would sit behind him, then me. Issaq, a Hazara about twenty, would lead, with Rasule and my pack.

A crowd of thirty materialized to watch the fun. Finally, with a laugh and a wave, we drove off, like five men on a camping trip. We rode east on pathways with six inches of dust as fine

as ash in a fireplace, our faces covered with our turbans so we could breathe. We raced, bounced, and pushed the bikes through sand drifts, gray mucky bogs, across narrow streams, sat with our faces covered when the sand blew too hard, and put the throttle to the floor and shot across the scrubland, past solitary rock formations worn jagged by the wind.

We came upon a shepherd and his flock of about a hundred sheep. He wore a heavy sheepskin cape, and his legs were wrapped in wool. He carried a staff and a sheepskin bag with a two-inch-thick loaf of bread, round like a giant pancake. He lived with his sheep for days at a time with only this bread to eat. He had a wide smile and hands as rough as unplaned wood. He had not seen any helicopters, he said. He gave us a chunk of his bread, and we raced off.

Just before sunset, we came to a small village on a wide plain. There were palm trees and a sparkling pool of blue water. It was all that I could do to keep myself from jumping in headfirst. Slowly, gently, my companions washed their feet and ankles, their hands, arms, and faces. They drank little. They spread their blankets to pray. Rasule came over. I had waited and would wash on my own. I did not know these men yet and hoped that, with Alishan's help, I could let them know I was not Moslem. I thought Rasule knew.

"Why don't you pray with us?" He looked at me seriously. I had not seen him smile yet. I had had the same feeling about him that I had about Rahim two months earlier.

"I am . . . Christian. I will pray separately, to myself."

He turned and walked away, and I had a cold feeling that I could not trust him. He was bound by orders of his chief and the honor of the Popalzai clan of the Durrani tribe of the Pathan nation to protect me. Even so . . .

They prayed, and I sat on a mound alone, my head bowed.

We drove on. It got darker. More villages appeared. Rasule asked directions, another bad sign. I tried to take a picture, and he refused to let me.

While waiting for Issaq to fix his bike for the hundredth time, Alishan explained that we were looking for a specific village that we could not find. Issaq and Mohammed had balked at first; the trip was too dangerous. But when Rasule offered big money—500 rupees ($50) for each man—they gave in. We had raced across the open spaces because they were terrified of helicopters. Mohammed was also Popalzai. Durrani was his chief, too.

We were safe only in a Popalzai village. The Communists were bribing the villagers, as the British had done—playing to old animosities—and we could not be certain of the allegiance of each village. I was to keep behind them and never speak, even when spoken to, until Alishan or Rasule gave the word.

By nightfall we reached a graded road, which, Rasule said, led to Kandahar. It was cold. We wrapped our blankets tightly, pulled our turbans over our faces, and speeded on with no lights. I wished for a pair of warm socks. When a village loomed ahead, engines were killed, pistols drawn. Rasule went ahead, decided it was not Popalzai, or the right one, and like crazed night riders, we raced ahead into the void.

A single beam of light appeared ahead. We stopped and heard the clank, clank, clank of metal tracks. Tanks! We fell from the bikes, and I rolled in the dust, grabbing my leg where I had burned it on the exhaust pipe. Rasule grabbed his pistol and went ahead. We ran over a ridge, covered the bikes. The clanking came closer. I planned my escape, due south until I hit Pakistan. Rasule returned. "Tractor." Some farmer working overtime. We got back to the road, shivering, and rode off.

Rasule decided that it was too late and too dangerous to go on. There was an army base ahead. We roared into a village, and a dozen dogs with vicious teeth and eyes as bright as cats kept us back. Rasule went off towards a light. In a few minutes, he returned with a man who led us to a guest house. Every village that I had seen here had one, or at the very least a room, for travelers. A man or a family does not pay and is never turned away. It is part of the *mehrmapalineh* of *Pushtunwali*.

The room was clean, and there were quilts stacked against the wall. No weapons. Rasule and Alishan put theirs away. A small boy brought tea and later bread. There was no sugar, but it didn't matter. The liquid was hot and delicious. The host looked at me carefully. The young boy—his son?—sat next to him, and an old man—his father?—joined us. The old man was tubercular and coughed and hacked mucus with blood and spat into the corner. Finally Alishan turned and said, "You may speak. This man is with us."

When our host saw that I was a foreigner, he bowed and stared ahead.

"We are ashamed that we can offer you, a foreign guest, only bread. We are very poor."

I looked closely at this man, so humble, so sad.

"The bread and tea are just what we needed."

"Are you French?" he asked. Two French doctors had come the year before.

He unrolled the quilts for us, and before he took the lantern away I was asleep.

We needed to travel under the cover of darkness and left before dawn. Shivering in the cold, we walked past what Rasule said was the military base, somewhere out there on the left. Safely past, Issaq and Mohammed kicked over the motors, which in the stillness were loud, too loud.

We went full throttle, racing against the sunrise. A herd of a dozen small white-tailed antelope ran and skipped as if their legs were springs on the plain 200 yards away. They were so beautiful and free that I quit pouting and forgot about the cold.

By midmorning we reached a village a quarter-mile long, with light brown houses and domed roofs, almost bronze in the morning sun. A four-foot wall surrounded it. We rode in, and I was quickly hustled inside a house and told not to move. A boy brought a cushion and quilts for me, and a man brought a tray with glasses, tea, and soft milky bread like I had had a month ago, bread made by a woman.

Within an hour we heard the helicopters and felt the earth

tremble as the bombs dropped. They watched my reaction. The men seemed unconcerned. Outside, a twenty-year-old green and yellow Massey–Ferguson tractor rumbled by on its way to the fields; children played, and mothers called after them; dogs barked, and roosters continued to welcome the sun.

Mohammed and Issaq were anxious to leave. They didn't like the idea of riding in the open with the helicopters so near. Rasule returned, pulled out a wad of pink Pakistani notes, and peeled off the rest of their money: The agreement had been half up front, half on delivery. We shook hands.

"*Hodai Pahman.*" (Go with God.)

They wrapped their turbans tightly, gunned their bikes, and were gone.

From now on, we would walk. I exchanged my brown turban for one that was black with silver threads; my blanket and fatigue jacket were exchanged for a black tattered vest and a dirty gray blanket with torn borders. A man gave me a sharp jagged scythe with a wood handle. A donkey was brought out. I was to be a deaf and dumb farmer traveling with his young brother and our donkey. I had to ride. Sayyid, the boy who brought the cushion and quilt to me, was to be my younger brother.

A man on a donkey is left alone. In Kandahar, the *mujahidin* walked or rode bicycles or motorcycles. A donkey is no getaway vehicle. I was to to say nothing; Sayyid would do the talking.

Now, say what you will, a donkey is not an easy animal to ride and, like a horse, knows when its rider is confident. We had a few laughs, but finally Ralph—the donkey—and I came to an understanding and headed northwest toward the bombardment on a narrow path which led across a plowed field. Rasule and Alishan walked a quarter-mile behind.

Men worked the fields, turning the gray dry earth with wooden plows pulled by gray Brahmin cattle or shiny black water buffalo; one had a tractor with a row of shiny steel blades behind it. There was a truck a few hundred yards away into which men and women loaded wheat. A pack of six helicopters

circled in the distance, bombing. In the haze, they looked like giant hummingbirds hovering and darting in the air. The ground shook. The farmers ignored them. We walked on. Two sets of MIG fighters, silver jets with bright red stars on the fuselages, roared overhead. This was insane! All around, farmers peacefully worked the ground much as they had for centuries, and in the sky the Soviet air force waged war from its central southern base a few miles away.

We plodded on, Sayyid, the donkey, and I, with a vicious-looking scythe in my hand. As we passed other travelers, I looked straight at them, nodded, and the boy greeted them. I looked at a woman; she would look back for a split second, then away. Did she know I was a foreigner? What went through her mind? A look, then away on a dusty path in Afghanistan was like a look on a street in Paris, New York, Moscow—it was always the same: the mystery, the excitement, the brief sadness when she passed, gone. There was always much time to think in Afghanistan.

I wanted to see how close I could get to the airport/air base. Built by the Americans in 1962, it is officially called Kandahar International Airport and is, as the crow flies, less than 800 miles from the Arabian Peninsula. The Afghans had hoped that it would become a modern Asian air crossroads, as Balkh in the north had been a great caravansary on the Asian Silk Road. But the runways designed by Washington were too short for big jets. Maybe the Russians had lengthened them.

By midafternoon we reached a village about 800 yards from the airport. We walked down narrow, shaded pathways and found an empty room. Rasule went off to look for food. In a while, a girl with big black eyes and two boys, the oldest of whom was about five, shyly appeared in the doorway with plates and bowls. They put them down and came back with more. There was bread, a bowl of milk, dishes of oil and onions, of chicken gizzards, of mushrooms and onions in sheep's fat, loosely scrambled eggs, and, for dessert, cool *mastah*—yogurt

with pepper—strong, pungent, delicious. We shared the food and a metal spoon for the yogurt.

In my mind I forgave Rasule. Maybe I had been wrong back at that oasis. This elaborate meal was for me. He ate little. He was worried that I would be discovered; this was not a Popalzai village. Alishan said little. Only Sayyid seemed at ease, happy to eat so well, or like any kid, to be in on the intrigue, instead of bending his back over a plow in the sun. I asked him about school; he shook his head shyly. Rasule said to be quiet.

I liked Sayyid and had come to feel close to him as we walked across the fields, a younger brother and a protector at the same time. Now he had to go. We did not need him now. Rasule gave him some money, and he jumped on the donkey, clicked his teeth, and cantered it down the path like I wish I could have.

I had promised Durrani that I would bring him pictures of the airport. He had told Rasule to bring me here.

I hung the movie camera across one shoulder, the other around my neck, drew the blanket across my back with the long end over my shoulder. The cameras were hidden and my hands were free. Rasule would stay here. They thought of giving me a pistol. No, Alishan would cover me. We walked to the southern edge of the village. So far we had not been noticed. A helicopter slowly came in to land. A passenger jet about the size of a 727 followed. A hundred yards away were two and a half crumbling walls of what had once been a small house. It was now an open-air outhouse. Two hundred yards beyond that was another adobe house; beyond that, scrubland, a clump of trees, and the airport. I would walk across the open land to the second house. Alishan was nervous. He lit another Kent with a Bic lighter I had given him. We sat on our haunches, bodies against a wall. He nodded. "Go."

I began to walk, my heart pounding. I got to the outhouse. Then a man came across the field to visit my four-by-eight-foot enclave; an MI-24 helicopter slowly came directly overhead in for landing. I waited. The man went around the back, seemed to

take forever, then walked away. Another MI-24 came in, and I let the camera roll. Flushed with success, I made for the second house. The airport was bordered by a high cyclone fence with light bulbs set thirty feet high, spaced every forty yards.

Then, something told me to stop. There was no one around. I turned; Alishan stared, watching me, unable to give his emotions away because two other men were watching me also, fifty yards on his left. Then I realized—mines. The field was mined. There was probably an Afghan soldier in that house in front of me. Keep cool. I put my arm over my forehead and acted like I was looking for a lost animal—a peasant farmer who did not know the field was 300 yards from a Soviet air base. Right. I walked back. The men did nothing. Alishan walked away, and once past the buildings, I joined him. Inside the room, he was shaking.

"You went too far. Those men watched you. The field was mined. By the grace of God, you are alive."

We left immediately, afraid that the two men might have suspected something, crossing the road and heading west on a path next to a ten-foot-wide cement-encased irrigation channel. There was a lock where it passed under the highway.

"The Americans built this," Alishan said. The American engineers and AID people would be happy to know their work was intact and better used than the airport.

We turned north past a village and walked across a barren rocky plain that could have been on the moon. I felt happy. My stomach was full, the sores on feet and legs were starting to heal. The air was clear and dry, and a gentle breeze bore at our backs. The sun was in the west, soon to set. It was perfectly quiet, and the rocks, which are were as jagged and beautiful as those in the American Southwest, seemed to hold mysterious and ancient secrets. Ahead lay Kandahar, second city of Afghanistan, settled by Alexander the Great. Maybe his army marched along this route before it headed north to Kabul and east to India.

Rasule had borrowed a bicycle from the last village and

gone ahead. The owner, a boy about fourteen, walked with us. He started to sing, and Alishan joined in. I walked ten feet behind. They had never met before, but now, an hour later, they were singing. Alishan turned.

"You sing, Mr. Jere." And so, for the next hour, I sang every song I could remember—American folk songs, ballads, Beatles songs, Sunday school songs, French school songs. Alishan especially liked "Clementine."

"It is good to be happy," Alishan said.

I asked him about himself, and as we walked, he talked.

He was a former administrator in the Department of Education in Kandahar until the middle of 1980. Finally, he said, he could no longer take the changes in the school system and in the bureaucracy. Education was not important. New thoughts were.

"My brothers were fighting, and I was in an office."

He escaped with his wife and daughter to Pakistan. He lived in a refugee village. He was an aide to Durrani and a member of the upper class. Durrani had told him to accompany me because he knew some English. He wore a watch. He had never carried a gun before.

At the edge of the plain, Rasule sat by a rock in the shade, the bicycle beside him. For the first time, he smiled. His village lay just ahead, and all was well. He gave the boy his bike back and a Pakistani note, and the boy left. A short distance away I saw a large adobe metropolis with many domes and imagined a city that Marco Polo would have happened on, shimmering round tops glazed by the sun, bearded men in long robes standing about in serious discourse, veiled women in silk, green grape-filled vines, flowing canals, happy children, melons and wine and rich exotic smells.

The sun had not set. We walked along a pathway in which the dust was three inches deep, like walking in powder. The path led to other pathways, past high walls and domed roofs, under Moorish archways, past old men sunning themselves and

children playing in the dirt. Little girls in dresses and long leggings and bare feet, boys in long shirts to their knees, small piles of onions and what looked like potatoes and watermelons. Watermelon! My mouth watered. I nudged Alishan. "I want one," I said like a spoiled kid. A few men nodded and called out to Rasule; he stopped, chatted, and we went on. No one seemed to take undue notice.

"Do not talk," Alishan said. "Even here we cannot be sure."

Three boys, the oldest maybe seven, sat in a small circle in the dust playing marbles. There were no steelies or cat's eyes, but the game was the same. I stopped to watch. Rasule went ahead. Alishan hesitated. I took out the miniature camera and kneeled, smiling, trying not to disturb them. One boy took one look at the camera, screamed, and ran away, crying.

"He thought it was a gun," Alishan said.

I saw another boy, maybe five, with a long dark gray shirt, bare feet, and blond hair and blue eyes. He held a stick in one hand and a metal hoop in the other. I couldn't resist his grimy face, little hands, the curious, wide, frightened look in his eyes. I took his picture, crouched there, trying to get him to shake my hand. He wouldn't budge.

Rasule was now with another man who led us to a thick wooden door and into a small courtyard. At the end, up two steps, was a white stucco portico, two white columns leading to Moorish arches, a porch, then a doorway to a clean, bright, white room with quilts stacked in the corner. We took off our sandals, entered, and a boy appeared with tea. An old man joined us, and Alishan and Rasule explained who I was and why I had come. The boy returned with a pitcher of warm water, a pot, a clean rag. Then he brought dinner—a bowl of hot milk and sugar, soft creamy bread, and a small community bowl of shiny blue-gray sheep's innards and white chunks of fat, and—hallelujah—real meat. I savored two precious morsels.

Four young armed men entered the courtyard and, leaving

their sandals outside, walked in. One presented a watermelon to the man who had brought us here. He stuck a knife in it and gave it to me.

I burst out laughing.

"Eat," Alishan said.

"We'll share it."

"No. It's for you. From our chief."

"The whole thing?"

"*Balli.*" (Yes.)

So while they talked, I went outside and stuffed myself. It was bright red, delicious, and juicy. The men came to the porch to enjoy the Kandahar night and watch this crazy American, who, unbeknownst to his audience, had never eaten watermelon with a beard before.

"Mr. Jere, we go."

"Where?"

"We go to the front."

After dinner and dessert I was ready for bed. Luxurious living will do that to you.

We left the village and began to quick-march on a path separating two five-foot-high mud walls. A gate appeared every hundred yards. Then far off to the right came a loud pop. A giant white flare lit up the sky. We crouched against the wall, waited, continued on. Pop—another one. We crouched, waited, continued on.

"Russians," Alishan said.

My companions were not scared. If they weren't there was no reason for me to be. There were no voices, no pounding feet, no guns. Total silence.

We walked for an hour. Twice the man who led us checked the ground in front of a picket gate for footprints. On the third try, he found tonight's hideout. He opened the gate; a man shouted, and I heard the cold steel mechanism of his rifle slam together. The chief spoke quietly. The lookout responded, and in single file we walked fifty yards, bent down, and entered the

large structure which loomed ahead. There was an antechamber, open on both sides, a blanketed doorway, then a large cavernous room with twenty-foot walls, a high curved ceiling, straw on the floor, a single lantern in the middle, rifles, pistols, ammunition belts hanging from wooden poles stuck into holes in the adobe walls, and in a wide circle on the ground, thirty *mujahidin*. I felt as if I'd entered the secret hideout of Pancho Villa.

We all shook hands, embraced. The chief announced they had a visitor from America, and I felt like a politician pressing the flesh. They crowded around, laughing, marveling at my ability to utterly destroy their language in so few words. A place was made in the circle and tea placed in front of me, and my new companions searched my face for the necessary clues to my character.

The chief, in his forties, was clearly the eldest. Some were in their thirties; most in their teens and early twenties. A few old blankets were stacked in a corner; in the center of the room, next to the lantern, was a black teakettle and a five-gallon can which said, unmistakably, "Standard Oil of New York." It now held the sugar for our tea.

There were twenty-three rifles, one submachine gun, ammunition belts, pistols, no Kalashnikovs. I took out my notebook and began to write, and I immediately had an audience. A young man finally got up his courage and said slowly: "What is your name?"

I told him. "What is your name?"

"My name is Sadul Den."

"How old are you?"

"Old?"

"Yes."

"I am . . . twenty-two."

The others marveled at this exchange, and I had a new friend.

Alishan told me to ask questions. I directed them at our chief, whose name was Ahmed. I saw immediately that his rap-

port with his men was open and easy, unlike that of a mullah-commander in the Paktia mountains. I asked a question, Ahmed would answer, a man would add a point, another would disagree, and Ahmed would quietly settle it.

I looked closely at Ahmed Khan, who had had the watermelon brought for me. He had four children, spoke no English, and was a cousin of Durrani. He was robust, about 5-feet-10, weighing maybe 180, with big arms, a fine olive-skinned face, and a thick black beard. His turban was black with silver stripes, and he wore a dark sport coat over his pajama-clothes, a gray blanket, a watch on his left wrist, cheap leather shoes, no socks, and carried a Lee–Enfield rifle. He never raised his voice, had a piece of straw forever in his mouth, and kept his bullets in his jacket pocket.

Our new home was a *kishmishkhana*, a raisin drying house, in the center of a vineyard. The grapes were harvested and then dried inside. The raisins were shipped to Kandahar and Kabul and then abroad. A boy gave me a handful to eat. They were moist, delicious, as big as your thumb.

"Very good."

"Russian soldiers like them very much," Sadul said.

"Do you live here?"

"No. We change our position always. Tonight we stay here. Tomorrow we might move. This is only a hideout. It depends where the enemy is and when we choose to attack. We fight at night."

"*Shubkhun*."

"*Balli*," Ahmed said, not waiting for the translation.

"*Shubkhun*," the others murmured.

In his soft gentle voice, Ahmed described the guerrilla war they were fighting in Kandahar.

"I am the chief of Zarkat, the village where we ate tonight. It is a Popalzai village. All these men are from there. We fight as one unit. I have chosen each man. I would take more—many

more would like to fight—but I only have twenty-five guns. Each *mujahid*'s family must approve before he joins us; we must keep our society together. Each village is like a large family. This is a social structure which we have had for centuries; we cannot allow the Communists to destroy it.

"If a man does not have a brother, or if his father is dead, he cannot fight. There is not a mother in our village who wants her son or her husband to die, but she knows that we must fight. These men fight. Their brothers work the fields. We don't have more guns because the Pakistanis make it difficult for us. We use our own money. The Pakistanis only want the six Islamic political parties to have guns."

"Why?"

"Pakistanis have created a new Islamic state. You know it is a very young country, less than forty years old. The political groups in Peshawar are all headed by Islamic fundamentalists. We are Moslems, yes, but we are Afghans first. Islam is only our religion. But no religious leader has ever ruled Afghanistan. Maybe Pakistan, like Iran, wants to change that and be in a position to control the future government of Afghanistan. The Russians want to control the one they have set up.

"We coordinate our attacks with other villages. Sometimes we fight together in major battles—if attacked—and sometimes we attack alone in small groups. But we always know what the others are doing.

"We attack at night, because, as you see, there are no mountains in which to hide as there are in Paktia. The ground is flat. Tanks can move easily on the ground—as they cannot in the mountains—and helicopters can see us from the air. At night, they cannot see, and it is cooler. During the day, we hide and sleep in the villages and meet to fight at night."

"Doctors?"

"We have none. We buy medicines from the bazaar and try to do what we can. We know little about such things. If a man is

hurt, we try to fix him here. It is a three-day trip across the desert to Pakistan, and it is hard. Many men die this way. We cannot go by roads."

There was a sense of immediate and constant danger that seemed to draw these men together. Being closer to death made them happier in life perhaps. They had a cause—survival, the protection of their families and of a way of life that had existed for—how long?—to them, forever. They had purpose. They felt that Communism would destroy their lives, their society, the order of things. Whether it would or not did not matter. They thought it would.

Ahmed did not talk about godless Communism with the same sense of moral superiority that the mullahs in Paktia had. It was, rather, a fight—as the Americans had once fought—for freedom. If you took these men and transplanted them to San Francisco or Paris, they would, perhaps, become like us; and if an American had been born here, he would certainly be like them. No better, no worse. Human beings. So were those who flew the helicopters. They also had families.

"Have you fought recently?"

"Two nights ago we tried to free some of our people from the jail in Kandahar. It was a major operation. We sneaked into the city, alone and in small groups, and using some RPGs we had captured, rifles, and fire, we tried to storm the jail. We destroyed some tanks which surrounded the jail, and we think we killed many soldiers. But by morning, helicopters came and we had to retreat. We did not succeed in getting our prisoners out."

My instincts had told me Ahmed was a good man, but if there had been any doubt—and there always was—it disappeared. Most Afghans exaggerate. He was not afraid to say that he had failed. He was honest.

We had talked for two hours; it was late and cold. There was no more tea. We spread out the blankets, one under us and one on top; I was given an extra one. Then a young man walked

around with a skullcap from which the men drew out pieces of paper, lots to establish the order of guard duty that night. There were groans and laughter and audible sighs of relief. Eleven men would take turns guarding us, sitting on the roof wrapped in blankets until sunrise.

I rolled over in the corner to watch my companions kneel together in the morning half-light. I could hear only the man's voice who led them; Alishan perhaps had told them I was not Moslem. No one seemed to care. After prayers, sitting in a circle, Sadul and Ahmed's second-in-command, Agha Mohammed, smiled. Alishan even went so far as to ask if I slept well. The morning BBC service came on, and they listened intently. Alishan found the BBC World News Service in English, and I learned about Poland and SALT II, the Middle East, Ireland, South Africa, again other places far, far away.

I went outside before breakfast to wash and watch the sun rise, to see where I was. The water in the clay jugs was frozen. Ten feet from the *kishmishkhana*, a series of trenches began, four feet deep, in which there were grapevines planted on one side. There were maybe twenty rows, parallel to one another, each a hundred feet long. A clay wall surrounded the plot; identical plots and houses spread as far as I could see. It seemed a good place to hide.

We had tea and leftover bread. In what some might consider less than civilized surroundings, it was impressive that a cloth was always spread out; and though our meal consisted only of cold pieces of unleavened bread and tea, it was treated with a sense of culture. It was a simple ceremony; anyway, food always tastes better eaten with your hands.

In the distance came the steady drone of helicopters, a dull thud, then another. The walls trembled lightly. The men stopped, gauged the distance, went on sipping their tea. It was not us the helicopters were looking for today. Ahmed asked Sadul, Alishan, and brown-bearded Agha Mohammed to accom-

pany us to other guerrilla units. He gave orders to the others, and said we would meet back here tonight. A young boy who sat next to me kept tugging at the digital watch I wore, fascinated, no doubt, by the blinking numbers. I said he could keep it for the day. I left my pack with him.

We headed north and east, judging by the sun, on wide dusty paths that passed many plots of grapevines. (I wondered if Alexander had introduced grapes to Afghanistan and taught the Afghans to make wine, and if Mohammed's legions, coming after, had stopped them. Wine was worldly.) Sadul, with the thick black eyebrows and a flashing smile, had adopted me as a brother, it seemed, and a sounding board for his English, which, though, deplorable, was better than my Pashto. Ahmed turned, put his finger over his lips. Alishan whispered, "Do not talk." We passed a woman with a child in her arms, a man with three white sheep, a boy on a bicycle, some idiot on a motorcycle raising so much dust we couldn't breathe, three men in deep conversation. Occasionally Ahmed nodded at a man, but mostly he looked closely at them, then away.

The helicopters were coming closer.

We came to a wooden gate under an arch of hanging vines. There were two bicycles hidden under blankets in the small enclosed yard. A fourteen-year-old guard sat in the corner, half-hidden by a three-foot-high clay jug. He recognized Ahmed. The *mujahidin* were asleep on the floor when we entered, but quickly rose. There were maybe twenty, mostly young. Their leader, a grandfatherly figure, looking about seventy, with big brown farmer's hands and a white beard, embraced Ahmed, and within minutes there was tea. Forever tea: I was sick of it. They lined up, adjusted their turbans and bandoliers, took up a few RPGs, one Kalashnikov, but mostly their old carbines, and posed for pictures like anxious children.

"A Frenchman came here a year ago, but since then there has been no one. It is sad for us that no one comes," the old man said. He wanted to explain how they fought: "We attack only at

night. We get inside information about the place—army base, government building, homes of top military leaders and government officials—then we set up lookouts, and we always have a rocket man in the street to guard against tanks; we follow the walls, where it is darkest, then attack quickly and disappear into the night."

It took tremendous courage to stand in the middle of a dirt track with an RPG on your shoulder and go one on one with a tank.

"It is not so difficult to attack," he said, "because all the villagers are with us, and we get information from our brothers inside the place where we will attack."

"What if someone deceives you?"

"We kill him."

The helicopters were much closer. The conversation stopped. A man brought in all the sandals. Are helicopter cameras so accurate, pilots so sophisticated, that they can locate and then attack a house with fifteen or twenty pairs of sandals outside the door?

The old man said I could take pictures. He pulled a scarf from around his neck, wrapped it around the lens, and led me up a set of winding clay stairs to a covered lookout. The helicopters turned in giant circles, hovering, then there was a burst of machine gun fire, another, and another. The ground trembled, but I could not see the bombs. The Russians could carpet-bomb this vast adobe complex in an hour. There was no scorched-earth policy, not here at least. The helicopters were trying to destroy the *mujahidin*, not the country. Their mission, it seemed, was to prey, harass, intimidate, wear down the resistance, win over the population, but not to destroy the land.

When I returned, Ahmed announced there was another unit to visit. Ahmed, Sadul, Agha put the rifles under their blankets, barrels down—the glint of steel would attract the pilot's eye—and we walked farther east.

More vineyards, a small herd of sheep, a solitary camel,

miles of clay walls and hot dusty paths that led into an ever-deepening maze. We came on openings the size of a basketball court with many mounds of dirt and stone two to three feet high, six feet long, each with a high pole and a white flag hanging limp at the top.

"*Mujahidin,*" Sadul would say in a reverent half-whisper.

The walls became higher, thicker, darker, and we entered another village. There were children playing in the paths, old men sitting in the sun; and we passed a butcher's shop with the heads, legs, and intestines of his slaughtered wares stacked neatly in front and black-red slabs of meat hanging from a ten-foot-high wooden cross. Flies covered the meat. We came to a courtyard with a batch of purple petunias and violets growing in the center and a whitewashed house with glass in the windows; inside, a dozen men were expecting us.

The name of this village was Durrani, after their chief, who was a cousin of the four men who sat across from me. A man with thick greasy cheeks took his tin of snuff, tapped the top, poured a mouthful under his tongue, replaced the lid, slid it across the floor, sent a shot into the nearest spittoon, and directed a question at me: "We have heard that journalists come, but it does no good. We have nothing to stop helicopters. We suffer still. Maybe you come just to take pictures and write words and sell them. You make money from our suffering."

The others murmured their assent.

I said that the West did not know them as people, there was a gulf between us, and, too, there was the fear of Islam.

The conversation was intense among them. A young man argued about the power of some mullahs over the *mujahidin.* A man with thick black eyebrows and a fierce and terrific mustache, who had sat quietly with his back straight, dismissed him.

"The mullahs will return to the mosque when the war is over. Mullahs, unlike in Iran, where they kill unjustly, are not of a separate class. We need them now. The tribe will prevail, in spite of Babrak Karmal."

"What do you mean?" I asked.

"Karmal killed forty of our chiefs last year. The Afghan Communists want to destroy us. They are, after all, Afghan; they understand the workings of our society."

"The chiefs were related?"

"*Balli.*"

They drank tea but served me hot milk with sugar, for more energy, they said. I wrote in my notebook: "Men argue, then disappear into their thoughts. It is as if I am not here."

Abruptly, the conversation stopped. The man who had cut the young man off before addressed me. "Do not worry that we argue like this. It is that sometimes we must, to clear our heads. It is better now. We have more food than last year. We can also penetrate Kandahar. This we could not do last year. We chiefs choose our men, coordinate our plans, attack in the city, retreat to the villages. The Afghan army once had 80,000 men. Now there are maybe 10,000–15,000 only. Their morale is down and falling. Ours is rising, like the sun over those mountains in the east."

We walked south. The irrigation canals gurgled and flowed swiftly. There were birds in the trees, children playing, and craters ten feet deep, twenty feet wide where the helicopters had left their marks.

"Children were killed here, no *mujahidin*," Ahmed announced quietly. His bitterness was still evident when we went to meet with a group of Gul Badeen Hekmatyier's group.

"They do not fight with us," Alishan said, "because of the mullahs."

There were thirty men, some with a frantic passion in their eyes. We crawled in a dark musty room and sat against the wall with our blankets around us. Every eye was on me, except those of my companions, whom, with these fanatics, I suddenly felt very close to.

One young man, about eighteen, with black eyes and a motorized mouth, unfortunately was smart and knew English. He pushed his way to sit on my left.

"My name is Mohammed Gul. How are you? You must

come with us. We kill many Russians. I alone kill 200 already. We are Moslems. We fight for God. Gul Badeen, our leader, is a great man. Do you know him?"

"I met him."

I wanted to say that my present conversationalist was remarkably similar.

"Stay with us. We show you how to fight. These people, they are no good, your friends. We have Allah."

"So do they," I said, pointing to Ahmed and Sadul.

"Are you Moslem?"

"No."

"Then you don't know."

In disgust, he grabbed his Kalashnikov and stalked outside.

The mullah-commander stood in the courtyard and called to the faithful. The men rose and followed. I sat in the doorway, watching them—thirty men, their rifles beside them, bowing, a fire like a sacrifice burning in front of them. The mullah rushed over and with an ugly look put his hand on my camera.

Night was falling when we returned to our hideout. I should have known something was wrong right then. There were more flares in the sky than last night. I heard what sounded like artillery fire. It was far away. A jet fighter flew low over our heads. Ahmed said something to Agha Mohammed, pointed to the artillery fire. Sadul turned to me.

"Cannon."

"Yes. Cannon."

We were welcomed like long-lost brothers back at the hideout, hugging, shaking hands. The tarp was rolled out. Dinner was served—bread, and for each man, two pieces of mutton, and sheep broth for me. Ahmed tore the meat apart and passed out each man's share. Tea was served and we sat around. With the warmth and my full stomach, I felt as if I had been with these men longer than I actually had. Sadul, big burly Agha Mohammed, Alishan, and of course Ahmed. The boy who borrowed

my watch that morning tugged my arm and held it up, smiling. I asked his name.

"Mohammed Yussuf." (Joseph in English.)

I asked the man next to him his name.

"Mohammed Mousa." (Mousa meant Moses.)

At 8:00 the artillery began to pound. It came from the southeast, where the airport was, every five minutes for an hour. It felt like an earthquake. The men looked at one another and huddled closer to the lantern, many holding their *chai* glasses in both hands for warmth and, maybe, security. At 8:45 a man named Abdullah brought out the radio for the evening BBC Persian broadcast. He turned up the sound; the bombardment was getting worse. By 9:00, the ground was shaking and rolling like the sea. Every five seconds, now, the huge guns fired. I imagined a row of howitzers and young men ramming a shell up the barrel, firing, discarding the shell, reloading, firing, discarding the shell, sweating in the night.

Some of the men climbed up on the roof to watch. We were in the middle. In the east, a flash, and a crash. Then, beyond us to the west and north where we had been that morning, the horizon burst with light where the shell landed. Between salvos, the sky lit up as if by magic; two, three, four flares hung in the sky, like giant white high-intensity lights. They floated down, leaving a line like a sheet of white lightning, then disappeared. The light and sound were beautiful and frightening. We huddled on the roof like birds at night, silently watching, wondering. When would ours come?

It tapered off, finally, and we went inside. It was quiet. Agha Mohammed and Ahmed sat talking; Alishan stared ahead, smoking. I pulled the blanket over my head and tried to sleep.

At midnight, the bombardment began again. The lantern was on. Ahmed was standing at the entrance, leaning against the wall. A few of the younger men leaned on one elbow, talking to one another softly, like boys at camp.

At 3:00 the bombardment was now all around us, pounding, pounding, pounding. I found myself feeling sorry for the poor Afghan soldiers, stripped to the waist, sweating in the cold night, tired, slamming shells into a cannon that was killing other Afghans out there in the night somewhere. Alishan sat against the wall, drawing long slow drags on his cigarette.

"What are you thinking about?"

"My family."

It was impossible to sleep. I heard shouts. It was the sentry calling for help. Three men grabbed their rifles and dashed outside. More shouts, shuffling, muffled sounds, then quiet. A man was brought in the room, with Abdullah holding one arm, Mousa the other. Briefly, Ahmed questioned him; they took him outside. I saw in the half-light that he wore a purple turban and a long, soft, purple and white shirt embroidered at the top. There was a gash on his forehead and blood on his cheek. Alishan explained:

"This man said he was from north of Kandahar and on his way to Pakistan. He was lost and came here looking for directions. We think he might be a spy sent by the government to find the *mujahidin*'s hideouts. That will make the helicopters' job much easier. We will deal with him in the morning."

The sun rose. The prayers were over. The guns were silent. No one had slept well; it showed in their eyes. We drank our tea silently.

"Today we will see how close we can take you to the airport. We will show you the big guns and the helicopters."

"How far is it?"

"Not far, a few kilometers. We are between Kandahar and the airport."

"Where are we now?"

"Mahalajat."

I was putting the telephoto lens on my camera when the guard shouted. Ahmed and Agha Mohammed rushed outside. I followed them. Now I could hear the rumble. I climbed up to

the roof and, in the bright sunlight, had to shield my eyes to see. Mousa handed me the binoculars. The length of the horizon, from the airport in the east to the south, was a low column of dust and, like a snake, was moving west. Ahmed stood for a minute, watching, and then gave orders to move—quickly. The whole village complex south of Kandahar—the guerrillas' hide-out—was being surrounded by tanks, armored personnel carriers, trucks pulling small artillery and probably carrying troops. It still did not register fully: the significance of last night's bombardment, now this. It was classic military strategy. Soften the enemy up with the artillery: keep him awake, frighten him, destroy his sanctuary, then attack with ground troops at dawn. Ahmed probably knew last night.

We buried everything—blankets, water jugs, teapots, cooking utensils—under branches and dirt in the trenches. A young man with a bicycle took the lantern, a blanket, his rifle, and rode off with instructions from Agha Mohammed. Sadul grabbed my pack. I kept the cameras.

In five minutes we were ready to move. I thought we were on the run, and so initially I wasn't worried. The tanks and armored personnel carriers were at least a mile away, and how could they possibly get through the maze of houses? Abdullah brought out the suspected spy. His face was cut, and his purple turban was wrapped around his eyes. His hands were tied, and he held on to the purple cloth, a ten-foot-long strip of his turban which was tied to his wrists and with which Abdullah pulled him along like a dog. We took off at a half-run, but we did not turn north away from the column; no, we were going south, towards it. North led to Kandahar, where no armed group could penetrate during the day; it would be cut off, anyway. East was the airport; and from it south and east was the armored column moving west. Ahmed was leading his men, and me, towards it. We were trapped.

We started running. The bombardment last night. The first

sight of those tanks this morning. Then the dash through the villages. The looks of fear in those children's eyes. Those ten men standing out there by the wall. Waiting. Waiting. Waiting. The spy in the corner. The helicopters above us. There was no way out of there.

We could hear rifle fire now, small bursts of Kalashnikov automatics, then a burst from something heavier, probably a machine gun. Then silence. Another burst. The approaching infantry did not know where we were. They were firing, searching, trying to draw our fire. We kept silent.

A man directly across from me placed his rifle in front of him, took out a black Soviet officer's pistol, pulled the clip from the handle, made certain it was loaded, counted out more bullets, put them back in his pocket. Then—he shoved the rifle across the floor towards me. I was the only one unarmed. Alishan had the submachine gun; it was the only automatic weapon among us.

They looked at me, silently. Sadul turned, and said softly in English, "Take it."

I looked at him, at everybody in the room. I remembered Kaufman's words a long time ago back in Islamabad: "I never took a gun in Africa. I figure my gun is my mouth. I scream 'Journalist, journalist!' and wave my hands in the air, talking fast, real fast. No, don't even take a gun. You're there as a reporter, an observer; you're not a participant."

Is that what I shout with my hands in the air when they overrun us? "Journalist, journalist! Observer!"

I took the rifle, cocked it, saw the brass cartridge slide into the chamber. They all breathed easier. I was no longer a burden. I was, now, one of them. The man gave me ten bullets to go with the six already in the clip.

Ahmed had been watching from the doorway. He looked at me, then quickly turned away.

With the rifle, it finally hit me: We were surrounded by

tanks and infantry on the ground, helicopters overhead. We were going to have to fight our way out.

I go to my notes: "It is now ten in the morning. This is it. I am calm, though my whole body is shaking quietly. My hands quiver and are cold. I think of my family, my friends, of God. I pray, wondering."

Ahmed called Sadul over to the door. They huddled in the small outside covering with a man I didn't recognize. Then Sadul, with a Bic pen, went around to each man and wrote two names in Persian script on the inside of their forearms. The first was "Fazal Mahmoud," the second "Sultan Mahmoud." Alishan explained.

"When the battle begins, no one will know who is on the other side of a wall, in the next trench, the next house. You must shout out 'Fazal Mahmoud.' If a man does not answer 'Sultan Mahmoud,' kill him."

It was the password for the day, chosen by a central leader somewhere, passed on to commanders throughout the field. The coordination was greater than I thought.

The sound of gunfire was closer; there was answering fire from our side. We sat, waiting. I watched the suspected spy, wondering what was going through his mind. He lay slumped in a corner. Whose side was he on? Then, an incredible thing happened. A man unlike any I had ever seen before walked into the room, followed by Ahmed. He was about six-four, with a jet black turban, a long light-blue shirt, and baggy trousers, a gaunt bearded face, flashing eyes. He was barefoot and carried a Kalashnikov. He walked over to the spy, looked at him, turned back to Ahmed.

"There is no time now. We'll judge him later."

"Who was that?" I asked Alishan. He didn't answer.

"Pay-yi-luch," Sadul said.

We waited another two minutes, and then Ahmed spoke: Agha Mohammed, Alishan, and I would go first. The rest would

follow and fan out into the trenches. We would leave the spy until later. Ahmed had assigned his chief lieutenant, Agha Mohammed, to get me and my escort out of there. As he spoke, the automatic rifle fire still seemed a ways away.

Sadul nodded to me as we stood up.

"God be with you."

We crawled through the doorway, ran out into the bright sunlight, and the whole world went crazy. We ran and dived into a trench twenty yards away as machine gun and automatic rifle fire raked the ground above us. I remember thinking for a split second that at close range bullets really do sing. Tank and artillery fire blasted away. Helicopters circled overhead. We pressed our heads against the dirt. All around us there was smoke, bullets whining, shouted orders, cries, shouts of encouragement and panic. I dug my head into the dirt.

Agha screamed at us to inch forward. Faster, faster. A boy—the boy who had sat next to me with quivering lips—who was twenty yards behind us stood up in the trench, crying. He couldn't do it. He panicked. Agha threw down his rifle, ran back, pulled him down, and forced him to shoot. The boy regained his composure and began firing. Agha screamed at me to get back to the next trench; at the same time, he shouted at the other men in our trench to keep firing.

It was a World War I trench war. The single shot small arms fire could not hold off this advance. We had to retreat, and Agha Mohammed was heroic: firing, shouting orders, trying to get us away. That was his goal, and it was more important than his own life. At the end of each trench, we waited, climbed up, ran into the open, and fell back into the next trench. Each time there was fear as we were exposed, relief, blessed relief, when we made it back down. In one trench, there was six inches of water; in another, a man lay dead. The grapevine branches were hard and tore at our clothes. I crawled frantically forward, the cameras around my neck, the rifle in my hands.

My mind was never clearer. Everything—the hard brown

branches, my rifle, the bullets digging into the dirt, Alishan's eyes, Agha Mohammed's open screaming mouth, a boy staring in disbelief at the red mass which was once his right hand—I will see and know forever.

I knew that the men firing at us were as frightened as we were. My heart was pounding so hard I thought it would burst my chest. My throat was dry, my lungs burning. I thought of only one thing: getting out of there alive. The firing let up, then came again.

We waited, dove for another trench. It was not as deep, and as I lay there, half on my back, tears came to my eyes. "Please, God, I don't want to die. Not here, God. I want to live. God, I want to live."

It came with no thought. Something deep within me caused the words to come out. I did not, even for a split second, think, "I must pray to God, I must pray so God will get me out of here," nor did I promise Him that I would change my life, if He saved mine here. No, nothing like that. I have always thought that things would work out for me in life. In spite of what many people thought, many of them my friends, I never dreamed that anything would really happen to me in Afghanistan. It would be a great adventure. There would not be pain. But right then, in the trench, I thought that I was going to die. I did not dwell on my life; I did not see it pass before my eyes. I did not think of anything except, maybe, the pain of a bullet in my back or of slowly bleeding to death in the dirt. Deep down inside there came the most powerful of all instincts, welling up within me—survival. I pleaded to something greater than myself for life, God.

The moment passed as quickly as it came.

We crawled back to the last trench. The only thing that remained was an eight-foot-high wall. The trench, two feet of ground, the wall. There were six of us: a man I did not know, Alishan, the boy whose hand was blown off, a boy-man about

seventeen from our group who was so shy I never knew his name, Agha Mohammed, and me. At the far end of the trench, three *mujahidin* had succeeded in setting up a .50 caliber Soviet-made machine gun, which they fired furiously. It gave the men cover and confidence. We waited. Men took up positions and began to fire back, firmly, steadily, accurately.

There were no Russians from what I could see. If they were here, they were probably manning the helicopters, directing orders from the air and from behind the artillery or tanks or whatever it was that was blasting away. I saw Sadul lying on his stomach up on flat ground, firing a pistol.

Agha and the first man took turns trying to knock a hole in the wall with their rifle butts, but it would not give. We would have to go over it. Agha crawled to where the wall joined another and, gauging when it would be safest, waved us to go. We were now five. The first man ran, dug his sandals in, made it over. The boy whose hand was blown off went next, and Agha, big, courageous, selfless Agha, dropped his rifle and stood up to push him over. We waited. Alishan went, scrambled awkwardly in his loafers, made it. The quiet boy-man was next; I was after him. He took off his sandals, threw them over: better traction with bare feet. I threw mine. He ran for the wall, then stopped, then screamed for me to go. Agha did not move. I screamed at him to go, it was his turn, he was next. He turned and fired his gun blindly and screamed at me again. I went up from the trench, one step on the flat ground, a bare foot on the wall, another, hands at the top, over, like an awkward high jumper, rifle, cameras, and fell wonderfully to the other side. The boy-man got to the top two seconds later, as the machine gun bullets ripped across his back.

I pulled him the rest of the way over. I looked for my sandals, but only one was there. I threw it away. Someone helped me lift the boy-man, and we ran along the wall, through a gate, and down into a trench on the other side. We took off his

turban, his vest, and pulled the shirt away from his back. It was covered with blood.

The man mumbled something, perhaps a prayer. The boy had peach fuzz instead of a beard. He was dead. The glamour of war, the romance, the need to test myself . . . what measure could there be against this boy's death? Is this what it comes down to—death? This dead boy cradled in this man's arms? Dark red blood in the dust?

Men I did not know joined us. Two would stay with the body. I followed the others, hoping to find Alishan. We ran from wall to wall, bush to bush, away from the fire. One of the boys kept slowing down, and I saw his shirt was soaked. A bullet had gone through his shoulder, missing the bone. We and the other men went to another *kishmishkhana*, where I wrapped the wound and gave him some pain pills. He did not say anything. We waited. The small arms fire was farther away now; there was no more artillery fire. Now it was just the helicopters, packs of them, turning in the sky, bending down, firing a burst of machine-gun fire, a rocket, turning again.

Somehow Alishan found out where I was. What a joy it was to see him! He slumped down, took out a cigarette, and we waited for the helicopters to go away or to find us. I realized that I had not taken a picture all day. It never had dawned on me to take one. It wouldn't have seemed right for me. A certain detachment is required to be a good war photographer, as it is to be a good journalist; separate yourself from the action. How?

We decided to move. The helicopters were widening their arc. We crawled out, ran along a trench, through a gate, and worked our way back as best we could to the rear. Eventually we ducked into a house while the helicopters flew over, and a woman, with no thought of covering her face before men she did not know, gave us water. We passed the jug around. I was the last. I took a drink and gave it back to her. Her eyes never let on that I might be different.

At sunset we came to a small mosque, and the men went inside to pray. Alishan gave me the machine gun to hold. I sat on a mound of dirt in the half-light, barefoot, with the perforated barrel sticking out from my blanket, an old British rifle in one hand, and two battered cameras around my neck. A group of old men and young boys watched me silently. Then an old man, leaning on a stick, came over and shook my hand. His eyes were watery. The others came over after him.

"*Tashukor, tashukor.*" (Thank you, thank you.)

Night fell, and the helicopters flew back to their bases—for a hot meal? a movie flown in from Moscow? Alishan and I hurried past groups of men carrying their dead and wounded on rope litters back to their villages. There was no electricity here, no running water, no medicine—only dark paths, dark walls, dark looming houses. Some men had flashlights; others carried small torches whose thick flames shot menacingly upwards. I didn't know anyone except Alishan, whom I sometimes lost among the others. I shouted his name, and he told me to shut up. He, too, was nervous. He did not know these people either. I had visions of being thought a Russian soldier as I wandered around barefoot, alone in the night, having someone, not understanding who or what I was, cut my throat.

I had another strange feeling: a tremendous sense of animal power. I walked with a loaded submachine gun in my hand; one pull of the trigger and I could kill ten men.

I had experienced what we call power before. It comes in many guises: fame, talent, money, politics. When Senator Jackson ran for president in 1976, I once rode in a limousine with Secret Service cars in front and behind, and Secret Service men in the front seat. Sirens blared and police directed traffic aside. It only lasted a few minutes, but the sense of power was exhilarating and fun. But it was nothing compared to the deep animal power that came from within me with that machine gun.

Passing a group of men with a torch, I turned. It was Ahmed and our group, or what was left of it. He grabbed and

embraced me. I shouted to Alishan. We fell in with the group. What a relief to see them! Mousa, Sadul, Abdullah, Agha Mohammed, all alive. Ahmed spotted one of the commanders we had tea with yesterday.

"I am sorry that it is like this when you've come."

I was given another rifle to carry. There were now more weapons than men. Sadul smiled and gave me my pack; I had forgotten all about it. We walked quickly and silently back to the village, and the men took turns as pallbearers for the three rope litters. One man, overcome at the death of a friend, cried uncontrollably.

The village walls loomed in the darkness. Ahmed knocked on a door. Four pallbearers stood outside, the torch burning. The rest stood back. A young boy appeared. Seeing his father's body on the litter, he let out a cry. A woman rushed out, and her cry joined her son's. She opened the door wide, and the men took the body inside. An old man who had been watching turned away. They went to another door with another body, then to a third. The wailing carried through the village, and the torches' yellow flames shot up into the night.

Ahmed, Alishan, Sadul, and I returned to the house with the gentle arches. I sat on the porch and washed. A gentle breeze blew; the stars were out. We had tea and pieces of bread in warm milk and sugar and sheep's fat. Ahmed said it was special, for strength. It was delicious. We ate it slowly, quietly, and I remembered it was Thanksgiving. I slouched against the wall while the others told war stories. Sadul had a new AK-47 and a black Soviet officer's pistol. He explained how he shot an Afghan army officer, and how his troops then turned and ran.

"It is always our goal to kill the officers."

Ahmed kept prodding him, smiling paternally. Sadul was his nephew and clearly his favorite soldier. Ahmed never said a word about what he had done that day. He said two of the men were dead and two seriously wounded. A third man was not yet

dead tonight, but would be by morning. Others were missing, and nothing had been heard of the ten sent to cover the forward wall. There had been about 750 guerrillas against, he thought, about 3,000 government troops. (The government would later report, for the international press, that 127 bandits were killed in the battle; it did not mention Afghan army/Soviet deaths.) The *mujahidin* had held their ground; the government forces had had to retreat. It was the biggest battle Ahmed knew of in three years of fighting at Kandahar; it was a major offensive to wipe out the guerrillas. It had failed. When they had regained the *kishmish-khana*, they found the suspected spy dead. Ahmed did not know who killed him, the government troops or the *mujahidin*, or whether he was a spy or not. It didn't matter now. It was over. We were alive.

I fell asleep.

At 1:30 in the morning Alishan shook me.

"Tanks. Come quickly."

We could hear the tank treads grinding and see outlines on the edge of the village a hundred yards away. They began firing, every third shot a tracer, just above the houses. Flares lit the sky. It appeared that their tactics were to flush the guerrillas out of the village and attack them in the open. Neither side wanted the village destroyed.

Ahmed made his decision. He would get me away from the battle himself. We rushed down a dark path, then waited in the bitter cold until we were certain which way to go. The village was stirring. Sadul joined us. An old man gave me his pair of rubber slippers. We made our way south, lying low when the flares went up, trying to predict the tanks' line of fire. At each village we passed, a man sat like a crow on a roof, wrapped in a blanket, watching.

We passed many armed groups on their way to the fighting that night. One, though, was different. The men approached, single file, blanketed, turbaned figures like medieval chevaliers,

rifle barrels pointed up as straight as their backs, dark silhouettes in the night. *Shubkhun.* They were all barefoot. Like cats, you saw but did not hear them approach. They immediately knew I was different. They spoke briefly to Ahmed and then went on.

"Who were they?" I asked Alishan.

"Pay-yi-luch."

The man who had come to see the spy before the battle.

"Who or what are these men?"

"Do not talk."

I stumbled over bushes, mounds of sand and rock, trying to keep up.

Pay-yi-luch?

At dawn we reached a village far enough away to be safe. We entered a small courtyard and then a room with two red and black carpets on the dirt floor. Two boys peered out from under quilts. A man came in with an armful of branches, and soon there was a roaring fire in a small adobe fireplace. The flames licked and cracked, and finally warm, we fell asleep. The next thing I knew it was noon, and two boys brought in soft warm bread, a big white oval plate with a mound of rice with pieces of boiled gray mutton and raisins and spices. For dessert, there was a plate of pomegranates. Outside, there were children playing, chickens cackling, pigeons cooing.

That afternoon, we sat in the sun on the roof watching sheep and camels grazing, green fields, children, women carrying water, old men sunning themselves. An Antonov Soviet transport flew high and distant and far above us. It would carry the bodies of Russian soldiers, which it picked up on its weekly tour of Soviet bases, back to Tashkent, headquarters for the Red Army in Afghanistan.

A little girl brought tea on a metal tray. Maybe five, she wore a dress, leggings, earrings, and had short black hair and dimply cheeks. She was the daughter of Ismael, who had built the fire. He looked about fifty, with big hands and a long deeply lined face. He held his daughter in his lap and caressed her hair.

"I have eight children—two sons, fourteen and fifteen, are *mujahidin*. My father and brother were killed by artillery last year. I have been wounded four times myself."

He commanded thirty-eight guerrilla units, fifty men to a unit, four Kalashnikovs per group, all from small villages on the edge of the desert.

"Where do you get your weapons?"

"We captured the Kalashnikovs. We get bullets from Russian soldiers."

He brought out what looked like a few clods of gray dirt.

"Hashish. One kilo of hashish for 1,000 Kalashnikov bullets. I have a good friend who is an Afghan army major. He goes between the soldiers and me. Otherwise, bullets are expensive to buy."

The Politburo is not going to like that. Shades of Vietnam.

That night, I met the legendary Khoudai-dad Shahazai. He wore a black turban, black pajamas, a black herringbone vest, two crossed bandoliers, a belt with two tiers of bullets and a black Soviet officer's pistol; he carried a long knife and an eighty-year-old British Lee–Enfield that he oiled while he smoked. His beard was black; he had a thick handlebar mustache; he was lean and he had eyes—that's what really got me—that were on fire.

Seven of us sat in a circle slopping up *khroot*. After dinner, Shahazai took out a dark olive-green slab of hashish, shaved off some with a blade six inches long, tapped it gently into the top of the *chillum* and, while we listened to the BBC, began to smoke. He had monopolized the conversation since he had arrived an hour before but was now quiet for a minute. The broadcast had mentioned Reagan, whom he assumed I would talk to on my return to America. He knew absolutely nothing of journalism, but he had a flair for publicity and for war. He drew the hemp into his lungs, coughed, sometimes uncontrollably, and talked. Shahazai was that type of man who loved war and no longer feared death.

He told us his story: "Before the Russians came, I was a shopkeeper in Mazar-i-Sharif in the north. I sold rope and twine. [I tried to imagine this wild man peacefully selling two yards of twine in a dusty bazaar shop six feet square.] I was married, with two sons. God had been good to me. I was a happy man. Then . . . the Russians came. My wife was raped and killed. I made my two sons go to a rufugee camp in Pakistan, and then I went up into the mountains to think. My wife had been violated and killed. It was my duty as a man to avenge her death. So I joined the *mujahidin*. It was *badal*, blood revenge."

He clenched his fist in the air, and his eyes burned. We were quiet, humbled and mesmerized by this man. He put more hashish in the *chillum*. Ismael's children sat at the outer edge of the circle, wide-eyed, silent.

"I have two bullets in my stomach and pieces of metal in my leg. That is why I take hashish.

"I fight alone. I belong to no man. I have God, I have my gun, and with them, I will drive the Communists from Afghanistan."

He waved his hands, coughing uncontrollably, smoking, talking. He was not a crazed fanatic, but when he looked people in the eye they saw pain and, behind the fierce warrior's stare, water. Though he had the most penetrating eyes I have ever seen, it was as if he were a little boy who wanted the world to know he was alive.

He slept with us that night, and the next day, after prayers, he again lit the pipe. Ismael produced a Honda 90 and a driver with a pair of sunglasses a punk rocker would love. Shahazai brandished his pistol, climbed on, and the three of us roared off in a cloud of dust to see the sights. The sky was clear: no gunfire, no artillery. For hours we sped along dusty trails, stopping to visit guerrilla groups hidden in villages or to see where a battle had been fought. Shahazai, always waving his pistol as a general would a riding crop, happily showed me where the tanks had come, the guerrillas had lain in wait, a battle fought. He pointed

out spent shells, armored personnel carrier tracks, proudly held a dead soldier's hat splattered with blood for me to admire. Everyone knew him. Two old ladies, unveiled—they no longer cared—carrying bundles of branches on their backs, recognized him, called him over, and chatted with him, imploring that he fight on. He spoke gently with them, as a grown man would to his mother. He hailed farmers and shopkeepers. Our idiot driver brushed next to a horse-drawn cart and Shahazai's knee scraped against wood. We stopped, he bent down, picked up a handful of dust, dabbed it on a three-inch gash; and we drove on.

We stopped to see a grizzled whitebeard who, for a photograph, sat in the rubble that was once his shop and held up a sword. Shahazai rolled another cigarette, hashish laced with Russian tobacco. For lunch we shared a bowl of yogurt that made my eyes water with a group of *mujahidin*, and Shahazai dominated the conversation, drawing, between outbursts, on a water pipe they brought out for him.

By midafternoon I couldn't take him anymore; it was too much. I pleaded, I demanded, I tried to show anger. He put his hand on my shoulder and said I was his friend—I had come to see their war; he would give his right arm and leg in battle for me. I would tell the world about Afghanistan, and also, of course, I would take his picture many times.

Only once he was quiet. He led me to a pile of rubble that had been a mosque and, pulling on my shirt, took me to a mound of dirt fifty feet long, with high poles stuck in the ground at one end and white flags draped at the top. He said thirty men and boys lay there. The helicopters had come and bombed while they prayed. He raised his hands and prayed for their souls, and then he was off jabbering away as if I'd spoken Pashto all my life.

Back on the roof drinking tea at Ismael's, I raised my hands and pleaded for deliverance when he started in again.

Ismael smiled and told us a story: "Last month, the Russians began to build up their forces in Kandahar to combat our successes. There were more helicopters, more troops. Our mo-

rale was low. We needed a success. Shahazai, in the middle of the day, sneaked up to the airport, past the mine fields, the dogs, the guards, cut through the fence, and with his old British rifle, shot out the tires of a big Soviet airplane while it was being unloaded. And then he escaped. Everyone knows about this exploit. Shahazai's wife is dead, and he is in pain, but he is not afraid of anything." Shahazai was quiet, embarrassed by the praise and sad at the mention of his wife.

But his bravado quickly returned. "If you would give me something to kill helicopters with, I would shoot down every one in Kandahar. *Insh'Allah*. I will drive the Communists and Russians away. Nothing can stop me."

Listening to men talk in Afghanistan was often even worse than listening to men brag in the West. But you looked in his eyes and you knew he told the truth.

Ahmed added something else: "Remember those religious fanatics we visited, Gul Badeen's people? They talked also, but during the fighting, they were the only ones among us who ran, and they were the only ones among us with Kalashnikovs." He sat cross-legged on a blanket, trimming his beard with a pair of scissors and a hand mirror. "You always know when a man speaks the truth.

"Tomorrow Ismael and Shahazai will take you to Kandahar. Then we must find a way to get you back to Pakistan. Rasule has disappeared."

Shahazai, Ismael, and I walked from the village to the main road which was graded dirt. We walked carefully. Every 200 yards there was a single rock in the road. Under the rock was a mine. Everyone traveling to and from Kandahar knew about them, horsemen, buggy drivers, children, bicyclists, camel men. We caught a horse-drawn buggy. Ismael said not to talk. Even Shahazai was quiet. No one carried a rifle. You could never be certain who was a spy or a sincere supporter of the government.

I was told in Washington and New York that maybe four to

five percent of the population is Communist; for protection, they have moved to the cities. Shahazai and Ismael both carried black Soviet TT officers' pistols under their blankets. We took the buggy to a village, changed, and took another; then we walked. Ismael and I went ahead; Shahazai, his pistol now drawn under his blanket, followed twenty yards behind to see if anyone watched us. We took another buggy. As we got closer, they pointed out tank and armored personnel carrier tracks, spent shells, blown-away walls, buildings that lay in rubble. There were no more mines in the road. We left the buggy and, taking a path that went along a mud clay wall, at last reached Kandahar. No one paid any attention to us. It was, I thought, what Berlin must have looked like after the war. Many of the stone and mud buildings were destroyed, showing beams charred black. But this was the outskirts, not the easy, green, bustling Kandahar I vaguely remembered. There had been trees before and a thriving bazaar with carts of fruit and shops and people—Hazaras, Pathans, Punjabis.

"I want to go further in."

Ismael and Shahazai exchanged looks; we kept going. We came to a row of large fifty-foot-high cylindrical brick structures which could have been destroyed by RPGs, as they said, or by what it appeared, neglect. I could not tell. I climbed to the top of one, and with the telephoto lens on the movie camera, peered into downtown Kandahar. The electric and telephone wires were up, a truck drove by, a construction crane hung in the air, a bus appeared, sunlight glistened off the windows of an office building. There were few people visible, but I was too far away to tell how alive the city was. Shahazai whispered to get down.

"I want to keep going."

Shahazai shook his head no. "This is Kandahar."

He was nervous. Shahazai, who knew no fear, would not go on. Ismael nodded at me. We turned and walked back.

I asked Alishan why we couldn't go all the way in.

"It is our duty to keep you alive. *Insh'Allah*. Remember, our

chief, Mr. Durrani, has told us to. Shahazai, you think, is crazy. He is strong brave man, but he is not stupid man. He turned around today to protect you, not himself."

That night, we had more *khroot*. Afterwards Alishan smoked, some chewed, and Shahazai drew on the water pipe, coughing, hacking, spitting, talking. Between puffs, he carefully cleaned and oiled his precious rifle and his revolver, which he tapped affectionately before sliding it into its holster. A fire burned nicely.

"It was remarkable that we could just walk in here as we did the other morning. There are no locks on the door."

"Every village has a place where travelers can stay. I have a box with a lock on it," Ismael said.

"Who governs?"

"We do, the chiefs. There is little crime. Where would a man hide? Any villager would turn him in. The tribal chief, with a mullah's help, decides what the punishment will be. All is according to Koran. We have four men in jail now, as mullahs study the Koran to decide what each man's punishment will be. That, by the way, is how the Pay-yi-luch started."

What luck!

"The Pay-yi-luch? Who are they?"

Ismael looked at Alishan, who stared ahead. Ahmed nodded. Sadul, like an understanding brother, smiled. Only Shahazai kept on as if nothing unusual had been said. "Tell him. What's it matter?" he seemed to say.

And so they told me. Ismael began: "Pay-yi-luch means 'the barefoot ones.' They began, many years ago when the Persians, who once ruled us, committed many terrible crimes and tortures against the Afghan people. Some men banded together in a secret society to defend their fellow Afghans from the oppressive tyrants. To show that they were stronger than anyone else, they went without shoes. For to go barefoot meant a man could withstand much. It was a sign of endurance. It was also easier for

them to run, jump, walk quietly, and attack at night. Because Persian was the language of the time, they were called Pay-yi-luch: *Pay-yi* means bare, *luch* means foot. Though many people were afraid of them, they were heroes to others. They were protectors of the oppressed.

"When Ahmad Shah Durrani, the founder of the dynasty which ruled Afghanistan for 200 years, came to power, he went to the Pay-yi-luch and celebrated the festival of Id with them. He went to show the people that he did not consider them criminals. They lived in a village called Shah Maksoud, which is maybe one and a half *kuruk* northeast of Kandahar." (One *kuruk* is the distance a man travels over flat ground in one hour—three and a half miles.)

Even Shahazai listened quietly. He, like the children, had perhaps never heard the full story before. These people were, it seemed, Afghan Robin Hoods or like the chevaliers of Europe, *chevaliers sans peur et sans reproche.*

"How did they support themselves? How did one join? What were their rites?" I had a hundred questions.

"You can always tell a Pay-yi-luch by his uniform, his conduct, and his bare feet. Each man wears a long wide shirt, blue like the sky, and trousers the same color, made with fifteen meters of cloth. Their vest is dark green. Their long turbans and blankets are black.

"In other days, they carried and fought with the horn of a gazelle, a knife, and a *khortom*—a cord one meter long with a stone or a piece of metal attached to one end and covered with leather. It hurts but will not show on your body. Today they carry Russian TT pistols, like Shahazai has, and Kalashnikovs."

"How do they choose their men?"

"If a young man wants to become a Pay-yi-luch, he must make himself known to one. If that man thinks the young man is worthy, he will tutor him to see if he qualifies. This young man must be known since his earliest childhood for his piety and virtue. He must be a good Moslem.

"If he passes this first test, he will, at an appointed time, meet with ten members at a *bogra*. Here he must put his hands, his feet, or his earlobes in fire, and he must bear the pain quietly. Then he must wait six months to one year, during which time he will pass other tests. I do not know what they are. Next, he must seek out an evil man and fight a duel with him—using his knife, gazelle's horn, or the *khortom;* he must be wounded; he must not cry out or go to the authorities. And of course, he must survive."

Ismael poured, took a sip of tea. We waited.

"Then comes the final test.

"The man appears before all the Pay-yi-luch, a thousand men. It is night. He strips, keeping only his trousers. He lies on the ground and burning charcoal is placed on his back, and then hashish is prepared."

"On his back?"

"*Balli.* Hashish is very important to the Pay-yi-luch. They call it *botah.* They believe it brings them closer to God and prevents them from committing sins. You must remember the Pay-yi-luch are very, very religious. If a man can stand the pain of the fire on his back while the hashish is being prepared, he can become a leader of the Pay-yi-luch. If after a time, he cannot stand the pain any longer, having done this much, he can still join.

"The man you saw in Mahalajat before the battle was Morch Agha, a courageous man. He has a thousand followers. The men you passed the other night were with a man called Takia."

"So you fight together?"

"No, they fight alone. They work with us, but they do not trust the mullahs. They will have nothing to do with them."

I wanted to know more. The fire was burning low, but I felt like a wide-eyed boy listening to this extraordinary tale. The pungent odor of hashish from Shahazai's pipe added to the setting.

"There have been many great leaders, Mama Ghousso

[*mama* means uncle], Mama Noy Noy, Mama Awaltar, Akaa-jano, Lalaga Sayeed. All of them died in duels. A duel is important to the Pay-yi-luch. If a man is insulted, a man's honor requires that he fight. Even if a man looks cross-eyed or coughs or talks loudly to another, these are insults and grounds for a duel. For it is manliness, nobility, courage, generosity, and chastity which are most important to them.

"The insulted man will say 'Come with me,' and the two will go to a secret place. While they walk they will talk about everything except the fight. Once alone, they strip to their trousers. The insulted man always asks the other to attack first, for a courageous man never starts a fight. The victor carries the defeated Pay-yi-luch on his back to a safe place and sees that his wounds heal. Nothing is ever said. No man will go to the authorities, whether he wins or loses. It is a humiliation to do this.

"You did not see dogs with the Pay-yi-luch the other night. But many of them, maybe all, have very powerful fighting dogs. It is said they run with them three to five hours every day. They feed and treat them very well. Noy Noy had a famous dog as black as the darkest night. His name was Kirgah [crow in English], and it is said it took four people to carry him, chained, to a battle. He would eat thirty eggs a day, and once a week, twenty plates of *ferney* [milk, cauliflower, and sugar]."

"Food. How do they get it?"

Ahmed spoke. "You remember Takia? Every Thursday he and his men meet and consume ten pounds of hashish, four lambs, and much bread. This is brought to them by the people of Mahalajat. The lamb and bread are for the body, the hashish is to bring them closer to God. They are very spiritual, very pious. You see, a Pay-yi-luch will never look at a woman's face. If a woman approaches, he will close his eyes, take another path, or stand like a statue.

"Their life is hard, but they are free," Ahmed said.

"And tomorrow, we must find a way to get you to Pakistan."

* * *

Ismael's daughter, with her two bare feet planted firmly on the family ground, her arms shielding her eyes from the sun, waved good-bye, and we headed south.

The rubber slippers had created new blisters and rubbed raw old scabs, from which, for the past few days, too many flies had been drawing nourishment. We had only a few days to go. The pathways were dusty; I would go barefoot. Sadul and I walked behind Ismael, Alishan, Ahmed, and Shahazai. Sadul pointed to a field of grapevines and showed me a receipt for delivery of a load of raisins to a processor in Kabul. He pointed to his chest.

"My fields," he said.

"You and Ahmed are good friends." I drew two fingers together.

"*Balli.*" He smiled. "He is my mother's brother."

A boy rode past on a bicycle. Ismael stopped and called after him. He kept going. Shahazai shouted, and the boy stopped at a cock of the Lee–Enfield. About fourteen, he had a white skullcap and long shirt and pants. The men questioned him. What was he doing? What was his village? His father's name? Where did he get the bicycle? Finally satisfied with the boy's answers, they let him go. Alishan explained:

"The boy rode by us a few minutes ago and now comes the other way. We thought he was a spy. There are Ismael and Ahmed—two famous commanders of many men, walking together; Shahazai, who is known; and you. They would love to kill us. We must be very careful. In Kandahar, we can trust no one."

Sadul whispered not to worry. He grinned and patted the Kalashnikov. Then he gave me a mirror. I held it, turned it over in my hand, and looked at him. It was mine, to remember him by. We walked on, kicking up fine dust.

There were no trees, no more walled-in grape trenches. A few hundred yards off the trail, there was an isolated walled

clay-brick compound with domed roofs. In the distance, another one. We avoided them and kept walking. By sundown, we reached a small silent village.

A dozen men sat around a shallow pit ten feet across, a foot deep. We joined them. They spat tobacco in the dirt and talked quietly and stared intently at the stranger. Their blankets were ragged, they were skinny, half their teeth were gone, their faces were drawn, and they had vacant, faraway looks in their eyes. No one had a watch, and none carried a weapon. Ismael, whom they seemed to know, talked softly to two men. One nodded at me, and the other left and returned with a man who was clearly their leader. He was about six-foot-two, slim, in his late forties, and had a gray beard and an easy, commanding presence.

The call to prayer came from behind a wall. The men rose and left. Shahazai walked to the middle of the deserted courtyard placed his rifle in front of him, spread his blanket, and bowed towards Mecca. The disappearing sun gave off a beautiful orange-red glow. Two little boys wrestled on a domed roof, unconcerned with the rest of the world. The wind picked up. This place seemed like the end of the world.

A boy led me across the courtyard past a four-foot-high adobe wall into a smaller courtyard where there were small children, three camels, chickens, a goat, and dark red slabs of meat, hanging from a cross like a Francis Bacon painting; there was a well surrounded by a two-foot-high wall, a leather bucket attached to a rope passing through a steel pulley. We entered a room, and the boy motioned me to sit by a small circular pit in the corner. He returned with a large pan and poured a pile of burning coals into the pit. We put our bare feet on the edge, drew our knees up, our blankets tighter, put our palms low over the coals, seeking their warmth. The coals were dried camel dung and gave off a rich pungent odor. In the half-light, the boy's hands and feet were those of a man of seventy.

An old woman with brown leathery skin and a long, frayed red and black dress and a ragged shawl brought more coals. She

talked openly and made no effort to cover her face, which was lined like a dry riverbed. Her hair was braided. I thought of the two of them—how fast her life had gone, how quickly his would go.

The men returned, and the old lady brought a giant bowl of *khroot.* I wasn't hungry.

"Eat," Ahmed laughed. "Unlike me"—he grabbed my wrist, wrapping his massive hands around it—"you need it."

I dug my hand into the bowl. It was our last meal together, and so we ate and laughed like old friends. It was the first time I had seen Ahmed smile since the battle. The old woman sat against the wall with a big, toothless smile. After we had eaten our fill, she took the bowl to where the women waited.

With tea, Alishan explained the plan. Yussuf, the village leader, would take us by camel across the desert to Pakistan. The journey would take two days and two nights. He knew the way but, because of the danger, wanted a lot of money. Ismael had got him to agree to 300 Pakistani rupees, half of which he would get when he returned after taking us safely to Chaman.

Ismael counted out the money. It was equal to thirty American dollars, half of what Yussuf made in a year.

Ahmed, who did not know how to write, then dictated a letter to Alishan for Durrani in Quetta.

Ahmed wished him well, but he was sad. Two days of fighting a modern mechanized army had taken their toll. "Please send us something besides these old British .303 caliber rifles." He picked his up in disgust as he talked. "We need automatic rifles. Without something else, I don't know how much longer we can hold out."

I told Ahmed a story I had heard in Peshawar. A group of guerrillas had crossed the Amu Darya into the Soviet Union, attacked a border station, and killed two men. A week later, the helicopters came and scorched the earth for fifty square miles.

Alishan translated, and the room grew silent.

"Yes," Ahmed said. "If we get better guns and missiles to

shoot down helicopters, the Russians will probably come with more soldiers and more helicopters. Many more of us will die. But we must make them pay a high price. We cannot hope for a military victory against the Russians. We must hold on and win a moral victory. It is our only hope. For this we must kill and be killed."

It was time to go. Outside, the night was cold. Two camels sat on their knees, heads erect, chewing their cuds, ignoring us. Yussuf and two other men threw a blanket, a wooden saddle, a quilt, and my green canvas daypack on a camel, whom I immediately christened Jenny. Alishan's camel was also made ready. I climbed on, Jenny snorted—for camels, like horses and donkeys, know when the rider is confident. The old lady who held the rope which led to the animal's nose quieted her. Alishan climbed on. By now we had everyone in stitches. Shahazai laughed, waving his arms. Sadul took pictures with my camera. Even Ahmed doubled up. It was clear no one had ever seen anything quite like this. Jenny rose, back legs first, then her front legs locked into place.

We left and the crowd stood waving until the night covered them. Yussuf led, with a three-foot rod cradled in his arm, holding the rope which led to the first animal's nose. We followed, with Jenny's rope tied to the other camel's tail. A boy followed for a mile to be certain that the saddles were taut, then returned.

How, I wondered, did Burton and Lawrence ever do it? The secret, it seemed, to get into this swing was to roll with the gait, but I jerked and bobbed like a rowboat at sea. Alishan passed a message back from Yussuf. "Keep hold of the saddle and the rope handle, and remember, don't fall asleep." I pulled the blanket tighter, huddled down to keep warm. The outline of a village eventually loomed ahead; and it was a lovely, mysterious feeling to ride slowly by on an animal, to look over the walls, to silently pass by in the night.

An hour later, the sky lit up with flares once again, and we felt the thud of artillery. We pulled off the trail, got the camels

down, and waited. Yussuf refused to go on. We were trapped
and turned back.

We found a light in the village we passed an hour before.
The boy led us to a separate compound, where eight *mujahidin*
were hiding. There were four carbines, one Kalashnikov against
the wall. Alishan said to remain silent until we were sure of their
allegiance. However, when they found out we were not spies
and that the mute was American, the leader offered me an extra
blanket and his pair of sandals. They said we could not travel
because of the tanks.

Cold, weary, uncertain, we returned to our village and
crashed in a room with animal dung and piles of hay. Yussuf
broke off a batch and set it on fire with Alishan's lighter. It
warmed us for a second, and we crawled under the camel
blankets and slept until two goats, sniffing around my head be-
tween bites of hay, woke me long after dawn. Alishan was gone,
and Yussuf, I assumed, had gone back home to sleep with his
wife.

The boy with the old man's hands appeared, smiling, in the
doorway and brought me to where we had eaten the night be-
fore. I was given tea and sat in the corner. I cupped my hands
around the glass and wondered what was next. Alishan walked
in and said a boy had ridden south on his bicycle to see what lay
ahead. We would wait.

I return to my notes: "The sun rises, and the room grows
warm, like the wind. White hot light spreads through the door-
way and window openings. The earthen floor is hard, dusty.
There are no quilts, no cushions. A tin box sits on a clay-brick
shelf. Next to it are two Korans wrapped in brown cloth. A rifle
stands in the corner; above it, a wood-frame bird cage. The boy
said there was a quail inside. There is no paper, no pens, no
lantern, no radio. The boy and I are joined by two companions
who stare at the strange markings I make in my notebook. The
old lady comes in and sits against the other wall and watches us
as she unravels a roll of yarn from a wood spindle. The bird

screeches. She tells it to shut up and smiles at me, revealing lines on an ancient face. Yet her manner is so young, her eyes flash, her hands are nimble. She is probably not forty, but looks thirty years older. If she knows old age, there is no sign of it.

"There are no toys, television, radio, or books, except the Korans, here, and no one can read those. These gentle, curious boys will never go to school. At night, after working in the fields or shepherding animals, they will sit in the corner in these same clothes they have worn for months, and they will listen to stories about their tribe, to local gossip, and they will learn about war.

"A young woman with braided silky black hair on her way to the well looked quickly, then away, as she walked past our door. She had thin brown ankles, and as she drew the rope her sleeves fell back, revealing thin brown arms. The old woman watched me watch and laughed.

"In the next room there were children's voices and mothers' voices. Outside, dogs lay on their sides, ribs exposed, asleep. Flies covered the black-red and white slabs of meat on the cross. One of the boys brought out a wooden flute, and when he played, the sound was as lonely and sad and desolate as this entire land."

Yussuf returned with Alishan. The boy reported that the tanks had left at dawn. To where? I wondered. The woman at the well, who must have been Yussuf's wife, took a stick and brought down a slab of meat. An hour later, we shared a pot of hot meat and gristle and potatoes cooked in grease.

This time we would travel with only one camel. Yussuf would walk. His two charges would take turns walking and riding. One camel, like a single donkey, was of less concern to a helicopter. The camel was saddled in the courtyard. Just as we were about to leave, the old woman walked over and said, "May the Angel of God carry you swiftly and safely in his wings." She pressed two hard-boiled eggs into my hand.

Yussuf led, Alishan rode, I walked. She watched us, alone,

waving. Alishan leaned down and smiled. "She thinks you are *mujahid*."

I felt the excitement; once again the journey. The sun was hot, the air dry, the pathway soft. I sang to myself and greeted other travelers; in my mind, I dared them to find me a foreigner. I took out Sadul's mirror and looked closely: the beard full, drawn cheeks, skin brown and cracked, older, like my hands; my fingernails had barely grown in two months. I rewound the turban, threw my fatigue jacket up to Alishan, drew my blanket around and over my shoulder, and caught up with Yussuf.

We passed the village where we had stopped last night, greeted men, kept going. As we moved south, the ground became hard, with long jagged cracks; small stiff thornbushes appeared. We came to a small hill and a lone scrub tree and another pile of rocks with three poles and white flags, the graves of three *mujahidin* who did not make it. We stopped. In front of us lay a hard, empty, vaporous expanse and, beyond, low rust-colored mountains of sand. It was awesome. Yussuf, uttering a deep guttural "Haw, haw," told Jenny to sit. I would ride and Alishan would go ahead, keeping 400 yards or so in front of us, just enough so that, from the air, we were not together. Yussuf told me to wear the blanket over my head like a woman and to bring it over my face if a helicopter appeared. I agreed, and we set out.

There is an Arab saying: "There are three things that cannot be hidden—a mountain, a man on a camel, and a man in love." I thought of that as we started out across the plain.

We came to an abandoned village. The wind whipped and sung through the crumbling walls and deserted rooms. We stopped to get a drink from a well of putrid water. I now knew, as I did not when I was with Rahim, that it was not good to drink much water in the heat. I watched Yussuf bend down to drink, his lips barely touching the water. There were at least a dozen camels foraging in the wasteland, and there was no sight of a man on the horizon. The Baluch, whose land we were approach-

ing, say, "If you see a cow, you have found water; if you see a donkey, you have found a camp; if you see a camel, you are lost." Yussuf walked gracefully ahead, turning to see how I was, and twice gave me a handful of raisins. The world passed slowly. There was much time to think on a camel.

We heard the dull thud of artillery, and Yussuf looked at me, questioning. I pointed east, to where I thought the sound came from. Far behind us, two helicopters flew in tandem, 150 feet off the ground. Yussuf saw them, and minutes later, two silver jet fighters—MIGs?—with bright red stars on the fuselages screamed low overhead, heading west. A two-engine propeller plane with no markings appeared and turned in gigantic circles from the desert in the south to the mountains in the east to far behind us to the western horizon. Yussuf asked what I thought it was. I took out my camera to show that I thought it was taking pictures. He hesitated, then went on.

At sundown we reached the end of the plain and the beginning of the desert. The plain dropped off abruptly, and ten feet below us, there was a wide, rushing river. Seven or eight camels and twenty men were on the other side, Alishan with them. I slid off Jenny and waded across. Yussuf pulled her gently and, on the other side, untied the goatskin which hung below her belly. (It was the coolest place for our water, where, shielded from the sun, it swung with the camel's gait, cooling in the breeze.) While he filled the skin, she drank slowly from the stream.

We climbed 200 feet to the top of a plateau on a clearly discernible trail. The sand was rust red, fine and warm, like on the beach at the end of a hot day. At the top, it rolled off into eternity.

The men knelt, some on blankets, some in the sand, shoulder to shoulder, bowing to Mecca. One man called out, and the others quietly joined him.

I sat in the sand behind them, humbled by our insignificance against the massive desert, the darkening sky, and the sunset. Our camels stood behind us, their shadows long and silent.

For devout Moslems, the fourth prayer of the day—Ishan—was at dusk, when, according to the Prophet, pieces of white thread and black thread looked the same. Watching them, I imagined that this was how it was in the Arabian desert centuries ago.

The Afghans have a word—*kismet*—which means "the will of Allah"—destiny. *Kismet Maydai*, "it is my fate"—fate. With these men, it was as if the twentieth century did not exist. In the East, it is man's fate, what is written, the will of Allah, that dictates his life; in the West, in America, it is the assertion of man's will, what he achieves, that is his fate. He struggles in the midst of tall buildings and concrete. There is no anchor in man-made objects, no certainty except uncertainty and absurdity. Man does not like that. He cries out to God and for certainty.

The Frenchman, Charles de Foucauld, wrote in *De la Trappe à Tamanrasset* that "to know God, you must go into the desert and dwell there." Yes—but we bring the West with us. We cannot shed it, like a snake sheds its skin, and expect to change.

Half of the men were merchants. Their camels were loaded, and the men were on their way to Pakistan. Others would join their families in refugee camps. A few were deserters from the Afghan army, fleeing to Pakistan where they would join the *mujahidin*. All of them had hidden in the caves along the water, waiting for the sun to set so they could travel across the desert. We would go together. The route was barely visible in daylight, and when night fell it was impossible to see.

The Arabs have an expression for a camel—*ata allait*—God's gift. It is right. When we did not know which way to go, the man with the lead camel would stop and wait for the animal to decide. The camel chose the direction, and we followed.

We continued on, and I was afraid we would travel all night. It was getting colder. For fear of being considered a soft foreigner, I refused to ride. I was tired, hungry. In three hours, the desert had lost its romance. Alishan told me to ride, and I told him to leave me alone. He glared at me and swore to himself. The young men wanted to talk; I wanted to be alone, but there was no place to go, no privacy, no place to hide. We stopped again to pray—Koftan, the final prayer of the day—and I lay in the sand staring at the stars. They knelt together in the dark, and it was as if I were a thousand miles away from them. I wished I had their purpose, their certitude. No matter how much I imitated them or understood them, I was different. I was Western man, and I wanted to go home.

Finally, we stopped, unloaded the camels, and the others gathered up handfuls of tumbleweed and brambles and the small thorn bushes I had been stepping on, cursing the world every time that I did. The stalks shot up in flames, but the bases burned slowly like coals, and ten of us sat around the burning embers, huddled together. Normally, camel dung is used, but no one had been stopping to pick it up, and it would not have dried in time as it was. We passed a pot around and drank from the spout. The water was from the goatskin, cool, delicious. Yussuf produced a large chunk of inch-thick bread—like the shepherd's two weeks before—which we all shared. Everyone talked, talked, talked. In a nonliterate society every man is a verbal poet, a storyteller, a braggart. What they talked about most of the time I never knew. Yet they talked while we walked, and they yakked incessantly around the camp here. It was enough to drive me crazy.

I pushed my feet closer to the coals. There was a momentary lull in the conversation, and then there was the tinkle, tinkle, tinkle of a tiny bell. Conversation stopped. Twenty yards away, the lead camel of a large caravan came across the sand. The train passed by, the shadows of a hundred strange forms. I counted thirty camels. Many carried women and children; the

others carried blankets, tents, pots and pans. A man's voice called out softly, *"Ah-salaam aleikum."* One of our men returned the greeting, and added, *"Astalah mashai."* Then they were gone, as silently and mysteriously as they had come.

"Who were they?"

"Koochis," Yussuf replied. The others nodded. The same people I had met in 1973, the proud nomads James Michener had popularized in *Caravans.* My spine tingled, and the little boy in me stared in marvelous wonder at the sand dune over which they had disappeared.

Yussuf said we would sleep for a while. I was freezing and prayed for a spot next to Jenny's warm stomach. She sat there, uninterested, ignoring us.

With his hands, Yussuf dug two holes the size of coffins in the sand. Then he took a bundle of sagebrush, set it on fire, and spread the embers in the holes, rubbing them into the sand. He told me to climb in. I lay in my bed and he threw a camel blanket over me. It was ingenious; the bed was warm, and gradually the wind picked up and blew sand over the top. I peeked out. If there were no camels, a traveler—the enemy?—would not know there was anyone here.

I pulled the blanket back over and snuggled up on one side, and thought about the caravan. It had been a magical moment. The Koochis would soon go the way of the Sioux, the Cheyenne, the Apache. The Communists would destroy them, just as whites had destroyed the American Indians. True, the women do all the work, the people die young, they cannot read or write, and their life is hard, unforgiving, and romantic only to those who lead more complex lives in the West.

Perhaps someday soon a Koochi chief will give a speech like Chief Joseph's of the Nez Percé, who also had to fight for his tribe's freedom against an unrelenting modern army. We read the speech in school. The Nez Percé lived in Washington State.

. . . I am tired of fighting. Our chiefs are all killed

. . . my little daughter has run away from the prairie, and I do not know where to find her. Perhaps I shall find her, too, among the dead. It is cold, and we have no fire, no blankets. The children are crying for food, and we have none to give. My people—some of them—have run away to the hills and have no blankets, no food. No one knows where they are . . . perhaps freezing to death. . . . Hear me, my chiefs; my heart is sick and sad; from where the sun now stands, Joseph will fight no more forever.

The Koochis though, for the moment, were free.

The wind blew. I thought I heard a wolf howl. The next thing I knew Alishan was shaking me.

"The camels are ready. We go."

I threw back the blanket and sat for a minute. The stars were still out, bright and awesome in their abundance. The foreigner, always a late sleeper, was the last to rise. I stumbled over to Jenny, amazed at how cold the sand was. I gave her a pat and, with an extra blanket around me, climbed on. We moved across the sand. A few of the men talked to forget the cold. Alishan smoked. I shivered. We were all lost in our thoughts. For hours we plodded on, then gradually the stars disappeared, the black sky turned gray. One could see farther in the distance. The sand dunes rolled on for eternity, like waves on a sea. The lead camels disappeared in a valley, then reappeared as they climbed ahead, like ships in a storm. The cliché is true.

The sky turned from gray to orange, the black-gray sand to rust red, and the colorless scrub brush to yellow. Then the sun, God to the ancient Egyptians, giver of life and heat, rose; and the whole world was bathed in warmth and light. It was the most beautiful sight I have ever seen—dawn in the desert.

It was time for Sobh, the first prayer of the day. The shadows of the men standing, kneeling, bowing, stretched far out in front of them. In time, we heard shouts and bells and dogs

barking. It was the Koochi camp. There were a dozen low, wide, black tents, and sheep, goats, donkeys, camels scrounging for food, and the short, gray, vicious dogs barking. Smoke rose from fires, babies cried, unveiled women stared straight at us. Some men were with the camels, but most were probably asleep. A hundred yards farther, we passed three shepherd boys watching a flock of sheep. They offered us a drink of water from a metal canteen encased in leather with a cork for a cap that one of them carried around his neck. It was delicious.

The day wore on. Alishan rode; I walked. I rode; he walked. It was getting hard to tell which was getting worse, my posterior or my feet.

By midafternoon we passed what Yussuf said was another nomad camp, in a valley surrounded by giant dunes. It appeared more permanent, a winter stop perhaps. A long blanket lay spread in the sand, a loom at one end. We were a hundred yards away. I took the fatigue jacket—there was extra film in the pockets—and a camera. Yussuf and Alishan sat in Jenny's shade, and I walked to the ridge above the camp. The wind blew north to south; I faced west. My blanket was draped over to one side, exposing the jacket as I focused the lens.

I had been there a few minutes when I turned to see Alishan approach me with two men. One had a Kalashnikov, the other an RPG. Alishan was furious.

"You are stupid. For pictures you almost got killed. You come to Afghanistan, take pictures, sell them back in America for money."

I tried to calm him, and he explained what had happened.

The two men with him were guerrillas. Their camp was hidden inside the nomads' camp. They had been on a scouting mission south of here where tanks had been seen a few days ago.

"They saw you, your Army jacket. They thought the camera was a gun. This man with the Kalashnikov said he shouted at you, and you didn't answer. [I had been upwind.] He raised his rifle and shouted again. You didn't answer. He was about to

shoot you when Yussuf saw him and shouted that you were one of us. Another second and you would have been dead."

We shook hands. I thanked him for not killing me, and they took me to their hideout. It was a bunker dug six feet into the sand, with a domed roof two feet above the ground. They posed fiercely on the roof. I took their picture, and we left. I felt uneasy around them. They said they were Gul Badeen's men.

The desert ended as abruptly as it had begun. Before us in the distance lay a jagged mountain range and a plain of vapor, below us a river, and on the right a dozen mud-brick buildings. Food. Again, Alishan put his finger over his lips. I rode and, because a festering sore on my calf was now a few inches wide, exposed it to the sun, hoping to dry it out. Two children saw it. I did not respond to their question, and they assumed I was a captured wounded Russian.

We stopped at a deserted house separate from the others. Yussuf returned to report that there was only bread and tea. I had been dreaming of yogurt, yet the sugared tea was like a shot of adrenaline. I must have had ten glasses. We were too dehydrated to sweat. A group of young men joined us and stared, explaining to Alishan that they had deserted from the army and were hiding. Yesterday, tanks and jeeps had come looking for them, but they had had fair warning and escaped to the mountains behind us. The tanks were probably somewhere nearby, but no one knew where. They said there were tracks through the passes and, on the other side, an army base where the tanks were headquartered, and where the road to Pakistan was. What, they asked, were they going to do with the Russian? Alishan said I was an American journalist, and they smiled, edging closer, amazed. The safest route, they thought, was the track which ran west, parallel to the river.

We set out. On our right, rocks, a two-foot-wide channel of water, plowed fields, the river, a few sheep, camels, then the desert. To our left, a rocky scrub wasteland for half a mile, then

steep rising mountains. I rode. There were tank tracks crossing in front of us. Farmers were bent over in the brutal sun, hoeing a furrow of gray dusty soil that had probably been worked for hundreds of years; no fertilizers, no nutrients, no crop rotation to save the soil here. I counted fifty camels up and down the valley. From the top of mine, on a flat plain, I could see for miles. We continued on.

In the distance on the right, where the river bore southwest, I saw a gleam of metal. I looked closer. It was a row of machinery, but what? Vapor hovered in the air, like in front of a car when you drive through Wyoming in the summer, and I couldn't make it out. I pointed, so Yussuf and Alishan could see.

"Tanks?" Alishan asked.

I didn't know.

"Look closer."

"I am."

Yussuf froze. He refused to go on. I refused to turn back. I wanted to get out of Afghanistan. I jumped down and, from behind a rock, took out the movie camera and looked through the zoom lens. It could be a row of tanks lying in wait, the tanks they'd all been looking for. I wanted to try the telephoto lens, but Alishan refused. It would glisten in the sun.

"We go back," he said frantically. "You stay."

The words hit hard. It was my biggest fear, being left alone. Any man who was not Afghan was Russian. You heard what the *mujahidin* did to some Russian soldiers. The coffins were sealed when they arrived in Tashkent.

"Hurry, take your things. Hide them. Take this." He gave me the pistol and the bullets. They turned Jenny around and said they would return to the village. I waded through the canal—the water was three feet deep with two feet of muck at the bottom—ran over the rocks, stashed the pack and fatigue jacket between two boulders, and found a hiding place under an overhanging rock near the river.

I checked the pistol. Six bullets. It was white, with a pearl handle, a silver barrel, and said "Made in England." I had ten more bullets in my hand. I practiced loading, to see if I could do it quickly. What should I do? If the tank troops had seen us stop and turn around with their binoculars, they would know something was up. The tanks would come. They would jump out with rifles. Should I let myself be taken prisoner, or do I shoot? Depends how many there are. I would have to kill them all or be taken prisoner. I could see myself in Kabul, brandished before the world. They would have found out in interrogation that I had worked for Jackson, Russia's archenemy. No matter that I had not worked on foreign policy. I don't dislike the Russians. I enjoyed my visits to Leningrad, Moscow, Tashkent. But I would be, of course, CIA, the Gary Powers of my generation. I thought of torture. Those pilots in Vietnam. What about the farmers across the way? What if they saw me and turned me in? How would I contend with them? I waited. An hour passed. I prayed, I dug my feet into the muck. Which way would they come? I sat with my back straight against the rock, pistol ready. I had never shot one in my life; nice place to learn. I looked at myself. I was scared. My heart pounded. It was the pain I was afraid of, the pain of torture or of a bullet in my gut.

Then came the sweetest sound in the world: Alishan calling my name.

"Come, Mr. Jere, come." It was not a row of tanks, but a row of bicycles belonging to the men in the fields.

We rode on. A little girl with a bright red scarf rode across the plain on the back of a donkey behind us. I looked and she turned away. I turned away and I saw her look, then quickly glance away. It seemed remarkable that she was alone. During the time of the reign of Genghis Khan, when his empire stretched from the Danube to the Pacific, it was said that a young blond-haired, blue-eyed girl could walk naked the length of the empire and not be harmed. The girl was far behind us

now, and still I couldn't see any houses where she might have come from. She looked about twelve.

The river entered a gorge; long sheets of granite had fallen into the water. The track ended, and we walked on a goat trail next to the canal. I asked how old it was. Yussuf said maybe two hundred years. It was quite an engineering feat. Like so many canals in Afghanistan, this one had milky water and flowed swiftly along for miles on end. The river rushed by hundreds of feet below. By nightfall the gorge ended, and we entered a tranquil farmers' valley. There were orchards and plowed fields and the sound of a tractor. There was a village nearby, but Yussuf wanted to go on.

He was tough; you had to give him credit. While Alishan and I had traded off riding and walking, he had walked, always with the same easy stride, his back straight, the rod across his arms. He was not educated and was frightened to death of the war machinery around him. But he could go without food; he could make a bed in the desert and handle a camel. He would sing to himself, and he always smiled and asked how I was. He made his living transporting raisins and hay to Kandahar, and sometimes he delivered goods to Chaman.

We talked about camels. A good camel will cost 30,000 Afghanis, $600. Where, I wondered, could a man get such money? "What is a good camel?"

"One that can travel and carry much."

"And not complain?"

"And not complain."

"What is best?"

"The best," he smiled, "the best is the fastest. That would cost 50,000 Afghanis."

How he would love to have one of these. Racing camels were said to cover about seventy miles in a single night. A hundred years ago, in Arabia, they were castrated and trained never to utter a cry. Smugglers liked this best, and this is what gave them their great value.

* * *

It was darker than usual. Clouds covered the moon. From two hundred yards away, we could barely make out the village where we hoped to stay. The blasted dogs, however, announced our approach. Alishan had no idea where we were, nor did he know anything about the village. I was to remain silent.

Yussuf called out. A man eventually answered and led us to the house of a man Yussuf said he knew. I kept quiet when we were met inside the wall, but Jenny betrayed me when she decided to sit before I was ready. By the time I got up and cleaned off the dust, it was clear to everyone that I was not one of them. We went inside and sat on cushions. I was given the softest. A boy brought tea for us and served me first. He made sure I had enough sugar. In the next room, I heard a baby crying. A girl of about ten entered with a stack of warm bread. She placed it beside her father, then stood back against the wall. A single lantern burned in the center. The men stared at me. Some spat out snuff into the usual tin spittoon.

"Why have you not killed this man, who is obviously Russian?" a man said quietly. "Why do you take him to Pakistan? to ransom him for captured *mujahidin?* It is better that you take him outside and cut his throat. We cannot. He is our guest. But we will give you the knife."

Alishan, convinced that the villagers were on our side, explained that I was American. They did not want to let us go. They tried to make me accept a pair of sandals, ointment for my sores. We had dinner, and I was given a separate bowl with more onions and oil than any man should ever have to eat. I needed it, they said, for my health.

"You have made us happy by eating with us in our home. May God give you a safe journey," said the man who, an hour before, had wanted me dead.

It had been quite a day.

We slept on the floor and left an hour before dawn. I rode for the first two hours, then, as I swore the flesh of my posterior

was about to go, I jumped down and said I would walk. Alishan was not pleased. It seemed that he now saw this as a test. The stronger man would walk. He did not want to ride. After two hours he said in his usual serious way, "You ride."

I took it the wrong way. I pointed my finger at him and said, "Don't you tell me what to do. You are here to help me, guide me. You are not my master. Do not treat me like a dog."

Something had set me off. My tired body, the tanks, the battle, the men in the desert, the trip which never seemed to end, the language barrier. His English was rudimentary; my Pashto far worse. He did not mean to lecture me, but that was how I took it. I walked; he rode in silence for an hour, two hours. He made Yussuf stop the camel, and he got off and fell one hundred, two hundred, three hundred yards behind. I marched on ahead, even though the brambles were getting thick. I refused to ride. A windstorm came up, and we sat on the ground, faces buried in our turbans until it passed, then plunged ahead. I couldn't stand to have him near me. Another hour passed. Finally I stopped, turned, and walked back past Yussuf to Alishan,

I stuck out my hand. "I am sorry. I was wrong. I know you are doing everything for me. I guess I'm tired. The boy back there in Mahalajat. All those men dead."

He held my hand firmly and gave me a long hard look. And then he smiled.

"I am sorry, too. My English no good. When Mr. Durrani ask me to go with you, I say no. Rasule is the fighter. I am not a *mujahid*. My hands are soft. But he say go for our tribe, for Afghanistan. I thought it would be only five days. It is now almost two weeks. And the battle, the tanks. Yesterday when I left you with the pistol, I was more afraid than in the battle. There is nothing we can do against tanks. I thought for sure we would not make it. I want to be with my family. I am tired, like you."

He put his hand on my shoulder, and we walked on together, talking. Yussuf had been waiting for us, watching.

* * *

The land was flat, dry, dusty, windy. Mountains rose in the distance, partially lost in a haze. We used our turbans to keep the dust and sand out of our faces. We came upon a lonely compound, maybe a hundred feet square. A grandfather, his son, his grandson were trying to cultivate the land in front with, it seemed, little success. Small narrow ditches of muddy water flowed into squares. I asked them for water. The man pointed to the ditch. I pointed to my mouth, water to drink. He pointed to the muddy ditch.

By late afternoon we got to the village where Yussuf said he had a friend and where there would be food. The wind blew hot and hard, and we kept losing the village from our sight. It was not walled, and the dust and tumbleweed blew around in circles. There was a tractor, a Ford 3000, Chinese-made bicycles, a Honda 90. We fell into a room and out of the wind, exhausted. Men joined us. A woman built a fire with scrub brush in the fireplace, put a black kettle with water in the middle. In five minutes there were twenty children in the room, come to see the travelers and the foreigner. There were two girls, four and six, with big round black eyes and black hair in bangs. I wanted to adopt them right there. The men apologized because there was only bread and tea. We rolled the bread up, swirled it in the sugar tea, and ate it. Superb.

We were now only a few hours from the border. But we would have to wait until night; tanks were patrolling the border. A problem: Yussuf did not know the way. He had asked at least three of the men. For 400 rupees, one offered to take us part way. True, it was a lot of money, but the trip was dangerous, the man said. He had a family. So did Yussuf, who wanted all the money he had been promised. Alishan was furious. Yussuf had misled us, and he was more interested in the money than in our lives. No, he had to cross the last stretch with us. Too, you can't blame a man having come so close for not wanting to give up so much money this near to victory.

The wind continued to blow fiercely, swirling the dust in the room. I sat in the corner surrounded by children who stared and laughed at this strange man. There were no guns in sight and, confirming our thoughts, no *mujahidin*. They were too close to the border; the terrain was flat, open; and the tank patrols came frequently.

At sundown, after prayers, we set out. The children crowded around, with their runny noses and wide eyes and bare feet, and waved, mimicking the movements of my hand. Yussuf walked ten feet away with a villager who pointed out the route: directly across the plain, stay away from that pass on the right, go between those two mountains, across the plain, through the wadis. Again, watch for the tanks and now something new: the foot patrols.

I rode. Yussuf led. Alishan walked thirty feet away. He couldn't bring himself to be near Yussuf.

We moved southwest. It got dark, and the village slowly disappeared behind us. Day to dusk, dusk to darkness, dog to wolf. The ground was hard-baked clay and echoed under Jenny's hooves. Mountains rose around us. Then, a disturbing sight. Far off to our right, a light shone brightly. Yussuf stopped. On our left, another. Then behind us, between where the village had been and a mountain, was another light. Yussuf was petrified. Alishan looked at each light, at me. I started to whisper. He motioned me to be quiet.

Whatever it was, we couldn't stand here like sitting ducks. "Let's move; let's get out of here. Keep going," I whispered loudly. "They're just campfires, Alishan. Let's go."

Yussuf looked at us questioningly. He wanted to turn back. Alishan hesitated. I was adamant. I sat high on a camel, my heart beating frantically, wondering if I were in the range of some lieutenant's binoculars. The lights went out. We continued. The moon rose, a pure white ball in a black sky to light the way, and expose us. All around us, the ground was white, and it felt as if we were on the moon.

The lights on the right, where the villagers had said the tanks were, came on again. We kept going. The moon ran through patches of clouds, and we picked up the pace again. We ran through a wadi, a riverbed a hundred yards across, climbed up onto sand. Momentarily, we were hidden. Yussuf pulled a rifle out from under the quilts—the villagers had given it to us. He handed it to me. Alishan took out his pistol.

We moved on, up and down small dunes of sand, through wadis. Then, far ahead in the distance, there were lights in the sky. Yussuf and Alishan stopped again. Flares?

I took a chance. "No, man, lights in the hills inside Pakistan. We're almost there. Let's go!"

Yussuf stood there. He wouldn't go. What was going through his mind?

I continuously whispered as loud as I could to keep going. I had, for the first time in two days, forgotten about fatigue and temperature. I kept the rifle under my blanket to prevent any glare from the moon. We came up over a mound of sand and finally, there in the southeast, a row of lights. Chaman. Pakistan. Freedom. Only a few hours to go.

Yussuf heard it first. The tinkle, tinkle, tinkle. He called out. A man responded. We plunged happily over the sand to the welcome red glow of a fire. A shepherd wrapped in a thick sheepskin cape welcomed us. Fifty sheep with bells on their necks foraged for food around him. He had not seen any tanks tonight, he said, and he directed us to a path. "Don't worry," he said, "there are no mines."

An hour later, we met another shepherd who directed us again. He thought he had heard machinery tonight. "Maybe the Pakistanis, maybe the Russians."

As a man on a camel is easily spotted, Yussuf told me to walk. We hid the rifle under the blankets, and I followed, sometimes falling so far behind I lost sight of Jenny's massive dark body. I silently cursed Alishan and Yussuf and kept running to catch up. Gradually the lights became brighter. We'll make it yet. *Insh'Allah.*

Yussuf stopped, had me climb on. Alishan told me to talk or to sing. We were almost across the border. It had to appear that we were not sneaking, just a few typical Afghans, yakking away on their way to Pakistan.

Quietly, I again sang every song I knew as a boy: every Sunday school song, every rock and roll song, every American ballad and folk song I knew. I recited every bit of poetry, every verse from the Bible, every bit of Shakespeare I knew. Anything to divorce my mind from the cold, the wind, the sores, the fatigue.

We came to a cluster of houses, and Yussuf pounded on the door.

"Is it safe to go on?"

"Yes," a groggy man said.

Did he have food?

He gave us three loaves of bread, which we ate in about three bites, except Yussuf, who ate slowly and gave half to Jenny.

Finally, at two in the morning, we passed the Pakistani border fort, and rode down the lighted, paved main street of Chaman. A dog scurried across the road. The wind blew. The camels' hooves were almost quiet against the pavement, and I rode high above the low wood frame buildings.

Two policemen wrapped in blankets with rifles asked us where we had come from. I stared down at them, too tired to care. "Kandahar," Yussuf said. They walked on. I looked at us—black and bearded, dirty, hungry—and I laughed. I was out, alive, free.

I leaned down and kissed Jenny on the neck. "We made it, old girl, we made it!"

A shopkeeper found a floor for us to sleep on. At dawn Alishan went off to find a taxi that would take us to Quetta. I stayed to have tea with Yussuf and a few other Afghans around a fire in a corrugated metal lean-to. Jenny sat on her knees, neck erect, forever chewing her cud, ignoring us.

Yussuf and I shook hands, embraced. We climbed in the car, and he stood there until we were out of sight.

Alishan sat in the front while I lay on my side in the back.

"It does not seem possible that we ride now in this car."

"No," I said, "it doesn't."

"I have not slept since the battle, worrying about you," Durrani said.

"How did you know about it?"

"Oh, my friend, I get daily reports. I know all about your trip. Only these past few days I lost contact with you."

When we were going across the desert. Again, the inpenetrable, mysterious Asian telegraph.

We talked like father and children. Durrani questioned, Alishan and I gushed with answers. We had eggs with salt and pepper and bread and butter and endless cups of tea. For two hours we talked, and then I took a rickshaw to the hotel.

I checked in, and no one said a thing. Then a shower, a look at my wounds, another breakfast. And to bed. It was as if I were coming out of shock. I had never been so relieved, yet I was nervous, edgy. I was emotionally and physically exhausted.

The next morning I flew to Islamabad, picked up my bags at the Holiday Inn, and went to the Reuters office. Maybe, just maybe, Kaufman had got my letters. There was a telex to Brian Williams, Reuters, from Kaufman:

KAUFMAN, DELHI.

PRO WILLIAMS, ISLAMABAD.

BELIEVE SPRINTER VAN DYK PLANS TO RETURN ISLAM-ABAD FROM QUETTA ENVIRONS SOMETIME NEXT WEEK AND WHEN AND IF HE DOES WOULD BE GRATEFUL YOU PASS HIM MY MESSAGES WITH MY URGINGS THAT HE CONVEY HIMSELF AND HIS IMPRESSIONS TO DELHI SOON,

IF THAT IS POSSIBLE. ALL BEST, AND IF I DON'T SEE YOU BEFORE THE HOLIDAYS, MERRY HOLIDAYS.

MIKE

Another message:

BRIAN, MATE.

CANST YOU HOLD AND ON PASS FOLLOWING TO VAN DYK IF AND WHEN HE MATERIALIZES:

JERE: RECEIVED YOUR MAILER, WHICH I THOUGHT WAS EXCELLENT. I AM HOLDING ON TO IT UNTIL I CAN HEAR FROM YOU AGAIN. MY HOPE IS THAT YOU WILL COME HERE AROUND DECEMBER 6 AND WE CAN THEN SEND OFF A BATCH. PLEASE ADVISE WHAT PLANS ARE VIA REUTERS CIRCUIT TO DELHI.

CHEERS, KAUFMAN.

Again:

BRIAN, MATE:

ANY SIGHT OF THE SPRINTER VAN DYK? HE INTIMATED THAT HE INTENDED TO SURFACE IN ISLAMABAD AROUND 3RD OF DECEMBER AFTER FORAGING IN QUETTA AREA. CANST YOU CHECK AND SEE IF HE IS KNOWN AT HOLIDAY INN? IF PERCHANCE HE MATERIALIZES SOON, CANST YOU GIVE HIM ALL MY MESSAGES, INCLUDING THIS ONE, AND CONVEY TO HIM MY EARNEST URGINGS THAT HE MAKE HIS WAY DELHI-WARDS FOR SERIOUS WRITING SIEGE WITHIN THE NEXT WEEK?

MUCH THANKS AND ALL BEST, KAUFMAN.

I danced—rather, limped—around the room. He had got the story, liked it. There would be expense money. Maybe I

would get a story published. I checked into the Hotel Islamabad, where the man behind the counter, after taking one look at me, insisted on keeping my passport.

I flew to Lahore, took a taxi to the border, went through customs in ten minutes (the border closed at dusk), walked over to India. An officer looked at my cameras.

"These cameras are quite old."

"They were new three months ago. Afghanistan."

He looked at me strangely and proceeded to dump everything I had on the table.

In India I caught a night train to New Delhi and called Mike Kaufman from the station.

I took a rickshaw to his house. He came out in the yard to greet me, put his arm around me, gave me breakfast. It was like seeing a long-lost friend. I called my parents and told them I was out and alive.

Mike put me up in a fine hotel, Claridge's. The next morning, I visited the best doctor in New Delhi. He said my feet were filled with staphylococci. The next day I wrote a story about the battle of Kandahar. Mike edited it and sent it off. Craig Whitney wired back that it would run and said he liked it. But still I did not realize the significance of that. He suggested a series. Mike and I sat down and agreed on what it should be. He would go now with his wife, Rebecca, to Goa for three days to write a travel piece for the Sunday paper and would leave me alone to write. It was another measure of him that he would leave me in peace; the office was mine. I was free to write without him standing over me. I quickly wrote the stories while they were fresh and before I came down. I ate, slept, put on weight, and my feet started to heal. I sent the film to NBC.

On December 17, I said goodbye to Mike and flew to Karachi. I had to wait a day. I returned to the airport. There was a flight to Amman, Jordan, and to Tripoli, Libya, just before mine to Paris. They called the flight. I sat in the chair, wearing a suit,

a scarf, my field jacket over it. An attendant came over to me.
"Aren't you going home, sir?"
"Yes, yes, I certainly am."
"Well, the flight to Tripoli is just about to leave."
"Tripoli?"

I flew to Paris and saw there was snow on the ground. It was almost Christmas. I caught a flight to Italy to see a special friend. After two days, I said goodbye to her and her family and returned to Paris. Sitting on the plane, I picked up the *International Herald Tribune*. I absentmindedly scanned it, and there it was—six columns across, front page—"Blood in the Night," my story about the battle in Kandahar! I could not believe it. I read the first paragraph and put it down. Then, sitting on that plane, I knew for the first time that it was truly over; I had won. I leaned back, fell asleep, and we landed in Paris. The next day, on the flight to New York, I put on shoes for the first time since Paktia province. My feet were getting better.

A group of friends met me at the airport. They showed me the *Times* stories that had come out thus far, two on the first page, two on the second, and there were two to go. It was beyond my wildest dreams. We had dinner. Other friends joined us. And for hours, I talked and talked and talked. I couldn't stop talking. I was home.

A year has passed. The fighting continues. The papers reported that a Soviet general was killed when his helicopter crashed near Khost; maybe Jaluladin and his men are finding their marks. Around Kandahar the Soviet ground sweeps and air attacks have become even fiercer. How many of Ahmed's men are still alive?

The weather will be fair all over Afghanistan; there will be a clear view for helicopter gunships for many miles around.

0-595-21553-X

6542929R0

Made in the USA
Lexington, KY
29 August 2010